~~CAN'T~~

BREATHE

A MEMOIR

LAESA FAITH KIM

LAESA FAITH KIM
Can't Breathe
A Memoir

Published by Laesa Faith Kim
Copyright © 2019 by Laesa Faith Kim
First Edition

PAPERBACK ISBN 978-1-7770601-0-7
EBOOK ISBN 978-1-7770601-1-4

COVER DESIGN Grace Han
INTERIOR DESIGN Jazmin Welch
TYPESETTING Stephanie Toth
EDITOR Lori Bamber
PUBLISHING SUPPORT The Self Publishing Agency

*Can't Breathe is a work of creative nonfiction. Everything here
is true, but it may not be entirely factual. The events, places,
conversations and medical terminology in this memoir have been
recreated from the author's memory.*

To those who stumble upon themselves in these pages.

CONTENTS

PREFACE

Humans crave happy endings, the feel-good moments. We cling to the stories with an ever after, the ones with some type of closure. And we would like to think that each story has a beginning, a middle and an end. Plot lines that run high, low, high.

But—life. It doesn't run like a neat script. It moves messily, more unpredictably.

What about when things fall off course, when there is no tidy line to follow? What about the endings that are inevitably unhappy? Open-ended sentences and never-ending roads. Plot lines that start low and get lower.

Moving down a path that has no guarantee of an ending. Especially the ending you hope for.

Do you continue to hope anyways? Do you continue to believe that it all could be different? That a miracle might sweep the terrible away? Or do you accept it? Do you take your lot, what's been placed in your hands, and move on with it?

"How do you do it?" Again and again they ask and congratulate. As if I have some magic formula, some rare ability.

How would you not do it? If it were your baby, if this were your story, you would do just the same.

Would you think me weak if I instead shared my doubts and fears? Would you think me weak if you knew of all the moments I want to scream for no logical reason? What if you knew I didn't feel grateful about how far we have come, but am continuously frustrated we have so far yet to go? That I often reject hope because it is not useful?

Am I weak for sometimes resting in jealousy of your comfortable lifestyle and healthy children and constant "regular" activities?

The reality is I am not stronger than you. I am just enduring that which has been placed in my hands. The path before me is not a fork in the road. It is just a road. I can continue to put one foot in front of the other. Or stop. Those are my options. My only options.

There is no creating my own future, or the future of my children, or believing in something better. No life coach or self-help book is going to change this path. This is the best. These are the better days. These shitty, monotonous, exhausting, no-end-in-sight days. These beautiful, inspiring, too-fleeting-to-hold-onto days. These are the ones that will make up my story.

So, you choose to pick up your feet, and you keep your eyes open, and you move on. You move until you don't need to remind yourself to do so. You move because standing still is the harder option, because the weight is heavier and more awkward to carry when you are still. And as you move, as you begin to take those steps forward, the weight becomes mostly bearable. It becomes more and more a part of you, as if you had been carrying it all along.

You cannot fight what it is right in front of you, this path you see. You can wrestle with it all you want. You can be angry

and disappointed and wildly enraged. But it will still be there for you to deal with after you have paused to take a breath. After you have stopped for a moment to scream. In fact, the more you fight it, the more you try to press against or resist it, the more energy you expend getting nowhere. Energy that could be better spent.

You learn to open your arms and embrace what has been given to you. All the trauma, all the grief, all the pain. All the love. Just embrace it. Feel every ounce of it, through every fibre of your being. Let it shape you and mold you. Let it change you from the inside out.

You see, I am not stronger than you. There is no right way to do this. We each have our own way of reacting to trauma. Experiencing grief. Feeling pain. Living through disappointment. We all have our unique path of coping when it happens. But if you can, and I know you can, be content in this pain. Find strength in suffering. Experience peace in the in-between. Open your eyes to the beauty that unfolds here. This is what makes us.

This.

This is what it is to be human.

PUSH

She consumed me with inspiration,
but she was no muse,
she was the brush stroke of my every word.

Atticus

Gasp.

I hear it ever so faintly. Accompanied by the most delicate of squeaks. And then, nothing.

Evelyn.

I cannot recall the umbilical cord being cut. Did James get to do it, or was it the doctor? It is all happening so fast. I get a quick glimpse of her arms and legs, dangling from the doctor's hands, as she is rushed to the room next door. While my doctor and nurse help me finish birthing the life-giving placenta still within me, my baby's team of medical professionals surrounds

her failing body. I watch my husband as he stands in the doorway between the two of us. I can see he is holding his breath as we both hope for Evelyn to fill her own lungs with air.

He watches intently and listens carefully, snaps a few memories onto his camera, then turns to me to provide a play-by-play of everything happening in the room next door. All I can do is stare at that doorway, desperately wanting to be nearer. Desperately wanting to see her face, to touch her skin. Desperate.

Doctors continue to flood into her room, apologizing as they rush past me. I nod, oblivious to the fact that my lower half is still fully exposed for all to see. I must be in shock, as I cannot seem to process what is unfolding here. There is a crowd surrounding my daughter. Later I realize that this wasn't a good sign, but right now, none of it seems real.

I want to laugh with relief. I want to share a smile with someone at what I just achieved: *I did it. I got her out.*

I want to wail my despair. My baby, the reason for all this, is nowhere to be seen. My body feels as if it has just been ripped in two.

None of this is real.

The contractions started in the middle of the night, early morning, really. I had sent James home hours before, after assuring him again and again that I would be okay and that he needed to get a good night's rest. He had slept all week on the floor, tucked against a wall at the foot of my hospital bed. Woken frequently by stress, nurses coming and going, and the constant howl of women in labour. We are in the high-risk pregnancy ward; there are mamas all around us on bedrest, trying to keep their babes inside just a little while longer. And

each night there seems to be at least one bearing down through contractions, moans seeping through the thin walls.

It is my turn.

I press the call button hanging from a cord behind my head. I don't want to. I hate being a bother. But I can hear both James and my nurse telling me not to be a hero. Telling me to worry about every single pain. There are no false alarms anymore; every twinge *is* the alarm.

My nurse comes quickly and attaches the familiar monitor to my belly. The wide elastic strap hugs my torso; two round discs are positioned to catch Baby's heartbeat inside. I've been wearing it off and on all week. Tapping my thumb on the button every time I feel Baby Girl squirm. They want to be sure she is still moving, still fighting within me. This time is just the same as the rest, except it is not. Because contractions have now started up again after a week on bedrest, of halting labour, of praying she stays inside to keep growing. I am somehow sure this is it. I don't say it, as if keeping the words to myself might delay the inevitable. Let us wait and see just a little bit longer. *Perhaps this just is a false alarm.* But it is not. The moment is here.

My cervix has been three centimetres dilated since I was admitted seven days ago, so when contractions begin, it isn't a gradual progression like the usual start of labour. My body has already moved through that first stage. Now we are skipping ahead. These contractions are rhythmic and regular, and the nurse swiftly calls downstairs to have me moved. Baby cannot come up here, where the healthy babies are born. And everyone is prepared for this to progress very quickly.

I am transferred, I don't remember how, back downstairs to the high-risk delivery room I was admitted in last week. James arrives. *Did I call him, or did my nurse? It is all a blur.* Contractions continue and I give myself silent pep talks, my eyes squeezed shut.

You have done this before, Laesa. You are able. You are strong. You can do this. Just breathe.

Nurses begin offering me an epidural. It feels like I am asked if I want one every few moments, though my understanding of time is clearly warped right now. It might have been just once an hour—I have no idea how many hours passed.

I start getting irritated. *No. No, I do not want it.*

Am I really in that much pain? What shape is my distorted face? How loud are these groans that seem to come up my spine and escape me?

I continue to say no to the epidural with more and more vexation in my voice. I am not trying to be brave or to prove a point. I am trying to be smart. *I have done this before.* An epidural will numb me from the waist down. I will lose control of my body and lose these ghastly sensations that are familiar to me now. *I have done this before.* An epidural increases the chance of ending up with a C-section or an episiotomy. There will be no cutting today, no added stress to me or the baby. *I have done this before.* Every normal thing has been ripped away from me with this pregnancy. This, though, this bearing down, this body-and-face-distorting process, is the most normal thing I can do. And I will get her out, on my own, with James by my side. *I have done this before.*

Yet I have not done this before. Not with fear in my throat, perched as a wail ready to cast loose. I have not done this with a

crowd of doctors standing by, with an outcome unknown by all. I have not done this. And I do not know how to.

The doctor comes in to see how far along I am. By this point I am passing out between contractions, falling limp into James's arms as I lean into him on the edge of my bed. Sweat drips off my face and my body swells with heat. Someone brings a cool cloth, and in my conscious moments I am grateful for it. The doctor reaches inside of me and her eyes go wide as she recognizes just how close we are. As her hand pulls free, there is an audible pop within, like a balloon has burst. And just like that, my water breaks, releasing a flood onto the bed and floor. I am certain I have wrecked the doctor's shoes. Conscientiously, I apologize.

I am engrossed in labouring. Focused on my task. Enduring the tormenting rhythms within. Then, unexpectedly, labour concludes. I can feel her—my baby girl is right between my legs.

"James. James, she is there! I can feel her right there."

My wide eyes produce a frenzy in the room and James takes it as his cue to take charge. He shouts into the hallway for the doctor, who seems to have only just left, then snaps at the nurse by my bedside, "Why isn't she standing by, ready?"

The doctor walks calmly in, pulls on gloves from the box on the wall and sits at the foot of my bed. If she feels any apprehension, she hides it well. Her job is to help me get my baby out, and that is all we focus on.

I cry out loudly with my first push. I want to let all reason, thought and care go—I want to shriek. But this is not the time. The doctor is stern. "You do not get to scream like that. You cannot take your time with this or waste your energy. We have to get this baby out. Now!"

So, I grit my teeth and channel everything within to my pelvis. Every fibre in my body draws together. Instead of a cry, there is a deep swell rising in my chest. The only thing in my view is this moment right here. And I have done this before.

I push.

More than a half-hour later, after I have done the excruciating work of bringing this babe into the world, I finally get to see her. My beautiful girl. It is obscenely bright under the incubator lights. Her eyes are dark and piercing, and so incredibly full of trust. I cannot get over how trusting she looks despite the hellish circumstances that have been her 40-minute life so far.

I wonder if she knows who she is staring at. Does she know this is her mama here, the one whose finger barely fits within her tiny grasp? Is she missing my warmth already, the sound of my beating heart and the protection of my womb? Already my belly aches for her to be back within its safety. My heart beats out of my chest as it attempts to get just a little closer to this being it has brought to life. There is no warmth left in my body, no comfort. As she teeters on the edge of life, kept alive by all these doctors, it feels as if my labour and delivery were only the beginning of her birth.

None of this is real.

The doctors pause for our brief hello, ready to whisk her away down the hall, to stabilize her in the neonatal intensive care unit (NICU). One stands right beside me, and her hand is holding something inserted in the baby's little mouth, her thumb moving rhythmically. I realize that this doctor is my baby's breath. She is sustaining her, ventilating her tiny lungs, with her very own hands.

None of this is real.

Back in my room, I entertain excited family members while I weep unseen tears. I smile instead, because I tell myself this should be a happy moment, a proud moment. But it is neither.

It is six hours longer before I get to go to her. Six hours before this mama can be in the presence of her baby, of her flesh and blood. To breathe in her sweet skin and touch her delicate fingers. Six hours before they are ready for me to be in the room. And that is all I am allowed to do, to be present. There is no holding, no comforting. I don't even have to ask. I can see the fragile body before me, tape and wires coming and going from her skin. She looks perfect to me. Small, so very small. But perfect. And I cannot imagine what has taken them so long to have her ready for her dad and me to be in here, though it is clear she is in need of a lot more than either of us can give her. She needs the expertise and support of a whole assembly of experts, and drugs and machines to keep her stable, to keep her alive.

She exited me. Sooner than we had wanted, sooner than perhaps she was ready. But also, perhaps, because she was ready. She was ready to fight, and she needed more than the safety my warm womb could give her.

The room we are in, I learn, is called Procedure Room 1. There are two others just like it on the NICU floor, reserved for the most fragile babes. The room is dark save for lamps in the corners, as the babies' eyes are so sensitive to the fluorescents overhead. The door remains closed to keep germs and noise out. Each time it opens you can hear the hustle in the open NICU space outside, where incubators line the walls, nurses talk loudly, babies cry and machines beep. Always, always beeping machines.

There will be times during our hospital stays ahead when the beeping becomes a comfort. Something regular, a background noise like the dishwasher at home. But there are other times I can feel my head falling in on itself as it tries to escape this noise. I hear myself screaming on the inside: Turn it off! Turn them all off. Let us rest. But there is no rest in an ICU. There is waiting and sitting, fighting and aching.

No rest.

As we take in this square room, our first "home" with Baby Girl Kim, the noise from these machines is startling. She has monitors above her head with rows of waves and numbers, and I try to make sense of them. But even if I could decipher what they mean, I couldn't possibly know what "normal" is supposed to be. The incubator she rests in makes noise as well, as it works to regulate the temperature for the baby in its care. The machine at the foot of her bed, the most vital of them all, plays melodic chimes to get the attention of the nurses or respiratory therapists. This one is filling my girl's lungs with air. It is her every breath.

How can I describe the heartache of watching my child alive but unable to breathe? Breathing is the most natural human activity. We all do it, moment by moment, day after day, without thought. Our breath quickens when our heart beats faster, responding to stress, excitement or physical exertion. It slows as we sit at ease, when our body quiets for the night.

Even as you read this, perhaps you take a large inhalation, filling your lungs with oxygen, and then return to a shallow easy rhythm again. Now think of a machine breathing for you: always the same depth of inhale, exhale, inhale, exhale. Always the same rhythm.

When Baby Girl tries to resist a breath, her machine chimes. Or when she tries to add to the breaths given to her, because her body knows she needs more, it chimes again.

I feel useless in this space. I should be lying in a bed with a sweet babe on my bare chest. Someone would help me shower and take photos of our first hours together. Friends would bring food and James would resist sharing his baby girl when someone else wanted to hold her. Her big brother Noah would curl up with me in my bed, shy and eager with this new person in our family. I would nurse her easily while the pain between my legs took its time to heal.

Instead I stare. I stare at screens I cannot understand. At faces I do not recognize. At a baby that is wholly mine but foreign to me still. I listen to words coming from the doctors' mouths, but none of it registers. I know I am doing an admirable job of composing myself, of keeping my cool, but I do not think it is because of strength at this point. It is just shock. I am shocked to find myself here. I am shocked by my current realities. It is not supposed to be like this. I yearn for this to not be real.

Doctors continue to surround her tiny bed. Our time together is never truly alone. Doctors and fellows and residents, nurses and interns. The hierarchy of the hospital is quickly made plain. In the room right now is the genetics team. They have a small measuring tape and are recording the size of her nail beds, the length of her toes, the distance between her eyes. Each bit of her is examined and analyzed as they make notes and formulate questions to follow up on. I am annoyed with their presence, partly because there was so little warning, but mostly because

I want to tell them that she is perfect, and they can move on now. That if they go upstairs to see all the full-term, healthy newborns, and analyze them all this same way, I am certain they will find just as many pieces to question. But I don't say these things, because the reality is that my perfect baby girl has holes in her body and organs not grown properly, and she is the one requiring oxygen, ventilators and feeding tubes. These people have every reason for concern, every reason to gather and pick apart all the data that is her, and to try to find a cause or label that explains it all.

I fear a label. I fear it for her sake. And I think I fear it for my own as well. I know what this world does to people with labels. Especially ones unfamiliar to them, labels they don't understand. I fear the conclusiveness, as if a label solidifies a specific future, depicts an unchangeable outcome.

I don't want to know anyone's conclusions about my little girl. Tell me what is broken and how we can fix it. Tell me what her needs are and how we can fulfill them. Don't you dare tell me what "her chances are." I do not want finality. The question mark over her life means there can be more goodness ahead than we currently see, a brighter future.

The first days in the NICU are like walking through a cloud, hazy and cold and unclear. Processing still what has landed in our lives, hoping for it all to be different. Trying to find peace in what cannot be changed. We laugh and make new friends with nurses and RTs. We hover over our baby's bed, taking her in with our eyes, praying and singing to her.

While I am still a patient myself, upstairs in the same bed I've been in since a week before her birth, I walk back and forth

between the NICU and my room countless times a day. Up and down the hallway and elevator, and more hallways again. There is a constant dull ache between my legs. I have just delivered a baby and I burn and throb. Instead of lying in a bed with her for weeks of recovery and bonding, I walk. I walk with urgency so as not to waste a moment. And it hurts. God, it hurts. But I cannot suppress this need to move quickly. To fit it all in and be back by her side again. I leave first to rush to the bathroom, where I sit ungracefully on the toilet, letting my body expel the leftovers of birth. I clean myself up, using my hospital-grade squeezy bottle for a brief sensation of relief. Then I eat the trays of hospital food left at my bedside three times a day. It may not be ideal, but it is convenient. I hurriedly finish my plate because I know it is necessary to nourish myself.

Now it is time to "express." All the different kinds of expression we do in our lives, and now it is time for me to express nourishment. Mother's milk. My baby's food.

The first handful of times, it is a slow, tedious process. Massaging and kneading my body's nectar into a small vial. A few drops. Then a handful more. Soon I will fill this vial with ease, and I move on to the mechanical pump. The *womp, womp, womp, womp* quickly becomes familiar. I attach myself for the process and sit waiting for the let-down to occur. It does, and soon after two small bottles will be full. I label each container. Name, date, time. Each label has her name and room number on it too, to ensure the correct babe receives it. Like a spiritual ritual, I wash the pump and its parts and lay them out on a clean cloth, ready for the next use, four hours later.

Then I walk some more. Urgently, up and down the hallways, and always, always carrying bottles of milk back with me. Milk that is produced faster than she can consume. Milk that inevitably ends up in the freezer. First just a couple bottles that sit at the bottom of a large bin. Soon there are two full bins. Near the end of our time in the NICU, my milk takes up a whole shelf in the commercial-grade deep freeze, all labelled Baby Girl Kim.

Rounds happen every morning in the NICU. There is no set time, as any emergency or admission can alter the flow of the day, but they generally take place between nine and noon. The NICU is divided in two, with two teams of paediatricians and neonatologists, and each team starts with the most fragile neonates in their care. For a long time, that babe was Evelyn, so I could count on rounds to be about the same time every day. And I never missed it, not once while she was at the top of that list.

Evelyn's day nurse would start by giving an account of the patient and her current condition. "This is Baby Girl Kim, born at 32 weeks plus two days, weighing 1,530 grams, to a healthy 26-year-old, via vaginal birth. She is three days old today, or 32 weeks plus five days corrected age. Cardiovascularly, she is diagnosed with tricuspid atresia, pulmonary stenosis and a VSD.[1] Cardiology came by this morning to check on her. Accepted sats[2] are above 70 percent. She was a severely difficult intubation at birth, via videoscope by ENT,[3] and has remained on ventilation support since. Breathing is irregular. Lungs sounds

1 Vascular septal defect, a hole in the wall of the heart that separates the two lower chambers.
2 Oxygen saturation levels
3 Ear, nose and throat specialist

wheezy. She is poorly perfused and mottled throughout.[4] No skin conditions noted. No known allergies. The patient had a difficult night, with frequent desats[5] into the 60s." Et cetera. Et cetera. Et cetera.

Once the nurse had gone through all that and listed the medications Evelyn was being given, a respiratory therapist would take over and reiterate her respiratory condition, followed by a suggested plan of care for the day. Sometimes that meant making adjustments to vent settings; often it meant leaving everything as is. It was then the resident's turn. He or she was quizzed on the patient's status or condition and the plan of action by the paediatrician or neonatologist present. The paediatrician would ultimately make the official "medical order" for the day, and it would be approved by the neonatologist, who would either nod along in agreement or question the reasoning or need for that type of care. A charge nurse took notes. A fellow wrote the orders. A pharmacist commented on drugs administered and ordered whatever was prescribed for the day. These discussions took anywhere from 10 to 30 minutes. The purpose was to put everyone on the same page, have a plan in place for the day, and let us all know how the day could go sideways. The more people in the NICU who know the patient, the better it is when an emergency occurs. And with these patients, the approach was always "*when* an emergency occurs." Not if.

On my second morning rounds experience, on Evelyn's third day of life, the paediatrician has an unexpected care plan for the

4 Indicates low oxygen saturation throughout the body
5 Desaturation: low oxygenation

day. She looks at me with sure eyes, a knowing smile on her lips. "I think the care plan for today should be skin-to-skin time with mom."

My throat tightens instantly. Eyes glossy and heart pounding, I nod my head with an anxious desperation. I want to say, *Yes, please, thank you.* All in one breath. And I think I try, though it is barely audible as my hand brushes across my face to wipe the tears away.

I don't know at the time, but I know now, that she wasn't just suggesting Mom should be able to hold her baby. It wasn't that she thought the baby was particularly stable and ready to be held.

No. She wanted to be sure that Mom got to hold her baby in case the weekend ahead went poorly and there wasn't another chance.

But on that day, I was ecstatic. After rounds finish, we made plans with the nurse and RT assigned to Evelyn for the day. It would be a complicated event, taking her out of her incubator with all her wires and tubes attached before placing her safely on my chest. I am reminded to eat, pee and pump beforehand because once she is securely in place, it's better to leave her for as long as she and I can tolerate. The fewer movements back and forth, the better.

I undress in the corner while the space is being prepared. Our nurse calls for assistance as many hands are needed to make this a smooth transition. I slip on a hospital gown backwards, the front open. Modesty is long forgotten, but I casually hold the front closed out of habit while I settle myself into the chair. The nurse has arranged pillows and blankets to support my sides and arms. The less actual holding, and the more resting,

the smoother this will be. I then watch from my chair as they make a plan. Who is holding what tube; who has Baby's head, body and limbs; in which direction will everyone shift? There is me, two RTs and two nurses. James is standing near with his camera in hand. It is quite comical, actually; such a performance to move our three-pound baby three feet.

As her skin touches mine, easing down on my chest, electricity travels between us. There are hands everywhere, fussing about, taping and pinning all her attachments to my gown, ensuring everything stays exactly in place. But it is as if everyone is moving in slow motion around us. At the centre is just me holding my baby, as it is meant to be. I have one hand securely under her bum, which rests in turn on my tummy, still deflating from the pregnancy. The other hand is over her shoulders, with my fingertips securing her head atop my sternum. Here we sit, her body wedged in my bosom. I can feel myself sweating from the stress and nerves as I watch her oxygen saturations on the screen dip and recover, dip and recover. And then my breasts start to leak. Finally, a baby is in my arms, and I am breathing in her scent, the top of her sweet head, and my body knows just what to do. Only this baby is unable to respond. So instead of nursing, I ask for a cloth to place on my nipples. And the fluid that could have created a beautiful nursing bond is instead absorbed by sterile fabric.

I tell myself to let it go. To turn my mind away. Do not dwell on sadness and disappointment. There is a baby in my arms that might not have been. The smallest living thing I will ever hold is in my grasp.

She is mine. And she is perfect.

DENIAL

To get through the hardest journey
we need take only
one step at a time,
but we must keep on stepping.
Chinese Proverb

At 12 weeks pregnant, I start to bleed. It isn't quite pouring out of me, but it is certainly more than a few drops. My past self would brush this off. Baby is fine. I am fine. There is nothing to fear. But, 15 weeks earlier, this same thing happened with our first baby number two, and it most definitely was not fine.

I was just eight weeks along. We had recently announced to our families and celebrated, in the heat of the summer sun, the new life that would be with us the following spring. These days, with such early testing, you can know almost instantly when you are expecting. This baby had been part of our family

for a month already. For weeks I was thinking about names and looking at teeny baby clothes and imagining the joy of meeting our second child. I had entered the due date in my phone's baby app and each week I watched its growth and development in the palm of my hand.

It was a Friday in August and the rain came down as I dropped Noah off at my mom's house for the day. I had noticed spotting that morning when I went to the washroom, but it wasn't much. A quick Google search reassured me that, yes, this could be normal. I told James when it persisted throughout the day, and he seemed sure the same thing had happened in the early weeks with Noah. He, the more anxious of the two of us, told me not to worry. Our baby would be fine.

The bleeding did not stop, though, so we headed to the ER that evening. After peeing in a cup, an incredibly uncomfortable and lonely ultrasound experience, and then waiting for more than two hours for a doctor to give us results, we were still optimistic. We were eating sandwiches and laughing, brushing fears off each other, when the ER doctor abruptly pushed through the door.

His tone nonchalant and detached, the words spilled out of his mouth. "The fetus is gone."

Shock.

James instantly called him out on his curtness and lack of empathy. It was as if he believed we already knew. As if he expected that we would feel no grief for a baby the size of a raspberry. But we didn't know. And we most definitely felt grief. Heartbreak.

Loss.

The grief swamped us in the following days and weeks. It came in waves, crashing over our spirits and our joy. Tears streamed down our faces as our baby slipped out of me. Each time I sat on the toilet, pieces of our future fell away. And I mourned this loss, bit by bit. I hadn't known such helplessness before. Never have I felt such plain sadness. Nothing could have prepared us.

Everyone knows that miscarriage is common. In fact, it is probably a more common experience these days than ever before because we often know there's a baby before it has time to properly start its journey. But when it happens to you, when you experience this loss, it doesn't matter how many others have walked through it before you. It is not reassuring to know that this is nature taking its course. It doesn't lessen the pain or quicken the process.

We tried to take our grief in stride. Our son Noah cheered our spirits and we continued on with life. It was difficult to put words to what had occurred. How do you grieve publicly when so few people recognize the weight of your grief?

Evelyn was conceived shortly afterward, not even a single cycle between the loss of our unborn baby and our discovery that I was once again, blessedly, pregnant. It was healing for both James and me. Having a baby in my womb felt right.

But it also felt strange, as if she was taking the place of another. I felt such guilt in those early months that I was forgetting a baby I had loved so deeply, even if for a short time. That I was allowing the joy of another child to replace the heartache of the first, and somehow letting them both down by doing so. I also lived in fear—I no longer trusted my body

to carry and grow my baby. I internally questioned every pain, every twinge.

So, you can imagine how my heart sank when I saw those now familiar spots of blood at 12 weeks. I could barely catch my breath as I immediately thought the worst. How could I not?

It took a day to get an appointment with the ultrasound technician. Then when we arrived, their frustrating protocols didn't allow James to come into the room with me. I lay on the hard bed, alone again, praying there was still a heartbeat within me. Politely, quietly, I waited for more than 10 minutes before saying something. The technician's face was studious and focused as he moved his wand back and forth across my belly, slight ridges in his brow. There is no way I am going to wait for these results, so I meekly ask if he could find the heartbeat.

"Oh, yes, the heartbeat is very strong. It's just—I am trying to locate the source of the bleeding, and I cannot seem to find it."

To this day, I am puzzled by this event. I question its significance. I question my memory of the details, as if I had made the whole thing up. Was my body prepared to let go of this baby too? Did it recognize the developmental defects and try to give up on Evelyn then? What made it stop? I can't say it was my faith. I certainly didn't believe as strongly this time that everything would work out. I questioned my ability to hold on to a baby. I doubted constantly.

What this event did, though, is give me an assurance that this baby was meant to be. And that she was meant to stay. So, when we are asked about do-not-resuscitate orders or skipping medical interventions, even when we are given the frightening survival statistics before each of her surgeries, I believe that she

will come out alive. Call it ignorance. Call it denial. Call it faith. It is likely a bit of everything. When doctors try to bring us back to earth, try to show us the reality of our situation, the severity, I still assume the best.

Evelyn is going to live. The alternative is unimaginable.

But … what will this life look like?

BREATHE.

I just got home from a trip to IKEA. There are more than two months to go before Baby arrives, but it is never too early to start organizing and nesting. I wonder if I can convince James to set up the crib this week.

Ow. That one hurt.

Breathe.

Braxton Hicks. It is really no big deal. They started at 28 weeks with Noah. I even spent a night in the hospital, monitored, to be sure it wasn't preterm labour. Nope, not labour. Just an overactive, overachieving uterus. They say it is because I need to rest more. Too much walking and activity. Maybe shopping wasn't a good idea today. Sometimes they are frequent, sometimes periodic. Never rhythmic or predictable. It is nothing to worry about.

Again? Breathe.

Breathe.

That is strange. They are not usually so close together. Maybe I should watch the time on the next one.

That was dinner time. By the time James arrives home from work the contractions are consistently 10 to 12 minutes apart. And they are no longer just short cramps to breathe through.

My whole torso contorts as the watermelon inside me tightens. When Noah is in bed and I crawl in myself for the night, they are still coming regularly. And I am still looking at my clock each time they do. Neither of us is very concerned, but James always likes to stay on the safe side with our kiddies. As he should. I tend to brush things off a bit more easily. I do not want to be a bother or look like I am overreacting.

He convinces me to give the on-call midwife a ring. She insists we come to the hospital to get checked, "better safe than sorry," so we put on comfy clothes and get our things together. James calls his parents and asks them to come watch Noah while we are gone. We will just be a couple hours, I am sure, looked at and sent on our way.

While driving I google preterm delivery at 31 weeks. It doesn't seem too terrible. Baby will be small, but there aren't any huge concerns. It will just need time to grow.

Am I concerned that this is labour? I thought I was brushing it off as a false alarm.

We are fast-tracked through the ER. They take labour pains seriously here, and soon I am in a bed in the triage area of labour and delivery, waiting for our midwife to finish with another patient.

While we wait, the nurse starts going through our chart and asking us questions.

"I see you have polyhydramnios, excess fluid? And there is a single umbilical artery …?"

Hold on. What!? I have never heard these terms. I don't know what you are saying. What are you saying?

She stands there stunned and slowly closes our file. "Let's

wait for your midwife to come. She can help explain these things to you."

What things?

Our minds are racing. Is there something wrong with our baby? How are we just finding out about this now? There were ultrasound scans done more than eight weeks ago.

Soon we are moved into an examination room. Our midwife brings our charts with her, and she begins her examination. There is no delicacy about it as she motions for me to lie back and spread my legs. She reaches in and discovers that I am three centimetres dilated.

How can that be? I didn't feel like I was in actual labour. Or did I?

Then we hear the words that turn our world upside down. The starting point of *life after,* when the life before becomes forevermore unrecognizable. We will never again be the same. Life, what it means to live, will never be the same.

"Your baby has a complex heart defect."

And there is more.

"There seems to be something wrong with her chin and jaw. It is very small."

Wait. Her? We are having a baby girl!?

I am in shock. *How are we just learning about this now?* I don't know how to react. *How am I supposed to react to this?* I nod my head, accepting her words but not understanding them. The gravity of this information has not yet set in. Babies have heart conditions all the time, right? It is going to be okay, right? And a girl. We didn't know what gender we were having, and I had been so sure I would be a mom of boys. A baby girl!

We are brought back to our bed in triage, while the team decides on the best course of action. The nurses start an IV for me; I can't recall what it is for. I overhear a few of the doctors talking on the other side of the room by the nurses' station. "Do we send her in an ambulance to BC Women's? Does she have enough time? Perhaps she can deliver here and then we can do a transfer."

Hold up. If you are not certain of your service capabilities, let's get an ambulance, now. I want to go to BC Women's STAT!

We are at a major city hospital, but there are no surgical staff here for neonatal patients, especially a cardiac one. If labour continues to progress, she will be here by morning. And if she requires surgical support right away, it will be too late for a transfer. A paediatrician from this hospital's NICU comes to our bedside. She explains the capabilities of her staff and unit, and why she feels confident they would be able to care for my 31-week babe. I feel she is giving me a sales pitch, as if we have a choice here about who will care for our fragile human. Then she goes on to say they are not certain what condition Baby's heart will be in when she is born, and that if she requires surgical support, they cannot help her here.

Why is she telling me what I already know? Protocol? I don't have time for protocol. Just send me on my way. Now.

A gynaecologist comes by soon after. With a thick Eastern European accent, she tells me she needs to verify my midwife's findings. Apparently, a midwife cannot officially diagnose a cervix. My parts are manhandled again so she can confirm that I am in fact three centimetres dilated. She goes on to reiterate that there is nothing to be done here. Labour has begun and the

baby seems to be coming. We must now prepare for her arrival. The gynaecologist is matter of fact but grim as hell.

I am given a dose of steroids, jabbed unceremoniously straight into my thigh. *That cannot be the right way to do that.* They say it will help her lungs grow; they say she will be stronger.

All I want to know at this point is where that ambulance is at. I can sense the hesitation in this place. I can see them reading our charts with fear, uncertain of what this delivery will bring. They are not equipped, and they know it.

As I see their apprehension, my mind begins to comprehend the severity of what is about to unfold. I know BC Women's and Children's Hospital is where we need to be. I know it is our baby girl's best chance.

The ambulance ride is brutal. I lie flat on my back, which is most definitely the worst position in which to endure contractions. And they continue to come, relentlessly. I breathe through each of them, though, trying to keep my nerve together. This isn't for me; this is for the one I carry within me. As the sirens blare and the paramedic beside me continues with questions needed to fill out his paperwork, I watch my belly jiggle and bounce. Vainly, perhaps, I feel the need to hold it in place. As if my roundness will fall right off of this stretcher if I do not.

We arrive. I have been here before. I recognize the entrance, waiting room and triage area from my first delivery three and a half years ago. We pass through quickly as I am wheeled straight into the high-risk delivery room. This is no longer familiar ground; high risk was never supposed to be part of my story. It is the one that can turn into a surgical space for emergency C-sections. The one that is connected to a neonatal procedure

room, with direct access for BC Women's delivery staff and the neonatal intensive care staff through adjoining doors. The nurse assigned to me begins asking questions and filling out her own paperwork. Prepping the room and preparing for whatever this night might bring. Being labelled "high risk" confuses me. My first pregnancy and delivery were textbook, perfect. I am healthy. I am young. This was supposed to be the same. There were no indications that it would be any different. I am still in denial. I want to convince myself that everyone is overreacting, being overly cautious.

James arrives shortly after I do. How he drove home and then to the hospital in almost the same time as the ambulance is beyond me. I give him a look for going so fast, but I feel such relief that he is by my side again, I grab his hand to keep him nearby.

It is the middle of the night and we are both exhausted. We sleep between contractions and nurses coming and going. I am given medication to try to reduce or stop the contractions. The nurses explain multiple times that there is no guarantee this medicine will do anything. They cite studies and personal experience—sometimes it works, sometimes it doesn't. I recognize, though, that this team is not accepting that it is too late. They see the seriousness of the situation, of this particular baby coming too soon, and they make plans to give us more time. I may be in labour, I may be three centimetres dilated, but they are doing anything and all they can.

The maternal fetal medicine (MFM) doctor wants to do another ultrasound. He needs more information. And I think he wants to verify the findings on our ultrasound done eight weeks earlier. The one no one told us about. The one with "STAT

URGENT" written on it that was sent to the hospital we were to deliver at and lost. He is afraid that if he moves me it will encourage more contractions; he wants me to be still. He has a portable ultrasound brought into the room. It is less accurate, but he is confident it will give him what he needs.

I know he is examining the baby for more important information, but the one thing I want him to verify for us is, is it really a girl? I felt so sure I was having a boy. None of this is as I imagined, and I just want to know who it is inside of me.

It's not a boy. It is a baby girl, and immediately we start calling her by name. Evelyn "Ava" Faith Kim.

Baby girl. Stay inside now, will you?

Our MFM doctor finds what he believes is the cause of this early labour. Polyhydramnios. A word that takes me more than a year to properly say. I understand the effects in moments, though, and everything about my pregnancy begins to make sense. Polyhydramnios is an excess of amniotic fluid. It made my uterus grow much quicker and bigger than it should have. Baby girl was swimming, which is why, most days, I was exhausted and out of breath, and not feeling at all as I did with my first pregnancy. I felt huge and told anyone who would listen. But it was brushed off as exaggeration. As normal. As typical with a second child. Now it made sense. I felt huge because I was huge. I measured 38-weeks pregnant at just 31 weeks. And my over-achieving, active uterus thought that this was its cue.

If we had known about all of Baby Girl's conditions eight weeks earlier, we would have been seeing this MFM doctor at Women's Hospital all along. He would have monitored us closely. Weekly ultrasound appointments. And, likely, to pre-

vent labour, he would have been draining this fluid. Bit by bit. Week by week.

But we didn't know. And now we are scrambling to keep Baby Girl inside after I'd already progressed through the early stages of labour. The only chance we have at this point is to drain this fluid, now. And hope it will halt the process that has already begun.

It is the wee hours of the morning. James and I have barely slept. The doctor is giving us the pros and cons of the procedure and what it entails. Like the ultrasound, he doesn't want to risk moving me and causing more stress to my body or baby. He wants to do it here in this high-risk delivery room we find ourselves in. He explains that most MFM doctors do this procedure in pairs, one to hold the probe and one to hold the ultrasound wand. He has been specially trained, though, and I feel sure he isn't bragging but just stating the facts. He can do this on his own, holding one of these tools in each hand. He needs to place a needle probe into my uterus to drain the fluid, using the ultrasound at the same time to ensure that the probe remains in the fluid and away from the baby. He is confident he can do it. But he is not so confident that the sudden change in fluid volume won't bring on more contractions and consequently make my labour progress even faster.

There is not a single question in our minds about whether we should go ahead with it or not. I don't even have a moment to fear a big-ass needle going into my belly. We must do whatever is necessary; we must give our girl the best chance we can. And this is the only chance, the only option.

We wait a couple more hours, as the hospital shift change is happening soon. The doctor wants everyone fresh and the hospital back to full daytime staffing levels before we begin. The contractions continue as we wait, nearer together and intense.

Once the go-ahead is given, the room swiftly shifts from delivery suite to procedure room. Sterile towels are laid out. Metal trays of instruments and needles are uncovered. We meet new nurses and an MFM fellow who will be assisting and learning from the procedure.

A litre and a half of fluid are drained during a 30-minute process of poking and prodding. I continually ask if we are almost done while I hold James' hand and nuzzle my head into his chest. Like a child myself, I shy my eyes away and whimper for it to be over. Touching (more like provoking) a uterus that is rhythmically contracting brings on intense pain. It feels as if my belly is contorting for the entirety of these 30 minutes, with no let-up in the sharp, agonizing sensations. I breathe through it, as I'm prompted to do, and I endure. There is no other option.

For an hour, the contractions continue with even more intensity than before. But eventually they begin to subside. Eventually there is less pain, less panic. And finally, more than 24 hours after the start of it all, I exhale freely and close my eyes. "Exhausted" hardly scratches the surface. My mind and heart and spirit are overwhelmed with all our new information. The situation we find ourselves in hardly seems real. And though we will have one more week to take it all in, I know there is no way to be prepared for what is to come.

I am moved to a slightly less high-risk room while we wait to see if the contractions will return. I continue taking meds, the

ones that I still cannot put a name to, the ones no one is certain will do anything. At some point I am placed in a wheelchair, and James wheels me down the corridors to the ultrasound clinic. It is time to get better images, to receive a diagnosis, to properly prepare the cardiology team for this soon-to-be cardiac patient.

His mind spinning too, James forgets that he isn't just pushing a cart and wheels me straight towards a wall to park me as he goes to speak to the receptionist. We have a small chuckle at the oddity of it all, me being pushed around like a child. Feeling helpless. He turns me around, away from the wall, so I have a view of the waiting room while I wait for him to return from the desk.

Though the waiting room is full, we are moved along swiftly to a room where I lie on the ultrasound bed for what feels like hours. The technician's wand methodically moves around on my bare skin, over my large (but less large than when I arrived) belly. At some point a cardiologist arrives to take a look. She is warm and friendly. I try to remain still and lie patiently, though my butt begins to numb at this point and I'm so ready for this session to be over. The only consolation is that James is in the room with me this time. I find I am giddy with happiness to have him looking at the moving images with me, to see our girl still active inside me, and I am steadied by his hands around mine.

The technician is able to zoom through my belly, uterus, the amniotic fluid and inside the baby to get clear images of her heart. It beats strongly, but they tell me there is something wrong. We wait to learn what that something is. They look closely at her face and jaw, and we try to keep her still to see

if she is swallowing. It seems minimal and infrequent, which explains the excess fluid. Notes are made and pictures are saved, and eventually we are done. I am helped back into my wheelchair, and we wait in a random hallway to go into a nearby conference room to discuss the findings.

In the conference room is the cardiologist from the ultrasound room, James, my mom, one of the cardiac nurses and me. This nurse is studious and generous, full of information she wants to share with us. At the time we are annoyed by her presence, perhaps because of the news she brings. What I don't realize is that she has been paired with Evelyn and we will be followed by her for the rest of Evelyn's childhood. This nurse is going to be our friend. She will stand with us through surgeries and endless uncertainties. We will laugh on the phone together during our weekly check-ins. Today, though, bringing this terrible news to us, she is not a friend. She is a stranger who thinks she can ease our shock and disappointment with diagrams and pamphlets. And although I begrudgingly admit they were useful, in the moment, they weren't really helpful at all.

The cardiologist, Dr. M, begins. "Your daughter has a complex congenital heart defect called tricuspid atresia, a VSD and pulmonary stenosis." The nurse who isn't yet our friend pulls out her diagrams and pamphlets, to point to and elaborate on what is being described to us.

Tricuspid atresia refers to a partial or complete blockage or malformation of the valve between the right ventricle and right atrium, restricting blood flow out to the body. Pulmonary stenosis refers to a narrowing of the pulmonary artery, the main artery that takes blood from the heart to the lungs. This ste-

nosis likely occurred because of the lack of blood flow coming through the artery; underused means underdeveloped. Rather than through the tricuspid valve, Evelyn's blood flowed through a small ventricular septal defect (VSD—in simple terms, a hole in her heart) that had conveniently developed between the right and left ventricle. This small hole, believed to be on a "muscly" part of her heart, was keeping her alive. Because of its location and size, the cardiologist believed she would need surgery very soon after being born because the hole would narrow or close. The first surgery, they then described, would be a Blalock–Taussig shunt, a procedure used to increase blood flow.

They went on to describe further surgeries, pointing at and labeling diagrams as we went along. I try my best to understand all the details. I envision a healthy heart in my mind, trying to recall my grade 12 biology textbook and visualizing what normal blood flow is supposed to look like.

I envision Evelyn's heart and the pieces that are out of place.

What does this mean for her, though? So, she has a few surgeries. Is that all? Kids have heart surgery all the time, no?

Patients born with this diagnosis go on to live fairly normal lives. They will go to school and participate in regular activities. They will not become Olympic athletes, but their hearts won't stop them from living ordinary lives, the doctor and nurse tell us. The more complications, however, the more uncertain the outcome. This baby, our baby? With a complex congenital heart defect, likely to be born prematurely, with a collection of other anomalies not yet fully understood? It is impossible to say what this will mean for her. It is hard to say what sort of disadvantages or disabilities she might have. The cardiologist shrugs

her shoulders, as uncertain as we are. Will she survive birth? Will she live long enough, the way her heart is now, to grow big enough for that first surgery? Will she come out of each of the surgeries just described to us? Will she have cognitive disabilities alongside her physical defects? Even if she comes out of each heart surgery alive, what will the life ahead of her look like?

We cannot know. And despite the intelligence, education and experience of the doctors here, they cannot know. Sometimes statistics can be a lifeline to hold on to, but there are too many variables here to be certain of anything.

The reality is that, even if much more were known, no one can tell us how any life will play out.

To live is to risk your life.

YESTERDAY

Normality is a paved road:
It's comfortable to walk but
no flowers grow on it.
Vincent van Gogh

I sit in a crammed row of eager parents and proud grandparents. The curtain goes up and dancing bodies, brave grins and poorly pointed toes move across the stage. I am filled with grief. All I can feel is the pain in my chest, the heat upon my cheeks and the strength it takes to keep the salty drops from rolling down my face.

Little girls dancing.

Little girls breathing.

Little girls living.

My little girl is in a clear plastic bed, sedated and breathing

with a machine. Will she ever be able to do this? Will she stand? Will she dance and smile and have the capacity to keep up?

GO TO SCHOOL, they say. Find a boyfriend, they say. Land a job. Get married. Have children—enjoy them.

They said it. I did it.

But not because it was expected of me. Not because it was someone else's idea of a future. I did it because it was what I wanted—to be a mother, to share my life with one person. I wanted to put my hands to work at something I was proud of. I wanted to experience love. I wanted to learn under a mountain of books, to create and add beauty to this world.

I've wanted a lot of things. But more than anything I wanted a family. In the most normal, ordinary sense. A husband to grow old with and children to raise.

My childhood wasn't exactly simple. And though it probably resembled many children's experiences, from what I could see at seven, nine or 13, I was the odd one out. I spent my weeks at one parent's house, experiencing family, routine and predictability. Then the weekends at another house, where freedom was enjoyed but security was not.

On top of my bouncing back and forth between homes, caught within my parents' arguments and strife, I missed my siblings. Four days a week with these two. Every day with this one, until a time came when it was every day without. And then that one, over there, just down the street, who I only saw just a couple times a year.

That one, who left me afraid.

I learned to walk pushing her wheelchair. I remember the

hospital-like bed in our home. She was the first experience I had with feeding bags, therapies and special needs. As a child as young as 12, I remember being afraid that this would be my future too. Would I have a child with special needs? As I moved toward marriage and children, I continued to fear. Just a dull hum in the back of my mind—that I might be called to this other life.

Did I have these thoughts because of my sister? Or does every mother-to-be have these fears? If it happened, would my marriage survive when my parents' marriage had not? Would this be a dark cloud over our future or a beacon of light?

James and I met when we were 13 years old.

Me? Quiet, a good girl. Him: loud and confident. Me from a disjointed, beautiful but sometimes messy blended family. Him from a "normal," first-generation Canadian family of four. We had been in the same school for years, since preschool, as we later discovered looking at each other's childhood photo albums. But we never ran in the same circle of friends, under-standably—he was athletic, cocky and outgoing. I was a shy bookworm, content in smaller crowds.

Somehow our paths crossed in eighth grade. Mutual friends pulled us into a circle huddle, the ones you see preteens standing in. As James recounts, I poked my head into the conversation with my finger pointed towards the sky. "Actually ..." and I went on to make a point about something we've both forgotten now. But the awkward know-it-all girl caught the attention of the cool kid, and the rest is history.

Well, not entirely. There was a lot of chasing involved over the next few years. We spoke frequently on MSN and phone calls. Not personal mobile phones, but house phones. The ones

little sisters can eavesdrop on from the other end of the house. The ones with a limited radius, in my case as far as our backyard swing set. We teased and flirted, poured ourselves into each other, and felt love any child can understand. He attempted to hold my hand while we watched movies in the dark with friends. And while walking our dogs together. And while standing in one of those familiar circles with our friends at school.

As much as I would pull away, nervous, anxious about being anything more than friends, I would also press in, giving him the smiles he wanted, letting him place his hand in mine for a moment longer before letting go. I touched his arm as we laughed; I leaned in close to tell him my thoughts. I didn't realize what I was doing at first, but I learned quickly about the power I had over him. I also learned about the power he had over me, drawing me into something I wasn't sure I was ready for.

By the time we were halfway through grade 12, he'd already had two girlfriends. Our friendship had moved through various seasons. It grew and plateaued, grew and plateaued, a few times over. Each time our friendship blossomed again, the pull between us would strengthen. The electricity would run wild. Desire and need moved hand in hand. And so eventually we let it.

We fell passionately into each other just months before graduation. We loved on each other, body and soul, day after day and week after week, drinking in the freedom and joy of young love. We bickered like an old married couple, disagreeing about nitpicky things, getting upset over petty details, depending on each other for our happiness.

He taught me all I know about passion and confidence and going after what you want. And I taught him patience, determi-

nation and living in the moment. We gave each other the best of ourselves, and in so doing, created our best selves together.

Our relationship hasn't been all ease and joy, though. We were young and stupid in love. We hurt each other badly. I hurt James like I never expected to hurt another human being. We lost each other for a short time and lost ourselves. But as our friendship blossomed and rekindled again, as it had repeatedly before, we found love. Love that was painful, stunning and deep. We have experienced pain caused by the other. Given and received forgiveness. Wallowed in self-pity and disappointment and grown in self-respect and character.

During one of our lowest points as a couple, rejoining after a summer apart, we recognized something so powerful that it changed how we saw our relationship and how we approached disagreements and challenging times. During a clear "aha" moment, while I wept in the car and James held me through it, we understood that choosing to love each other meant choosing to fight for each other. To fight hand in hand against everything that might come between us or at us.

This meant that in every argument, big or small, every life event outside of our control, it would never again be me versus him. It was never again going to be a battle between us but a battle before us. Instead of directing negative energy against each other, we would act together to deflect all negative energy back towards its source.

We chose to stand hand in hand, our eyes forward on the same target, the same prize, the same future.

Four months after this realization, we were engaged. Seven months later, we married. We moved to the big city. I finished

my degree and James began his career. We travelled. Baby boy came along just after our second anniversary. We struggled financially. We struggled to find our identities as young parents in a career-focused city. We moved four times in the first three years. We travelled again, with our boy child and alone together. The hard parts came and went, cyclically. But really there was nothing hard about it. There was nothing hard before the arrival of our baby girl. Before our beautiful love story became a family of four.

A month before she was born, I was living this fairy tale story I'd created for myself. Married to my high school sweetheart. My perfectly healthy three-year-old attending preschool. I was propelling myself along in my own career path after years of struggling to figure out where I wanted to go. I studied and pursued this new path for almost two years while my son outgrew diapers and I worked part-time in restaurants and marketing. James and I had dreams. Travelling with our kids. Paying off debt. Putting together a down payment to buy our own home.

It is all gone now. The dreams are on hold. Some of them have vanished for good. Many of them will never be as easy to fulfill as we'd imagined when things were simpler.

I was in the middle of my very first transaction as a realtor, helping my client secure her new home, when I landed in the hospital on bedrest. I knew, logically, I could not handle it from a hospital bed. Especially when Baby Girl could be born at any time. I knew I needed to let this one go. I'd re-evaluate what I could handle after she was born.

My mentor, another realtor in my office, was incredibly supportive and took over everything I had been right in the middle of.

Our mothers stepped in and, from the beginning, said they would be there for Noah in whatever capacity we needed. Grandmas became our on-call, around-the-clock babysitters.

I used to drive to work a few times a week, with a coffee in my hand. For the first time since I was in university, before my son was born, I felt like I was doing something purposeful. I was contributing financially, contributing to our dreams.

I was living a fairy tale, with my healthy son and handsome husband. Both of us with careers and parents supporting us from either side.

Yet the most we could dream up was buying a house and travelling?

How very unoriginal. We were so young.

Who was I before all this began, before the day we learned that nothing would ever again be the same? Priorities, hopes and dreams, completely altered. How did I see the world beforehand—community, family, basic human needs and desires? I sincerely cannot recall. Have I lost myself or found myself in this process? Perhaps a bit of both. My focus has narrowed to the needs of my children and the needs of my husband. My strength grew day by day as I leaned on grace and peace to carry us. And it has carried us. My perspective on life expanded rapidly.

We stop kissing when we say goodbye. Instead a simple "I love you" and "I love you too" rolls off our tongues. And it is true. We do. But I think we are trying to convince ourselves that love is here, and it is enough. That love will get us through this day and bring us out on the other side, unscathed. It brings us through, yes. But we are all battered and scarred. And the casual "I love you" has a question mark at the end.

Are you still here with me? Am I alone in this? No. We are not alone. We are together, entwined more than we've ever been before.

But there are moments, days, that we both feel so alone in our experience, that we say, with a question mark, "I love you?"

TOMORROW

Heartbreak is the art
of adaptation;

and we just keep finding
new ways
to breathe.

Chloe Frayne

Noah is three-and-a-half when Evelyn is born. It was exactly the age diffcrence I'd hoped for. Just what I had envisioned for him, for them. Old enough that he would be independent and helpful with a newborn at home. Not so old that he would be bored of a toddler companion in a couple years' time.

She was more than a week old when he came to meet her for the first time. It had no resemblance to the first meeting I'd had in my mind: Noah brought to the hospital hours after her birth to see his mom and kiss his new sister on her tiny, warm head. He would ask to hold her and the two of them would snuggle

with me on the hospital bed, squishing into the edges to fit. Him with his sweet smile, looking down at her and then back at me, proud and cautious. Daddy would be taking pictures and capturing these moments for us to look back on only days later with love and joy. Baby. She would be safely tucked in the crease of my arm, her lips puckered delicately, eyes pressed shut, sleeping soundly just as her brother had.

This wasn't like that. No, it didn't happen like that at all. The timing wasn't spontaneous or celebratory, but strategically planned. We wait until we know for certain she is stable. And then to be certain than he doesn't have so much as a sniffle. But we also don't want to wait too long. If something happens, if she doesn't make it, we know he needs to meet her.

The day comes when all the stars align, and we make our familiar way to the NICU, this time with a preschooler in tow. We walk the hallways, following the little duck footprints all the way to the NICU doors. We demonstrate how we wash our hands at the entrance and say hello to the receptionist. Noah was timid and shy back then—anyone who mistook his beautiful face for one that wanted to interact was quickly shot down with a piercing stare. He wasn't there for friendly exchanges with strangers. He was there for her. Enthusiastically he pushed the large red button on the wall to open the doors to the nursery, and I pointed out each turn toward her special room. He led the way, just ahead of my pointing hand, and entered the room with an unexpected confidence, like he had been there before. Like he knows exactly where he is. Like this is a perfectly normal place to be meeting a baby sister. And then he approached her incubator

with just the slightest bit of caution, barely able to peer over the plastic edge into the enclosure.

We offer him a chair and he shakes his head. Instead he begins to wander the room. Hands in his pockets, absorbing the walls, the floor and the blinking screens. Taking it all in. He points at different things and asks what it is, what it is used for, why is it needed. The nurse on today answers each question in detail, as he nods along acceptingly. A few minutes later he changes his mind and asks for the chair he was offered. He wheels it right next to Evelyn's isolette window and awkwardly hops up so he can get a better look inside.

Someone told me before this first introduction not to worry about his reaction to all the cords and wires attached to Evelyn's body, that kids don't notice the way adults do. And perhaps many don't. But as I watch Noah looking at his baby sister, with the many medical devices embellishing her body, he looks genuinely concerned for her—more aware than any of us might give him credit for.

But how do you explain all this to a three-year-old? What do I say to encompass the importance of this place without it being too scary? How do I offer him assurance when the truth doesn't merit assurance? "Your baby sister needs some help breathing and growing," we explain. "The doctors are taking care of her until she is stronger and big enough to come home with us."

He nods in response. But I am certain he knows there is more to the story, even if he is not yet capable of voicing it.

And now he sits, still. Staring at his baby sister with a concerned frown upon his face. Intuitively, I feel that this encounter cannot be all concern and sadness. We cannot let fear be the

ignition of their relationship. This is his baby sister he is meeting, and he should feel happy. Excited, even. Proud, most certainly. James and I try to shift the energy, offering big smiles, as genuine as we can muster. We exchange some celebratory statements to lighten the mood, the weight in the room. "Isn't she so tiny and so beautiful?" "Don't you think she is cute?" Noah relaxes a bit, seeing Mom and Dad at ease. If we can be content with this, so can he. If we can look at her without worry, he can too. A small smile starts to form as he looks back inside the incubator. "Oh, yes. She is so cute! She is so cute and so fuzzy!"

He gazes a little while longer at her, taking in this special being that he knows to call his own. "My sister."

Just days after Noah's first visit, I walk with Evelyn's entourage as she is wheeled down the corridors towards the operating room. One foot in front of the other, purposefully. Carefully staying near while trying not to be in the way. My hand has settled on the plastic enclosure she is cocooned in. It trembles as it rests there.

Evelyn is tucked safely inside her incubator. Except she isn't safe at all. The smallest bump on this hard-surfaced floor sends her heart rate racing. And as it races, she continues to desat, her oxygen saturation levels dipping again and again. The machine tells us these things as it beeps louder, faster, more highly pitched as we move. It is a terrifying musical accompaniment to our slow-fast, rhythmic walk down the hallway. Slowly, so as not to disturb her delicate positioning. Faster, so they can take control of the situation, and soon.

There is a lump in my throat as we move. A chill on my skin. A heaviness in my step.

The nurses walk ahead, clearing the path as we go. This is a public hallway, and many people are coming and going. I see the looks of astonishment on their faces as they get a glimpse of this tiny thing inside the plastic box beneath my resting hand. Then pity, as they notice me. For a moment I am outside of my own body, and I see what they see.

I feel pity too.

Another mom walks along beside her child's bedside, also being wheeled down this hall. They pass us going in the other direction. There is a gentle touch on my arm and a pained smile, a familiar expression. I don't know her. But her face is my face, she is me and I am her. And in this brief encounter we are the only two people in this hallway, and she is the only person in the world who knows me at all.

She will never know what that touch meant to me. How it brought me into the now of what I was experiencing. How it awoke the need to find humanity throughout these hospital days. I am not the only one in this hallway. My girl is not the only one fighting for her life here. There are babies and children filling the rooms of this hospital. And parents walking up and down these halls every day and every night, fighting alongside them.

Evelyn got sick with pneumonia at the end of her first full week earth-side. It was after this we decided we needed to get Noah in to see her. I listened to the report over the phone, devastated as I pushed through my morning routines before getting to the hospital. *How did she get sick? Does she have the strength to push through this? Can her heart continue to endure?* She was being fed my milk via an oral gastrointestinal tube, one of the many variations of feeding tubes that she will experience.

Despite the small, measured amounts going into her belly and her lack of movement, being both intubated and sedated, she somehow ends up with aspiration pneumonia.

They stopped her feeds immediately and placed her on TPN, total parenteral nutrition. My breast milk kept coming, but instead of going to her room's personal fridge it now accumulates even faster in the deep freeze down the hall. TPN enters the body through the bloodstream. Because of the number of IV meds she's continually getting and because we don't know how long she'll need TPN, they decided to place a PICC[6] line as well.

Actually, they didn't decide. These things are always ultimately up to Mom and Dad. Big decisions and little decisions, they wait for our nod of approval to keep things moving. It was strongly recommended, though, the literature given to us to go over before we signed the papers giving our official consent.

Usually PICC lines are placed somewhere in the arm. They enter the vein flowing towards the heart. But try as they might, Evelyn's line would not go through where it should have. There was a discussion about shaving her head and trying to place it there instead. (Apparently, this used to be a more common practice.) But the idea of her head being shaved and attached to lines made me so incredibly frustrated and sad that I pressed for them to find a different option. Eventually they did, as one of the PICC line experts (a very experienced nurse) was called and was able to get the line in through her leg instead. It entered into the outside of her calf; the left-over line was coiled neatly

6 A peripherally inserted central catheter, an implanted device that enables intravenous treatment without having to puncture the skin each time.

round and round, and meticulously taped in place to keep it secure and also to prevent anything from getting in. The more holes in a body, the greater the risk of infection. Keeping the PICC line sealed and clean was now of top priority.

Her pneumonia was a puzzling, momentous concern. We knew her jaw, chin and airway were small—being intubated took more time and specialist intervention than normal. Her nasal cavity was also small, and some of the doctors feared it might even be entirely blocked as they hadn't been able to place a feeding tube through. So, the specialist paged to assess her now was an ear, nose and throat surgeon.

It takes three days for the ENT to get to her. It could have been sooner, but we needed a paediatric ENT. So, we waited. When the team finally arrived, they could see immediately that she would need further assessment. An OR was booked right away for a bronchoscope.

The bronchoscope does not go well. They get the information they need, but she was in distress the whole time she was out of her NICU room. The walk down the hallway to the procedure was rocky, and it only went downhill from there. Her oxygen saturation levels fell frequently, and her heart reacted poorly to the anesthetic. By the time Evelyn got back to her room, the NICU hospital staff were on high alert for what might happen next, for what her body might do.

Yet a lot was learned from the procedure, details that proved invaluable to proper treatment. Risks and benefits, pros and cons. She struggled through it, but we needed to gain all that we did.

The cause of the aspiration pneumonia was found to be an H-type tracheal-esophageal fistula (H-type TEF). Fistula

means hole, which means they found Evelyn had a hole between her trachea (breathing tube) and esophagus (eating tube). Any reflux ended up in her lungs. Often when patients have a TEF, they also have an atresia (or blockage) at the end of the esophagus. Rarely, and beneficially, as in Evelyn's case, they do not.

While these findings are explained to us, someone casually mentions they found a cleft palate inside Evelyn's mouth. The doctors explain this to us nonchalantly, stating that it is not a point of concern at this time, as they moved ahead to discuss the more immediate needs.

But I am rattled. *Not a concern?* There is yet another problem inside my baby girl's body. Another piece not properly formed. Another surgery for us to look forward to in her future.

A cleft palate, on its own, is a rare occurrence. Again, we are told how unlikely each of her defects is. Usually a cleft palate occurs with a cleft lip. Sometimes a cleft lip occurs on its own. And rarely, as is found here, the cleft palate is present by itself.

Another diagnosis is added to Evelyn's charts. Not yet an all-encompassing diagnosis, one that speaks to all of the developmental anomalies, but a stand-alone title for a handful of them. Pierre Robin sequence, or PRS, which refers to a collection of craniofacial anomalies presenting together, including a small chin, recessed jaw, difficult airway—and a cleft palate, the final missing piece of this PRS puzzle. It is common for those with PRS to have difficulty breathing, which explains the struggle it has been to intubate her. And it is also common for those with PRS to have difficulty with feeding. These babies cannot create suction with their mouths around their mother's nipples, so breastfeeding is almost always impossible. Often PRS babies

end up with specialty feeding bottles, and sometimes, as with our girl, feeding tubes are required.

A cleft palate is a concern for me. Because while most of my mind and energy is focused on the situations at hand, the day-to-day NICU challenges, a small part of my mind tries to think to her future. And though keeping her alive is the doctors' primary focus, as it should be, my imagination is haunted by what that future will look like. The obstacles that she will have to overcome away from this space, without the assistance of these doctors and specialists. Beyond the acute to the everyday, to create the best version of a future that may be possible for her. A cleft palate is a big deal, in and of itself.

Why must she have this and all the rest together? Where is the end to this future of struggle?

I understand how it is irrelevant now, today, as we fight for her tomorrows. But tomorrow, months from now, I can envision how this will make so many things difficult. Eating, drinking, talking.

Breathing.

And I cannot help but feel another blow to my spirit, as I try to hold pieces of her fragmented future together in my mind.

I cannot bring myself to dream of tomorrow.

All I can see is right now, this moment right before me. All I can see is what is currently in my hands.

And in my hands, today, is this wee fragile baby. Not her body, because I cannot hold her often, I cannot take her in my arms each day. But her fingers are in my grasp. I clasp her face and stroke her head. I rest the weight of my hand on her back to soothe her and stroke the length of her with my fingertips to soothe myself.

This child with holes littered throughout her tiny frame. With tubes coming and going, scattered all about her bed. All I can see are the medications administered around the clock. Feeding pumps, whirling as they push. Alarms and equipment engines are the lullabies to which she sleeps. The white noise in this nursery is the chatter and footsteps of nurses, RTs shuffling in and out of the room. In my hands are my breasts, full of milk again, and hooked up again, to the mechanical *womp womp womp*, again. And all I see is the struggle before us to get this milk into her body, without a tube, one day. Will it ever happen? The days that pass are the days I see us trying to gain back. When? Will we ever?

Will I feed her in my arms, with a bottle in my hand? Will I hear her voice while she cries? Will coos and babbles come out of those delicate lips of hers? Those lips—puckered and pushed open by the tube still reaching down her throat. Does she hear me when I say her name, when I sing her sweet songs? With the meds going into her body, and the unknowns of her diagnosis, does she even know I am here?

I cannot bring myself to dream of tomorrow, because my dreams of today are being crushed, moment by moment. How can I build on them? There is no foundation to build tomorrow upon.

I do hope, though. I must hope and hold on to something. Because I still believe she will be here tomorrow. I still hold on to that, at least.

But I dare not dream beyond her being. I dare not dream of her hair growing long, that I might brush it and watch it bounce behind her. I dare not dream of the words she will speak; of the songs she will sing with her beautiful raspy voice. I dare not

dream of the places we will walk, with her hand in mine, leading and pulling me along. I dare not dream.

I fear dreams now. I fear what may never come to be. I fear I can't imagine what her future looks like. That what I envision might be out of reach for her. I fear that allowing myself to dream may conjure a nightmare instead. My dreams have become my fears, and I cannot trust them.

I am aware, though, that this fear is creating a gap between us. She is right there, before me, and my inability to see more of her, to see beyond what is in front of me, has made it hard to be mother and babe, entwined, like we were when she was within me. Isn't that what we do? Baby comes out and we stay intricately entangled, slowly unravelling ourselves physically as our spirits grow together instead. I have nothing physical to hold, so my spirit grasps at the wind.

My spirit has been battered and is unsure how to entangle itself this way, with this babe.

I cannot dream.

Hello, Sunshine. There have been visions of you as a little girl, running in a field, with your shiny dark hair bouncing in the wind. I have not seen this, but others have. Others, many others, are seeing into and praying for your beautiful future. And they are reminding me to look into your future myself and see past all that is right in front of me. At the moment all I see are tubes, screens, medications, IVs, more doctors' appointments, more surgeries, follow-up after follow-up—a never-ending story of medical events. I dream of your blood saturations remaining stable, that you gain weight, that you come out of the OR without complications. My biggest dream is that I will take you home. But there is more for this mama's heart to dream; there are more visions to be had for your full, rich and beautiful life. Perhaps I fear letting myself hope past these hospital walls, perhaps I fear hope itself. But if I let myself dream, if I let myself see past all of this, I see you, Evelyn Faith. I see you standing with grace, I see you walking into rooms with confidence, I see you reaching out to others with generosity, I see you playful and bright, I see you FULL of life. I see you, my child.

[10 weeks old]

SURVIVE

You are fierce. You're a survivor.
You're a fighter through and through.
Little brave, breathe.
There is a warrior in you.
Beau Taplin

Late—on a Friday night, I believe. Just two short days after birth. Two of the longest days of my life. Sitting here next to this incubator. They, the doctors, are discussing a spinal tap. Meningitis, they think. They are trying to rule out the reasons why my body would evacuate its delicate inhabitant. Why a perfectly healthy 26-year-old would go into preterm labour. It must be an infection. Perhaps.

Didn't we already conclude the cause was the polyhydramnios? I guess they still need to rule out other possibilities.

So, they want to do a spinal tap to rule out meningitis. Of course, I know of this deadly word. I have heard of the damage

that it can do. But I am also listening to the risks involved with this procedure on my fragile wee girl here. Risks and benefits. Pros and cons. To do or not to do. This moment is setting the stage. This is the foundation of our path from here on out. It is the theme with which we will move through these NICU days and those ahead. Each time these decisions come at us, they are abrupt and unexpected. Each time, we are given the facts that are known and the opinions of the experts, and then—again and again—the responsibility is laid in our hands. To choose. Repeatedly, it is up to us; how to save, or not save, our baby girl. And there is always a clock ticking. Time is always running out.

The doctor on Evelyn's case today seems incredibly invested. He has barely left our daughter's side all day, which I know isn't normal practice. At least I assume it is not, as we sit here in Procedure Room One, reserved for the most acute patients. There are dozens of other sick babies in the NICU, and plenty of fellows available for one-on-one care. He seems to know what he is saying; he sounds confident, intelligent and kind. I keep hearing from the nurses that he is their favourite, that if anyone was going to do this procedure, it should be him. I have also heard he is a father himself. A boy and a little girl. So, I feel inclined to ask him, "Would you do this for your daughter?"

"Yes. Yes, I would," he responds, without hesitation.

It is all we need to hear.

"Okay," we say. "Yes."

It is out of our control now. Though it was never in our control to begin with. All of it, none of it. The good and the bad. The possibilities and the lack of possibilities. We take this stage that we have landed on and we choose to act it out. We choose

to be participants rather than bystanders. We choose to fight, to be proactive, and to do.

The answer is continually yes. Before she was even born, while I moaned through contractions on the delivery bed, they asked us in awkward huddles what measures we wanted taken after our baby was delivered. How much intervention should there be? Are you sure, are you sure, are you sure? The answer was yes. When we learnt of her complex heart diagnosis and the uncertainty plaguing her future, they asked us again how we would like to proceed following her birth. And again, yes. Yes to all intervention! From the very beginning, we have told the doctors to give our girl just as much fight as she is giving them. If her heart is still beating, if there is still air in her lungs. If she is still reaching for life, then yes, we are too.

I sit by your side and watch you breathe, even though the breaths you take are not your own. I stare at screens beside your bed and pray that the numbers they display mean you are stable. I hope, I pray, but mostly I wait. Wait for one more day to pass, wait for your little body to gain one more ounce, wait for the freedom to hold you. They say that motherhood is the hardest job anyone will ever have, but nothing prepares you for this. They say that no one is given more than they can handle; I wish then that I could handle less. I wish that you would have to endure less. But this is where we sit, Baby Girl. So, we both find the strength inside to do what we must. Because, we must."

[3.5 weeks old]

66 PERCENT SURVIVAL RATE.

I have just asked the general surgeon how sure she is of this surgery. Those are good odds. Right? Two out of three, two thirds. I say it over and over in my head, visualizing what it looks like. A piece of pie, sliced in three, as we were taught in grade school. Then I see the third piece. And it sinks in, what this means: a 33 percent mortality rate. One-third, one out of three. Those are terrible odds. Those odds are infuriating. Those odds make my stomach hurt. I hate that I am now thinking of her future, or lack of future, with numbers. I appreciate the surgeon's candidness. She isn't sugar-coating any of this. There is no gentle bridge between us and reality. But still, those numbers are simply not fair.

"And intervention?" I meekly ask, scanning the room and the faces within it. "What sort of intervention will be there if her heart doesn't tolerate the surgery? If she starts to crash, what is the plan?"

The question needs to be asked. I need to know. If she starts falling towards the terrible, crashing into the 33 percent, what will you do?

All the doctors in the room look downcast. The general surgeon, whose brilliance comes through in her dialogue and posture, but who looks much too young to be an expert in her field. The studious fellow, lugging his brown leather satchel around everywhere he goes. It is propped on his lap while he lets the rest of the room do the talking today. The paediatrician on Evelyn's case now is the same one who gave me my first opportunity to hold her. She holds my phone up, with James on the screen, as he FaceTimes into the conversation from work.

Nobody had warned us about this discussion; we are improvising here. The neonatologist, on Evelyn's case for the last two weeks now, is also present. His communication skills have been less than ideal to this point, but in time I will grow to respect his viewpoint and mannerisms.

It is Evelyn's cardiac anesthesiologist who finally speaks up. The old man in the room, with scraggly hair and loose scrubs, kind wisdom beaming through his eyes. "There is no intervention.

What?! How can that be?

"No heart and lung machine present, no cardiac surgical staff standing by, no resuscitation plan in place. She is still too small for the heart surgery she requires, so there isn't anything they can do, or will do, in the interim. Evelyn will have to pull through on her own. Her heart will have to be strong enough."

The weight of these words sinks in. I nod. Somehow none of this surprises me. I trust these doctors; they are giving us the best options they can. And they will do the best they can with whichever option we choose. But ultimately, it is up to her. Evelyn has to fight to live.

James and I agree to the surgery. Before we are told, with confidence, that if she does come out of this surgery alive there will still be post-operative complications to prepare for. That even if she does come through this battle, the outcome is still uncertain, and the number of battles yet to face and overcome still unknown. We agree, though. We agree together while we continue with our discussion, with me sitting on the couch across from the general surgery team and James on the small phone screen before us. Words are not spoken between us, but

we know. It is a no-brainer. Our girl has a hole between her esophagus and her trachea. She is at severe risk for aspiration, reoccurring pneumonia and permanent damage to her lungs. Her tiny premature baby lungs. Lungs that will be her lifeline when it comes time for her future heart surgeries and life with a single ventricle heart. She needs these lungs healthy and strong. She needs this surgery to survive.

But the risks here are huge. The primary neonatologist is trying to paint this picture realistically for us. Gently. Politely. He reminds us that she might not survive. We could wait until she is bigger, until she is stronger. This doesn't have to be the answer, today. We could spend more time with her before gambling with her life. I can tell he is apprehensive for us, perhaps to balance the lack of apprehension from us.

However, we know it and he knows it: waiting could also make her sicker and weaker. It could cause more problems and complications. Waiting could end up being too late.

The clock is ticking.

No. We need to do this. And now.

The next day the neonatologist suggests that Mom hold her baby again. And this time it is painfully more obvious than the last time that this might be goodbye.

I cannot believe it is. I cannot believe that is her story, or mine. But I won't say no to an opportunity to have her in my arms again. Hello or goodbye, I will take whatever moments with her I am given.

We prepare for this cuddle like before. Twelve days since that first, and last, time holding her. With RTs and nurses assisting in the great transfer event. From incubator to Mom.

I take her in my arms. Breathing her in, stroking her fuzzy skin, feeling her heart beating against mine.

Sleep and rest today, my love. Tomorrow you fight. Tomorrow we have a grand mountain to climb.

Haraboji, my father-in-law, goes at night to the NICU. He is not comfortable in this setting, not like his wife. With years spent working as a nurse in intensive care units and emergency rooms, she is familiar with the smells, noises and dramas here. She confidently befriends the staff, knows what questions to ask and understands the responses. He is not so familiar. This is not an easy space for him. But neither is it an easy space for his fragile granddaughter, spending all her evenings and nights alone, without family. So, he goes to sit with her. Beside her plastic bed. Often fully enclosed and covered with blankets, due to the bilirubin lights that are on. He doesn't mind, though. He is not doing this for his own pleasure. He does not go to hold her or touch her or disturb her sleep. He goes so that she is not alone. He goes to pray over her body. When Mom and Dad have no words, no prayers left to say, Haraboji sits at her bedside.

She is prepped for surgery two days after our conference.

If we are going to do this, there is no point sitting on it. At the start of this week, she was wheeled back from the OR where they found this hole. She was crashing, fighting to live just from a bronchoscope and short ride down the hallway. And now we are sending her out again. Sending her away from the sanctuary and safety of this NICU room.

The same anesthesiologist who sat with her then is with her now. He reassures us that he is the very best and I do not doubt him for a second. His arrogance and grey hair are reassuring,

and he knows this. He tells us that he and Evelyn are going to develop a good relationship. He has already learned so much about her from their difficult OR experience a few days back, and those challenges will help him care for her even better now.

Then he utters words I never thought I would hear. Like out of a movie, a distant scene I am observing from afar. I don't feel connected to them at all, because I cannot believe they are directed towards us.

"If things don't go well, I will come get you, here. Okay? And then you can come back with me to the OR to be with her."

If things don't go well. If she clots or bleeds out on the table. If her heart cannot sustain the stress of cutting. If she reacts poorly to the anesthetic. We will come get you, to come sit with her in her final moments.

We nod our heads but do not reply. There is no vocabulary available to respond to such statements. There is no benefit in yielding understanding to these words.

Because we do not. We cannot.

My spirit is undone. Did he really just say that? We knew this was the plan. We knew there was a chance that this part of the plan would play out. But to hear it spoken so directly, so matter-of-factly, is startling. Unnatural.

It cannot be real.

James walks back into the waiting room after stepping out for a break, and I can recognize instantly that he has been doing just as I did this morning.

Screaming in the emptiness of my car. Hands slammed on the steering wheel. Head between my fists gripped there. Heavy sobs, eyes left raw and marked.

We will embrace each other later. Touch is not welcome now. There is no strength for leaning or being leaned on. At the end of the day we will sit across from each other. Feet slow dancing under the table, eyes locked and lips mostly sealed. The few words that fall will be enough. Enough to exhale this day and breathe in tomorrow, together.

We cannot take care of how others feel about all of this now, when we can barely recognize our own feelings boiling beneath the surface. Our baby's body is being cut into, the scalpel moving towards her skin. Strangers hold her life in their hands.

Others in the room make small talk, but it doesn't reach me. Learning about a neighbour's new dog, the trip a friend is on, a leather bag just bought, these details glance off me.

Anger washes over me as I watch the world passing by. Everything just keeps on moving. Everyone continues on, sometimes peering into this tunnel I find myself in. A quick peek to see that I am still here, still holding on.

Would you join me in here? Would you choose to brave this dark space?

Just sit.

Dammit.

She comes out of surgery.

The NICU receptionist finds us to tell us they will be coming down the hall shortly.

We make our way to the entrance and stand by the double doors, staring down the long corridor. Waiting. Pacing under the threshold, between the hallway walls, hearts racing and fingers fidgeting.

Until there they are. A crowd of caps and gowns, flowing and studious. Not the kind who grant degrees on solemn stages, but those who perform miracles in operating rooms. The ones I now know as the true heroes, who heal with needles and scalpels, skills and instincts.

The crowd of them push her down the corridor. Just as they did days before when I walked alongside. And James and I contain ourselves; we don't get in their way but try too to get close enough to see her chest rise and fall inside her incubator.

Yes. *Deep breath.* There she is. *Exhale.*

She breathes. Albeit because of the ventilator attached to the tube down her throat. But she breathes. Her body looks patched up, with dressings and cords holding it together, but it is there. Her body is there. And it is alive.

The relief is both overwhelming and nonexistent.

Did I believe her not coming out was a possibility?

She is back in her room now, just where I expected her to be. And the room is crowded, even more so than the day she first arrived here. Cardiology, general surgery, anesthesia and the NICU staff fill even the corners. The overhead lights shine as spotlights, highlighting the various hierarchies and department heads passing along information. Relaying each detail of the day's event and her care plan following it.

The general surgeon, who I will forever see with the greatest respect and admiration, pulls us aside for a quick conference with her general surgeon fellow. The two of them give James and me a recounting of the surgery. Where the incision was made, how she responded to the anesthetic, her tolerance throughout. They are both dumbfounded, they tell us, describing the seam-

lessness of the operation. Even if she beat the odds to live, they had anticipated many things going wrong. But the surgery was almost a complete success; the most difficult part for Evelyn was going into and coming out of the anesthetic.

I stand in the doorway, the commotion before me. I want to be near her, of course I do. But I am much too practical for that these days. And besides, she came out of surgery alive. I will have time to be near her now. I stand back instead, to give everyone space. They are checking her vitals every 10 minutes. And everyone wants to take a look, to be well aware of her baseline going into the evening. I will have my time with her soon enough, and for now, I watch her by watching the numbers on the monitors. We have been here less than two weeks, and I am now well aware of what these monitors should read. What the waves and curves mean, the numbers rising and falling. So instead of staring at her delicate heart beating in her chest and the air rising and falling within her, I stare at the numbers. I am not distracted. Here I can listen in on conversations, overhear the words not spoken out in the open. The ones whispered or shared behind clipboards. They tell parents everything in the NICU, but they do not tell us every thing. We find the nuanced details ourselves. Reading between the lines, observing doctors' body language and the subtleties in their word choices. We listen to more than the top of the ladder, too. The nurses, RTs and students ramble on with thoughts and information, all valuable education in understanding jargon, procedures and protocols. To advocate for Baby Girl when it becomes necessary. Knowing everything is my job, because, other than filling her freezer with milk, there isn't much else I can do these days. So, I stand back.

I give them all their space, to continue caring for her in ways I cannot. Watching her from afar, watching her monitors like a staff member myself, and listening to all the details being chattered around me. I stand back and stare at the busy crowd before me, all for this tiny child of mine within this box.

I stand in awe.

TODAY

*There are feelings in me
that don't even
have a name yet.*
Gemma Troy

I feel. I feel. I feel. I feel.

All. The. Time.

I need you to know that I feel more than I show. That I want
to break, I want to let myself feel these things, I want to be the
one to be cared for. I want to crack open from within. But if I
start, can I stop? Do I have the strength, without falling apart?
And who will catch me? Who will be patient with my breaking
self and pick up the pieces? Who has got my back and tired feet
and weary heart?

I AM NUMB THESE DAYS. An empty shell. A simple grin is plastered on my lips, but my eyes are heavy and sad above them.

I SPEAK WITH A SMILE. Daily. Reassuring myself, and those around me, that yes, I am fine. I am fine. But I am not fine. And I am screaming inside for someone to notice. For someone to see my unwilling bravery and give me a moment to breathe. I am suffocating here. Someone, please, turn the lights back on. I am tired of stumbling around in the dark. Can someone carry me through this? Must I walk through these days all alone?

"You are not okay. What do you need today?"

I need to hold my baby. Without worry. Without a task sheet and to-do list. I need ... I need, simply, to be Mom.

A TEXT MESSAGE APPEARS from a friend. From across the country, someone I haven't seen face to face in years.

"I dreamt about you last night," she said. "You were sad and tired, and I scooped you up and carried you somewhere. You weighed almost nothing. I forgot I was even holding you until somebody asked who you were. And I said, 'Let her sleep. She needs it.'"

I weep in my car as I hold these words to me again and again. I've pulled over to let the sobs come. I am so comforted by the clarity, by being seen and understood.

"What did you do today?"

What the fuck do you think I did today?

This question is asked as if my days are empty. As if without a to-do list or special event or major accomplishment, my day is a waste, unproductive.

I did nothing today, except watch my child fight for her life.

I did everything I could today, to keep my family alive.

My three-year-old wakes up early these days, before six. He wakes beside me, his face nuzzled into my neck. His sweaty curls stuck to my skin. He crawled in sometime around midnight, sneaking in right between James and me. I don't have the strength or desire to move him back to his bed. Not in this season. (And not in the seasons that follow. Because this habit goes on and on and on, and he wakes on his sixth birthday still wedged between us.)

I go to the kitchen to get him some breakfast and come back with my laptop and pumping supplies in hand as well. He watches cartoons in our bed while I expel the liquid bursting from my chest. James gives each of us a kiss as we settle ourselves deeper into the covers, then rolls out of bed and into the shower, getting ready for work. I feel rushed myself, constantly looking at the clock, but I try my best not to appear rushed to Noah. I'll sip my tea while he eats his apple slices, finish pumping and give him some more cuddles. The sooner I leave the sooner I can get to the hospital. But I was home late last night, and this is the first time I've had with Noah, awake, in 24 hours. I force myself to linger a little longer. Evelyn is stable today, and her rounds will be a bit later in the morning. I get him dressed and then walk him upstairs, to my in-laws' home, where he will spend the day. Where he spends most days. "I'll be home before bedtime tonight," I tell my mother-in-law. It has been days since I have been the one to put him to bed, and I know he wants me to.

James leaves the house as I do. We drive, separately, through rush-hour traffic, going to opposite ends of the city. It is an elaborate expense. Driving and parking fees and bridge tolls. But there isn't really any way around it. We had talked about

finding a short-term rental near the hospital, and we looked frantically on Craigslist while I was still on bedrest the week before she was born. But we soon decided that Noah needed his home and routine to be as "normal" as possible. Living close to the hospital with all our childcare options three cities over would not be helpful. We walk out the front door together, going our separate ways for the day. Our hands embrace and give a gentle squeeze.

"Send me a picture when you get there," James reminds me as he does every morning. "I want to see her face."

"Of course, love. I'll update you after rounds too."

Then off we go. I listen to the radio as I drive, background noise for my monotonous journey. Over bridges, on traffic-riddled highways and across the city, one streetlight at a time. Sometimes I try a new route for a few days, but mostly I stick to the one James showed me in the first weeks, when we did this drive together. I like the repetition of it, the predictability. The trees blossom, beautifully, as the days and weeks go on. Until the blossoms begin falling to the ground; today I drive on clouds of pink petals.

I arrive at the hospital to a full parking lot. Another downside to lingering in bed. Sometimes I find a spot instantly, but most days I drive in circles waiting for one to open up, 10, 15 or even 30 minutes later.

Tim Hortons is at the entrance, and I get my medium steeped tea, double double. Once I get to her room, I won't want to leave for a while.

I walk the long hallway to the NICU with my tea in one hand and my day bag in the other. I pack a water bottle, some

snacks from home, a book, a sweater, breast pads and the milk I pumped this morning. It surprises me how familiar this hall is to me now. Not too long ago, I felt lost here, always searching for landmarks to be sure I was going the right way. I am not lost now, though. I walk to my home away from home, towards the other half of my heart.

The nurse charting in front of Evelyn's door today is familiar and I let out a sigh of relief. A familiar nurse will call me by name, Laesa. She will know the routines of our day. She will be enjoyable company. Not just polite pleasantries, but a friend to me in this space.

Evelyn is sleeping when I come in. I put my things down on the plastic lounge chair and make my way to her. I snap a picture on my phone to send to James and text some cheeky comment about her sprawled position. "She's such a diva!" The nurse follows me in and begins a report on her night. We brainstorm questions and concerns to bring up during rounds; I feel reassured that she will be my ally in these discussions. Neonatologists and doctors rotate frequently, nurses and RTs a little less frequently. But Mom? She doesn't rotate at all. I am here every day. I know every med Evelyn is on, and how her body responds to adjustments, and why she might be constipated or what a spike in her heart rate might mean. Others can speculate based on clinical experience. I speculate based on her, on her patterns that I know like the sound of my husband's voice. I speak hesitantly to those in authority, those obviously more educated than me. I speak for her, as best I can, despite my awkwardness, because I know my voice is all she has.

I wait to pump until after rounds unless our nurse sees

that they are running behind. The last thing I want is to be quickly covering myself up and rushing the pump when a crowd of medical professionals show up. It's happened before, a few times. No matter how professional everyone is, it just isn't worth repeating.

I stand in the doorway while I wait. Building friendships with nurses. Watching other parents coming and going from their babies' rooms. My eyes linger on the room across from us, twins, where Grandma is present each day with her daughter, participating in rounds and helping with feeds, taking turns holding.

I wonder if they will let me hold my girl today.

The rounds crowd appears, and I politely move inside my room as they begin across the hall. Eavesdropping helps keep me stimulated here, but I don't want to be outright rude. Twenty minutes later the door slides open again, and our nurse pokes her head inside. "It is Evelyn's turn now, Laesa."

I make my way to the doorway. One foot in her room and one foot in the hall, at the end of the huddle.

"This is Baby Girl Kim. Born on April 13, 2016, at 32 weeks plus two days. ..."

As plans are made for the day, my nurse speaks up for me. "Laesa is wondering if we can arrange for her to hold Evelyn today?"

The doctor looks at me with a quizzical look on her face, "When was the last time you held her, Mom?"

"Last week."

"Last week? Why so long?" She turns to the team here. "Why haven't we got Baby into her mom's arms?"

The RT pipes in to defend the past doctor's decision. "She's

been very unstable and unpredictable on her ventilator settings. And I think there is fear of her ET tube coming out."

"She is always stable when she is on my chest, though," I interrupt. "I know it is a bit rocky to get her there. But once she is on me, she doesn't desat. Can we try it again today, please?"

The words come out shyly, desperately. I keep telling myself that they know better than me. But then I know too, I know better than them. She needs to be held by me. I need to be held by her.

"Let's do whatever needs to be done to get Baby in Mom's arms safely today." Today's doctor is more confident than yesterday's. Or she more strongly believes the benefits outweigh the risks, and not the other way around. "Have an RT stay in this hallway, if you need to, in case there are any problems. Let me know when it is happening, and I will be on standby as well. This baby needs to be held."

Yes. Yes. She does. Thank you.

As the crowd disappears, the RT stays behind to make a plan with the nurse. It is not just a matter of picking her up. This needs to work around everyone's lunch breaks, my pumping schedule, Evelyn's med and feed schedules. We find a window of time that suits everyone and I sit down to pump again. Hours have passed since this morning's letdown, and my breasts are again ready to fill multiple bottles. Our nurse leaves for an early lunch, and another one steps inside to inform me she is across the hall if we need anything.

"What did you do today?"

I do not have the energy or desire to explain these details to you. You know where to find me, each and every day.

If you want to know better, come. Spend a day experiencing it.

With me.

After holding Evelyn for as long as my bladder and breasts will allow, I ask the nurse and RT for help again, to get her back into her isolette.

She is settled atop her new linens, thoughtfully chosen by her nurse, a new cocoon created while we cuddled together on the other side of the room. I excuse myself to get some time alone. Time stands still here. Somehow it also passes by much too quickly. The yellow walls and moody lighting pull me into a different world; now I desperately need to see the sky and breathe in fresh air.

I go for lunch, on my own.

Do I feel like Starbucks or the cafeteria today?

I make my way to the cafeteria. I don't feel the need for more caffeine, and a freshly made sandwich sounds more appealing than a prepackaged one. Today anyways.

My tray fills: a sandwich, some hot potato wedges, and a juice from near the check-out. I pay for my overpriced lunch and go to find a seat in the old cafeteria room. As I sit and consume my day's nourishment, my eyes take in the space. It isn't as full as it would have been an hour ago, but there are still crowds of people scattered about, eating. Doctors and students, RTs and receptionists. Most of them are in conversation. Every few tables I come across another lone body, like mine. Bodies crouched over their food, eyes periodically looking up; mostly, they are within themselves.

I walk aimlessly back down the hallway to my sanctuary corner. The sky I desperately crave is found through a handful of windows as I move. It will have to do.

I pull my chair up to her bed to watch her sleep. If her eyes

peek open, I'll be there to greet her with a smile before she slips back into her dreams. I scroll my phone, searching for a friend. Searching for connection. Searching for others caught in this same scene.

"Hi, love. How's your day going? Just checking you are still able to leave early and be here for about 5:00?" I press SEND on the text.

"Yeah, day is fine. Yes, I'll leave here by 4:00. No problem, love," he responds. "Do you know who her night nurse is?"

"Not yet. But I will try and find out."

He arrives when he says he will. He walks into the room as if it is his, as if he is the boss here. And I envy his confidence. No tiptoeing around doctors' egos or nurses' feelings. He will ask the hard questions, the awkward ones. There are few smiles and pleasantries exchanged. Because he is not here for them. His time is pulled in a dozen different directions. And here, his time is for her alone.

His hand finds my waist, slips in unannounced as he pulls me in. Just briefly. A quick kiss on the forehead as we both stare at the sleeping baby before us, blinking lights and beeping monitors all around us. It's the first time I've been touched in days. And it leaves me craving more.

Moments later it is but a lingering sensation at my hip. I am turning around, gathering my things and heading back home.

There is a child there who has been waiting all week for his mama to hold him as he falls asleep.

I gather Noah in my arms as soon as I come through the door. His bright face and chatty voice are such a stark contrast to my dull day. At last, I am simply Mom. At last, here is some-

one to hold my hand. At last I can feel joy for a moment, and my fresh air is breathed in as his fingers brush my face.

James will be late. Noah and I curl into my bed again; as we started the day, we will finish it. We talk about his day at preschool. The bugs he looked at, the picture he drew, something funny his teacher said. My smile forms on my face easily, naturally, as this boy lights me from the inside.

We talk about some goodness to look forward to this weekend. Perhaps an evening at the beach after visiting at the hospital. We will sink our feet into the sand, just as our hearts settle in our chests. We will look towards the horizon as we look towards the vastness of tomorrow. We will feel the weight of the day and the lightness of our evening. Settling ourselves in memories of peace as we finish one week and step into the next.

I don't wear my heart on my sleeve. I wear my heart underneath my skin, in the darkness of my flesh. It is buried, but not too deep. Really, it's right near the surface. My emotions are raw. I feel them all over, vividly, privately. Rarely exposed, constantly felt. Sometimes we choose who gets to see. Sometimes we do not.

We all share our hearts in different ways. Our beating hearts; it's what gives us life. Some beat strong, some beat slow. Some acknowledge the life it gives. Some have yet to recognize we are all the same and none of us are the same. Recognize each other. See each other. Do you see? I don't wear my heart on my sleeve. But it beats, just the same.

[Five months old]

BREATHLESS

It is the greatest task—
Declaring beauty in
Both
The bloom
And the defeat.
Anna Lisabeth

"She has proven to be an outlier."

I am dumbstruck by these words. From Dr. G, Evelyn's cardiac surgeon, this simple sentence is so powerful, so affirmative.

I cling to this string of syllables in this moment of uncertainty, for all future moments of uncertainty. And I attach this phrase to all past moments of doubt. I have read Gladwell's book; I know the significance of this statement. She is set apart, she is a conqueror, she is capable.

This season of frustration we find ourselves in, though. Weeks in hospital, the paediatric ICU, battling complications

following her first open-heart surgery.

"She has defied the statistics stacked against her. We would have expected a very different course of life for her, given the number and level of complexities that she has. Palliative care seemed a much more likely outcome."

But ... she has proven to be an outlier.

I am stunned, Dr. G. Truly. To hear these words from your mouth. The surgeon who needed to be convinced, over the course of many months and conferences, that Evelyn was a good candidate for the heart surgery she required. That she could survive it, and pull through, and flourish even. That a tracheostomy would not be a hinderance, or a problem, because her lungs were not the reason she was in need of the surgery; that her trach gave her a breathing path that she wouldn't otherwise have.

I feel new confidence, new strength of spirit, for her sake. Despite the setbacks and the hurdles we still have to face, I hear his words and I am sure, still, that she, that we all, will pull through. Again.

The first time I hear the words "palliative care," we had been in the NICU for just shy of two months.

I was sitting in a cramped closet-like office, home to two overworked desks for the NICU social workers. Awkwardly pulling chairs into the room is the neonatologist on Evelyn's case this week, her ENT surgeon and the same cardiac anesthesiologist who has been present for each procedure and surgery so far. The social worker pokes her head in to ask if she can stay, for support, and I let her. This is a spontaneous, unexpected meeting, and I am here on my own as James is at work today. I am often on my own. And I do not fault him, not

in the slightest. There are others I fault. But not him. Routine is necessary for our family unit to continue to function, despite these very unusual circumstances. Life, careers, finances cannot be put on hold. Not entirely. Not by us both. So, he is at work unless there is reason for him to be here. And I am here, unless there is opportunity for me not to be.

This meeting is called to discuss the current options for Evelyn. The main players were on staff today, each stopping in to check on her progress, so the meeting just fell into place. She has undergone two surgeries already. The first, by general surgery, to repair her tracheoesophageal fistula. The second by plastics, to mechanically move her chin forward in an attempt to open up her airway. Scattered throughout these surgeries, we have tried repeatedly (and once she tried on her own) to remove her breathing tube and give her a chance to breathe unassisted. Each attempt has been unsuccessful. Each time required a traumatic procedure to intubate her again and get her stable and back to her baseline. Somehow her heart has remained steady throughout and has not yet shown signs of needing that first open-heart surgery. Her lungs continue to receive oxygenated blood though the small VSD in her heart. But still, the cardiology team continues to check on her, and continues to press the need for her to be able to breathe on her own. To be rid of the ventilator and ultimately prove the resilience and strength of her lungs. They frequently remind us, and the NICU staff, that this random hole in her heart could begin to close at any time, at which point it will be imperative that she is ready for surgery. Being attached to a ventilator is not optimal when going into heart surgery, especially as the heart

surgeries that she will eventually have require a set of strong, healthy lungs.

Cardiology asks, almost daily, "How much closer are we to getting this tube out?"

How can any of us answer this? She cannot breathe yet. She has failed that test. Are her lungs strong? Perhaps. Strong enough? She has yet to fill them with air without the assistance of a machine. And the longer she is on this machine, the weaker her lungs become; the outcomes of those inevitable heart surgeries worsen.

So here we are, meeting about what to do next. We thought she needed time and growth. Then we tried physically adjusting her jaw to open up her upper airway. The options are slipping through our fingertips. As is the time, the clock running against us.

Presented to us now are three options for moving forward. We can wait, leave her intubated, and hope that a successful extubation will happen eventually. In the meantime, she remains ventilated, with all the risks that come with it: weakening lungs, ventilation-associated pneumonia and no developmental progress, as she is moderately sedated.

We can go ahead with a tracheostomy, giving her a safe, functioning airway, allowing her to grow and develop as a normal baby rather than being attached to a machine. But then we limit our options with cardiology, as we've been warned that a tracheostomy disqualifies her from the surgeries that she requires. It would have to be only a temporary fix. Finally, if one or both of these options do not work, I am told, "It may be time to start talking about palliative care."

No.

I shake my head as I hear it, clenching my fingers together in angst. It certainly is not time. She has pulled through, again and again. She is still alive, even past the days we were warned she might not survive. Palliative care is not an option. That is not her path, it is not her story. It cannot be.

I do not recognize what palliative care truly is, though. I do not recognize that much of Evelyn's future care will be palliative. Having a tracheostomy tube to breathe through. Being fed by a feeding tube. Heart surgeries that do not fix anything, just prolong her life as best they can. "Palliative" is continuing care for anything life-threatening. For one unable to breathe, for one with only half a functioning heart, life is threatened.

Hearing the words palliative care now, I believe they mean end-of-life care. And I am horrified that this is even a thought, let alone a suggestion. My heart breaks that one of her doctors would think this is something to begin preparing for. Am I in denial as I shake my head at this? Am I blinded by my beautiful baby?

No. Those words can go rest in our memory. We won't speak of them again. We won't be preparing for anything less than life, the best life that we can offer her.

MY PHONE RINGS and vibrates on the table by my head. *What time is it?* I pick it up and sleepily gaze at it, immediately recognizing the first few digits displayed. It is a call from the hospital.

"Hello?"

"Hi. This is Evelyn's doctor, Dr. K."

"Um …"

"She is okay, don't worry. I am calling to inform you that she self-extubated this morning."

It is hardly morning. The clock hasn't even reached six.

"Oh, shit."

"Because the plan was already in place to trial an extubation on Monday, we are going to keep the tube out and see how she fares over the next couple of hours. How do you feel with that?"

"Okay, that sounds good. James and I will make our way over soon."

"Don't rush. She is okay. We will call if anything changes."

Is she breathing then? Truly? Unreal. Our little girl did it, on her own! She is probably on a significant amount of pressure support through a CPAP mask, but the tube is out! I am so elated, and yet still anxious to see how she does. I can hardly believe that this is happening. Am I sure I heard all that correctly?

It is a Saturday and we usually move a little slower; it's a day to spend a bit more time with Noah. Sometimes only one of us goes in, so the other can have a one-on-one day with him. We have spent many Saturdays in hospital now; there is a regular weekly routine in place.

This changes our plans, and that is okay. We are always prepared to change the plans, to alter the routine on the fly. It seems to happen every few days in this season. I give my mother-in-law a call and ask if she can take Noah earlier in the day than we had planned. James and I need to go in right away, together. She agrees, no hesitation. Her own life has been placed on hold, to be available to us as needed. She opened her arms and told us from the beginning that would be the case. "Evelyn needs you now. It is important that you are there. I

have got Noah; he will be okay. Don't you worry." And he was okay. I think so anyways. Though we squeeze in one-on-one dates, bring him in for the occasional day at the hospital, spend a few evenings at the beach, he is predominantly cared for by our village now.

We make our way into the NICU. It is an easy drive on a Saturday morning. The pink and white blossoms are still falling, and the sun rises behind us as we go. We find a parking spot right by the entrance. The hallways are quiet, eerily so, on the weekends. Families are here, with children who are inpatients, tucked away in the corners of the hospital rooms. But there are no outpatient clinics. No students or volunteers lining the halls. No hustle and bustle or line ups at the coffee shops.

We turn into the NICU and move right to the sinks, scrubbing our hands. We don't stop to see the receptionist anymore. We are regulars now, especially since being moved to a private room in the back. There is no need to ask for permission to go in or to give our nurse a heads-up. We walk down by ourselves, turning the hall corners, eager to see our baby girl breathing.

As we turn the last corner and look down to the end of the hall through glass doorways, we see a commotion outside her door.

This cannot be good.

We hurry our steps as our hearts hurry in our chests. As we approach her room, we see a collection of faces, many I do not recognize, surrounding her bed. There is a female doctor standing over her, attempting to intubate her.

Fuck. This is not what we were hoping for.

This doctor has jeans on and is wearing gardening clogs on her bare feet. Not typical hospital attire. I later learn she was on

call and had been urgently paged to come help with a difficult intubation. She probably lives down the street and was knees in her flower bed this morning. There is no one else on staff with the right expertise to get this tube in. It's Saturday; staffing levels are minimal. She wasted no time in leaving her plants to come here. She is focused and frustrated as she guides the tube and watches the videoscope screen before her, a tool that shouldn't be needed for intubations but that has been required every single time to get a tube into Evelyn. "Wow. I have never seen anything like this. I have never seen an airway this difficult." She lets out a huff and sigh at the end of her exclamation.

Never? She is the expert. She has probably intubated hundreds of kids and babies. Seen so many abnormal anatomies. Never is a bold word choice. Never encompasses a lot. Is our girl really this different? Is her structure truly so poor?

"Why isn't this baby trached? She should be trached already." She seems irritated. As if her team has overlooked an important aspect of care. More words continue to be spoken between her and the ENT fellow handling the videoscope machine.

She hasn't noticed that James and I are standing here. Nobody has informed her that Mom and Dad are listening from the door. I get the feeling she would have said all the same regardless. And she doesn't say it in a condemning, judgemental tone. Just honest facts, stating what she knows.

I brush off her thoughts about Evelyn being trached. It is not the first time I have overheard a doctor say this. Never directly to us, but I have picked it out of their discreet conversations.

They don't know her. They don't know what she needs.

The doctor continues to struggle to get this tube in. I am not exactly panicked about it, though logically I know that I should be. I should be hysterical. I can hear her alarms going, as she desats and struggles to breathe. Her neck is stretched back, the best position to get this tube down, and her face is turning purple. It makes her mad to be held like that, obviously. She is struggling and crying, which doesn't lend any assistance.

And I stand in the doorway, numb. Unshaken by the commotion and alarms. Unshaken by my girl crashing before me. I am unshaken, because I am in constant disbelief.

How is this happening? This cannot be real.

This extubation was supposed to be a controlled event. Monday morning, with her familiar team on shift, with a fully staffed hospital, in the safety of an OR room in case anything went amiss. Instead Evelyn did it herself. Feisty and independent. It doesn't really surprise me. While we watch, our nurse is explaining to us how she has done since pulling her own tube out. They had her on CPAP from the beginning, which she initially seemed okay on but quickly began struggling with. That's when they needed to call in reinforcements.

I had not held Evelyn a lot leading up to this event. Just a handful of times, each resembling that first hold, a grand orchestration to get her in my arms. About once a week on a stable day, when her whole team is on board and the most senior RTs were available for assistance. This, though, seeing how easily she could get the tube out on her own, and more significantly how difficult it was for the team to reintubate her, put an abrupt halt to holding.

There are photos of mamas holding their babies, skin to skin, all over the NICU. Kangaroo care, as they call it, is highly encouraged by the medical staff here. Where Mom or Dad sit, holding their baby against their naked chest, for as long as they can. There are statistics on the benefits, not just for the baby's growth, development and healing, but also physiologically, for Mom and Dad to bond with their child and heal their own spirits in this traumatic setting. Beautiful, idyllic NICU photos, of babies with a standard monitor and perhaps a simple feeding tube, otherwise bare and free from scars, picturesque in their mothers' arms.

These posters frustrate me. Nobody needed to tell me it would be a good idea to hold her. Nobody needed to convince me to stay throughout the day, to fit it into my schedule and make it a priority. I wanted to hold her, desperately. I ached to pick her up, to properly soothe her cries and comfort her in her pain. And when I did get to hold her, when I did finally get her in my arms after debate during rounds and the timing and preparation it took from her team, my kangaroo care looked nothing like those photos. I could barely feel her skin, as there were so many cords and tubes in the way between us. I felt stiff and scared with her in my arms and dared not move at all for fear of her breathing tube being dislodged. I was never entirely alone in my time with her, as our nurse was always a handful of steps away, an RT hovering nearby.

The photos broke my heart and angered me. Why did our experience have to be so different? So rare?

I was grateful for the connection. I was so grateful to hold her. I took each opportunity for what it was, not knowing how

long it would be before it happened again. But I was also keenly aware of the differences between my journey and the one being promoted in this NICU space.

Instead I held her when she was on the brink of death. I held her on days they feared for her life. A brief hello; an incomprehensible goodbye.

Above her bed there is a bright yellow sign reading "DIFFICULT AIRWAY." Below it is the size and depth of her ET tube, as well as the names of the staff who need to be paged in the emergency that this tube came out. It was a constant reminder that this wasn't normal, a constant reminder that the story unfolding here was challenging even to those who see rare and unexpected challenges every single day. This baby didn't follow any usual course of healing. We were living in some "other" category.

I WALK INTO THE NICU, to the large basin sink with six taps pouring into it and soap dispensers every foot. I lather my hands, turning my fingers to get into each and every crevice. I finish and pull the paper towel down, carefully dabbing to dry these red, coarse, over-washed hands. As I approach the front desk where it is customary to check in, there is a mom there with her child in a wheelchair. There are tubes coming from the child and going to machines in the basket underneath. Bags are everywhere. As I get closer, I see a tracheostomy tube in the child's throat.

Oh. You don't see that every day.

I feel pity. For the child, for the mom. For what I do not understand.

I am so sorry that that is your story. I am heavyhearted for this path you walk.

Boy, am I glad it won't be our story.

How ignorant I am. How very unaware.

We choose to go ahead with a tracheostomy.

Like every decision before, we choose the option that is the most proactive. Always taking steps forward, steps that give Evelyn the best chance at life and at living her life fully. Staying intubated and hoping for a different outcome is not useful. Waiting to see if she'll end up in palliative care. That is not for her.

A tracheostomy is scary, scarier than any decision we have had to make on her behalf so far. I feel disappointment like never before. Like my hope has been wasted. As if all of our prayers have been lost, vanished into thin air. She still cannot breathe on her own, and I was so sure she would. I was so sure it would be her miracle, our miracle story. I feel like we are giving up, on her, on what she is capable of. We are giving up on faith and belief in a better outcome. But she has proved, again and again and again, she is not yet able. She is not yet ready. Now I fear the risk of her heart nearing its time for that first surgery. And a cardiac surgeon who has yet to agree to go ahead with anything while a tracheostomy tube is in place. What does her future hold with this decision we are making?

The two weeks following Evelyn's tracheostomy surgery are devastating. Emotionally, mentally, these two weeks are enveloped in the thickest fog. We fought so hard, put so much of ourselves into hoping for the best with her airway. Now, even though she is breathing, technically, we are defeated. This isn't

the way I had envisioned all of this going. It isn't how I thought we would be taking her home. Putting it plainly, I am simply sad. So sad. Caring for a baby with a tracheostomy is incredibly overwhelming, and the fact that there are still many hurdles for us to get through with her heart has me anxious. I try to remind myself constantly that we can only take this one day at a time. It is how we have gotten ourselves this far. It is also okay to feel all these mixed emotions, all the time, as long as we keep putting one foot in front of the other and continue moving forward. She needs us to keep pressing forward.

But regardless of the pep talks I continue to give myself, defeat settles in.

I am breathless now, as I stare at her face. Awestruck.

There she is. That's my girl.

It is as if I am meeting her for the first time. As if these last nine weeks have only gifted me fragments of who this being is, truly, before me.

Her face is bare, uninhabited by foreign objects. And she is stunning. Absolutely stunning. She takes my breath away. The way her lips pucker, delicate and plump. Her eyelashes resting on her round cheeks as she sleeps. The wispy strawberry-tinted hair upon her head. Her button nose, and her dimpled chin, lost behind rolls and rolls of imposter chins. I am staring; mesmerized.

You are so very beautiful, my darling. How have I not seen you before?

Our girl came off the ventilator just one-week post-op. The RTs tell me that this is the fastest they have ever weaned a patient post-op to trach placement.

This is a milestone achievement, different than most people will ever have the opportunity to achieve. But I am proud.

Evelyn is heavily sedated after surgery. I lose track of all the drugs listed during rounds, drugs dripping through her PICC line into her small body, drugs that one hears of being rampant in Vancouver's Downtown Eastside. The nurse lifts Evelyn's arm to feel her pulse and the weighted limpness is obvious to me. She doesn't even flinch. She is rotated frequently to prevent bedsores, to keep her lungs moving and loose. Her body flops into the newly chosen position as the nurse shifts her and the RT keeps the ventilator tube straight and attached to the trach. The first couple of days are crucial for the stoma site to heal and establish itself. Everything must be kept straight, intact.

Six days post-op, she is 10 weeks old. Six pounds, six ounces. The size of a newborn now, though already a couple weeks past her due date. It is a long week of sitting and waiting. Bit by bit, weaning sedation meds down. Bit by bit, lowering the ventilation settings. Yet though it feels like nothing is happening, these smalls steps start to add up, bringing us that much closer to where we want to be.

At post-op day eight, her ventilator is removed. And for the first time since she was born, she is safely and easily breathing on her own.

No support! From entirely ventilator- and sedation-dependant to breathing through her tube and wriggling in a real crib. Ten weeks later she gets her very first bath. Ten weeks later I get to dress her in clothes, and I've had the sweetest newborn kimonos waiting for the opportunity. Ten weeks later and I am free to pick up my baby, hold her in my arms, whenever I

want. No nurse or RT assisting. No permission required from a doctor.

Ten weeks later and her big brown eyes are bright, engaging with mine for what seems like the first time.

HOME

Perhaps, even here, I am growing.
When the days are long and I do not feel as strong and when the hours go by
slower than they ever have before, and sun is shining and I am lost indoors,
perhaps even here, I am growing...learning to be at peace in what does not
make sense to me. Perhaps, even here I am growing.

Morgan Harper Nichols

They tell me this will get easier. That one day, this will be second nature. That I won't need to look at a screen to be sure she is okay. Moving across a room, with her body in my arms, no cords coming from her, I won't think twice about this reckless (normal) action.

They are right, of course.

Less than a couple of weeks at home and we stop connecting her monitor to her foot during trach care. We know she will cry. She will turn blue, as usual. We will stop halfway through to give her tears a rest, as usual. We will stop and breathe—wait

for her heart to steady itself within her heaving chest. Her oxygen saturations will drop into the 60s, maybe lower, we guess. Then we will finish, and she will recover. As she always does.

Within a few months we stop bringing her monitor with us on car rides. Another piece of equipment to carry around, it quickly becomes a nuisance rather than a help. Her skin, her cry, her face tells us all a monitor does, and then some.

In a year's time, I will understand her breathing rate and the depth and variations of breath better than any screen could detect. Her colouring and mannerisms will be all the indicators we need to know when it is necessary to take a closer look.

I do not know this now though. I do not understand it. I cannot believe it.

But they are right.

After three months of sponge baths it is finally time to give Evelyn a real bath. To submerge her in water and let her feel as she did when she was safe from this world, still inside me.

I gleefully, casually, take her from her nurse's arms at the end of the bath, and we twirl together. As they hand her back to me, bound in bright blue cotton, free in my arms, I feel almost as if this is the first time—as if she has just been birthed, swaddled and placed in my arms.

And then my heart stops, and I freeze.

"Her monitor!" I panic. 'We need to attach her back to the monitor." I don't know her numbers. For the first time in 10 weeks, I can't see her heart rate and oxygen saturation numbers. I feel blind. Like my senses are gone.

"It's okay, Laesa," our nurse reassures me. "Look, her face is pink."

No. No, it is not okay.

I place her in the crib. Unwrapping her lower half and placing the new probe on the fleshy part of her foot. Our nurse follows my lead and turns the monitors overhead on. There, the lines bounce; the numbers settle.

I can't. I can't do this. I cannot hold her without fear. I cannot hold her without a screen to stare at.

"You will. One day, you will. You will know her colour and her breath and her beating heart. One day you will know her better than these monitors do. Just give it time."

Six weeks later I have her in my arms as I lounge under the large window in our living room. The light is pouring in, brightening the edges of this scene I find myself in, a preschooler running about the house, playing with every toy in sight. Dad stands at the sink cleaning the feeding bag, again. Baby Girl, our four-month-old newborn, sleeps soundly in my arms. I gaze at her face, studying her rosy cheeks and lilac-tinged lips.

So many people tell me how I am supposed to feel about this. About coming home. I know they all mean well. They assume they know how they would feel in the same situation. They place their expectations on me, waiting for me to react in the way they think they would. But instead I feel as if there is something wrong with me for not wanting what I'm expected to want. For not feeling so very excited, relieved, and eager. I feel those things, but mostly I feel anxious. Disappointed even.

What is wrong with me that I don't feel happy for this? Isn't this what we hoped for?

It's not, though. I expected us to come home eventually.

I believed, again and again, that she would breathe. That her

tube would come out and all we would have to focus on would be her heart. But she couldn't breathe.

Going home with a tracheostomy, and a G-tube for feeding, was never what I envisioned. I knew we were fighting for life. I knew we were saying yes to whatever was needed to give her life. But as I prayed and believed with so many others that she would be healed, I never imagined that this would be the way. I wouldn't say that hope has left me, but it has taken on a different form.

I expected that eventually she would breathe. Then she would get the heart surgery she needed. And then, and only then, we would be discharged from the NICU.

Not only is she home now with more holes in her body than we started with, but we are leaving without the hole in her heart being fixed at all. We are sent home to wait, in limbo, waiting for "when" she needs surgery. A week later? A month? And it is left up to us to notice the changes that will signal that "when," to watch and observe, waiting for our baby girl's heart to begin failing her.

I feel ripped off in this coming home celebration. Watching families around me bringing home their well babies. Fixed. And mine, here, still so very broken. Still filled with holes and scars and tubes. I realize that we are all more broken than when we first arrived.

Home is first brought up as a discussion point during morning rounds on day 82. The very first time in more than two months the possibility is real. I feel moderately joyful at the sound of it, but then I begin to think about what still needs to occur for this to happen. My mind goes into planning mode,

organizing our home and lives for the major adjustments that are to come.

I set up her crib in our bedroom before home was mentioned. Originally, I had a bassinet there. I had begun arranging our bedroom at home the day that preterm labour started, unaware that I would not touch it again for a couple months. The irony in my timing. I placed the bassinet atop its stand, on my side of the bed, just underneath the windowsill. I had a handful of muslin swaddle blankets carefully folded on the edge of it. A soft stuffed bunny I pulled from Noah's collection, a teether, a couple onesies I had picked up throughout my pregnancy, all neatly laid inside. I made space on my dresser for a small basket for diapers and wipes and all the random little baby things. And I passed this empty bassinet each night as I crawled into bed and my baby slept an hour away in her incubator. Sometimes looking at it helped me, I think, as it gave me hope that she would one day sleep there, where I could tend to her in the middle of the night and soothe her cries, just as I had with her big brother. Often though, especially as more and more days were added to our NICU stay, seeing that bassinet hurt. It embodied what could have been, what may never be, what is but will never look the way I thought it might. The way I thought it should be.

We knew early on in our NICU journey that it would be a long stay. We braced ourselves for three to six months, so that we wouldn't get ahead of ourselves in expecting anything more. There was no point in having unrealistic expectations about a discharge date when we had no control over how that would come to be. There was no point getting our hopes up, no point being too optimistic about it. She had a lot to get through: to

breathe, to eat; a heart repair. There wasn't any sense in rushing her or our hearts. As the weeks passed, and our baby girl began growing and nearing the month of her actual due date, I realized she might not even use this bassinet. She might be too big for it by the time she came home. And though the plan was to have her share a room with Noah eventually, that was no longer going to be the case. We would want her near us for as long as we could.

So, we set up the crib in our bedroom. Rearranging the room yet again to make space. I put a cart on wheels beside it for her clothes and baby things. I left the bassinet beside my bed, just in case, but moved one of the blankets and the soft bunny stuffy into the crib.

Then home is mentioned, on this 82nd day in the NICU, during morning rounds. And I know now that it will not look like anything I imagined. The space I had so carefully prepared will not be used at all.

Evelyn's needs are much more complex than those of a typical baby. Wherever we are, we will need the same equipment and supplies we use now in the hospital. We are her parents, but now we will also have to be her medical caregivers, too. Boxes of supplies will sit on our shelves; equipment will need to be sterilized and maintained daily. We will need to be trained to perform all of her regular medical procedures; there is almost no resemblance between this care and tending to a healthy newborn. We need to be taught what to do in each possible emergency, how to use each of these tools, how to clean and care for the lifeline tubes in her body.

Our home will be inhabited by nurses. Strangers, initially. Strangers we will come to place our trust in. To tend to both her

medical and emotional needs each night. To assist us in driving to and from her frequent doctors' appointments. And to be an extra hand in the many developmental therapies now required.

In the first couple of months at home, I fall into a pit of grief. More than ambulance rides, trauma rooms and sitting bedside in an ICU, being at home with a sick and medically dependant baby is crushing.

No longer is there someone to clean our space each day. I am the janitor here. No longer is there someone to order and stock supplies; I am the care aide. No longer is there a nurse to administer meds and keep me company throughout the day. I am the day nurse, alone. I am the counsellor to my children and myself. No doctor, no RT, no coffee shop nearby for convenient fuelling and snacks. No longer is there someone to watch over her while I pump milk or make a lunch for my son or step away to the bathroom.

At home, I feel guilt—a constant numbing guilt. In the hospital, I could be so purposeful with my time. In the hospital, I am Mom to my newborn, holding and cuddling and singing over my baby. I am a caregiver, training and preparing for our life at home. I am wife, being a support to and leaning on my best supporter. I am Mom to my son, my beautiful boy, who sees me less and less frequently.

At home my time is fragmented. My attention divided. My spirit fractured. There is a level of myself that I give to Evelyn, without question, to keep her alive. To keep her healthy. Administering her meds every couple of hours, on time. Attaching her feeding bag throughout the day, and then washing said feeding bag again and again. I am suctioning con-

stantly, holding and rocking nonstop. A four-month-old baby, so, so much needier than a newborn. And now Noah at my side. Watching from his corner on the couch while my focus is directed towards his sister. I am anxious to care for him the way I have always cared for him, but I can't. Food is placed in front of him and the television turned on; I shush him to stay quiet so I can get his sister down for another nap.

Evelyn slept in the living room initially. We couldn't have a nurse sitting in the corner of our bedroom, so we adjusted, again, and set up her crib in the living room. It was perfect at the time, for those first six months. I could be in the kitchen and have a direct view of her and her monitor. She could be attached to her humidifier at all times and still be near all the action of the home, rather than alone in a quiet bedroom. Her stuff didn't need to be moved around the house. Her bed sat underneath the largest window, so she could watch the tree in her view outside. Seeing the sky and the seasons changing before her. But it also meant the living room was a napping space three times a day. It meant constantly telling Noah to keep it down because his sister was sleeping. And long days in one room of the house, hours of not moving more than a couple feet while I cared for her.

Our home nursing support was minimal in those early days. No one's fault—just the way the system works. We were given the most hours we could qualify for, given Evelyn's needs. But she had so many follow-up appointments each week, and with nurses periodically calling in sick, there were few hours of respite. Not many hours left each week for me to have an actual break, let alone to get groceries or have that shower I so desperately needed.

James comes home after working hard all day and somehow summons the strength to ask, "Where do you need me?" Knowing that I had been counting down the minutes till his arrival. Knowing I had reached my limit hours ago.

Sometimes he wouldn't even ask. He didn't have to. Those days he came in and saw me with tears rolling down my face while I rocked her. Numb with exhaustion, bouncing my knee, blankly staring out the window.

People asked me how we were doing. It must be so great to finally be home! I didn't have the heart to say I often hated it. We had just walked through four months inside the neonatal intensive care unit. This should be a breeze. This should be a joy, all of us together. But it wasn't. Home was the most foreign and isolating place I had been yet.

Home had been my safety, my normal, throughout our NICU journey. It is where I came to rest after a long day at the hospital. It had let me continue some simple, everyday routines. Now it only highlighted how very not normal this whole scenario was. With her in hospital, I could separate the life we hoped for from the one we were handed, going from home to hospital each day. I could continue to believe that I might bring home a healthy baby and we would go on with life as we had envisioned.

Home is where we now learn we are never safe. Where we recognize we will never be free of the realities in our hands.

We are going on with life, for sure. But not the way anyone would dream their life to look like.

It is my chaos, my peace. My sanctuary and my prison. It is a sacred space, a shared space, an open space. Sometimes it is too quiet. I can't hear myself think. I don't feel; I feel safe here. I feel stuck here. Here I feel comfortable, at ease, in control. I am not in control of anything and I am not myself. I am lonely and never alone. I am free to be nothing except what is needed of me in each passing moment. I am free to be everything that I can be with what is given to me. I am trapped by the walls that surround me, walls that contain all that I hold dear. Home is where they are, and I will move and evolve and adapt wherever, whatever, that may be.

[9.5 months old]

REALITY

Stumbling

Falling

Bleeding

Kneeling

Standing

Healing

This is how we grow.

Becca Lee

No one comes to visit. Not often anyways. Perhaps I should call. Perhaps I should ask. Though I make it plain I am home. Here. Babes in my arms, going about our day.

They are afraid of bringing germs. As they should be; I don't want them in my house. Afraid of awkward conversations, tension-filled moments, of saying the wrong thing. As they should be. I seem to be offended by most phrases of encouragement these days. They are afraid of inconveniencing us, of further crowding our crowded space. But my life is inconvenienced enough. It is their turn to be burdened with empathy.

Because I am alone without them.

I am angry and disappointed when no one shows up. As I sit chained to this chair, suction catheter in hand, eager to share this world with others. Am I living in a dream? Some moments it is. Sometimes it is a nightmare I cannot shake myself out of. Another person's presence might be just what I need to help me find solid ground. Might be the pinch that I need to make sense of this new reality.

Then company comes and it doesn't feel comfortable or natural at all, to share this intimate space. This space where my heart is laid open, as I try with all my might to keep it closed to the world. I cannot yet show you this pain I feel. Their very presence is irritating. I'm anxious about how I talk. Awkward in my interactions. When will they go? Then they do, and I am alone again.

I realize I cannot be pleased, either way. Nothing about any of this is pleasing.

Did this all really happen to us? Did we truly walk through those terrifying days? I begin thinking that I wish this first year, the first couple years, would whiz past. I just want to get it over with. I want the hard stuff to be done. I want to be truly free of tubes and appointments. But then I am reminded of where we've come from. How much we have come through. And I am in awe. I am humbled and saddened. Suddenly the idea of speeding through Evelyn's first year of life is more terrifying than any of the hard details in it. Suddenly the moments I crave are not in the future; they are the ones that have already passed. All of the moments. The heartbreaking moments. The make-me-sick-when-I-think-of-them moments. The tiny-body-against-

my-skin moments. The silent cries. The small grins. So much of it becomes a blur, yet at the same time it is all painfully imprinted, a tattoo of hope, longing, love and sorrow on my heart. And somehow, I crave it still.

I am recognizing that being truly free is not to be free *of* something but to be free *in* something.

Embracing the hard stuff, letting yourself sink into the hard stuff. There can be joy in that. Perhaps it is in these places where we can find the greatest joy, the most liberating freedom.

Perhaps we can find *ourselves* in these hard places. Perhaps we can find each other. Perhaps we can find hope. Perhaps there is a lot to be found in these hard places, these moments that we are so eager to put behind us. But then they are left behind—and did we bring anything from them?

Last weekend marked 117 days at home, 117 days since we left the NICU. It's significant because that's how many days we were in the NICU, which means we've now spent more time at home than in the hospital with our sweet girl. It is significant, and I knew the date was coming up, and then it just passed us by like no big deal. It is a big deal, but it's also not. There was a time when I thought being in the NICU was the hardest thing ever. And then I thought that being at home with a medically fragile baby was even harder. Fact is, there are a lot of difficult things I've walked through in life, difficult things each of us have walk through. Until you are on the other side, it is the hardest thing. Then as time passes, it is just a thing, a small piece of the bigger picture, a moment in time, a fragment of your story. These hard things shape us like the waves shape a cliffside. It's aggressive and painful and relentless; it creates something beautiful, unique and inspiring. These hard things soften our hearts, make us more aware of the world, alter our perspectives, give us a clearer vision. They make us who we are. So. Yay! We have now spent more time at home than in the hospital! We are experiencing the calm seas these days. And it's good. But I'm also grateful for the raging waters we've walked through.

[Eight months old]

SOME DAYS ARE HARDER than others. And for no obvious reason, because it's just like any other hazy, moving-through-the-motions day. Some days just suck; there are a few other words that better describe how I feel about it all. And I can't comprehend how any of it is real. And it is all such a blur, staring me straight in the face. And I just need a moment before returning to the scene.

And, deep breath.

I miss him so much these days. We're like ships passing in the night. Moments of togetherness are brief. Moments apart feel like eternity. Some days there are endless words to exchange, filling each other in on our day's events, our heart status, where our minds have settled or raced off too. Other days there just isn't much to say.

There isn't anyone I would rather do it all with. He is the hardest-working man I know. Incredibly passionate and diligent about his craft. He gives all of himself to each project he takes on. Including his greatest endeavours: being a husband. Being a dad.

After long days at work, he comes home to chaos. Whether it is cranky kids or an emotional wife or both, he doesn't complain. He walks in the door with a deep breath, ready to support me and conquer the evening routines.

I couldn't do it without him. And I know he couldn't do it without me.

James comes home from work, as he does. The weight of our family's stability, comfort and livelihood on his shoulders. I sit in the same chair he left me in 10 hours ago, the weight of our children's immediate needs upon me.

I notice, now that another adult has entered my space, that I have been crying. Silently. I haven't seen my face in a mirror in days, but I can feel the warm pink blotches. The wet edges of my sleeve keep moving back to dot the rim of my cheek.

She is cradled in my arms. Asleep perhaps. Another time crying, still. Is she restless here? Is this space still unfamiliar to her, weeks later?

My whole body aches to put her down. Yes, this is a beautiful moment we are having, love. A stunning picture we have created, and I am grateful, truly, but my bones hurt. My knees crack as I bounce, and I feel my neck stiffening up. My arm beneath her head is going numb, and for the love of god I have got to go pee! But I continue holding on, perhaps one moment longer. Perhaps one more inhalation of her beautiful scent.

Because I remind myself what this picture should look like. Of what it could have been.

In this rocking ritual we have created, I should have her sweaty skin against mine as she nurses from my breast. I should be nourishing my babe, lulling her to sleep with my milk and presence. I should be holding her just so as we stare into each other's eyes throughout the day. This should be a simple routine. A familiar routine, like the one I had created with her older brother. But it is not.

Instead I hear her lips smack, smack, smack against the rubber soother she's gratefully accepted as a substitute. And instead of a slow process of nursing and falling into that deep sleep, I rock her in my arms, wishing her eyes would fall shut just a little bit faster. I'd like to say that rocking her is a pleasure and I always feel so lucky to have her in my arms, but the reality

just isn't that. This is hard. The weight of her, and I mean the weight of all of this, all that she encompasses, is hard. Bedtimes are a reminder. I connect all the different tubes and wires to her for the night, and I rock her in my arms while holding it all in place. If she is fussy and crying, rocking gets interrupted as I place her down for a quick moment to suction, only to pick her up and begin the process all over again. There is no cry it out method or attempting to teach her to sleep independently, because her heart, and mine too, probably, wouldn't endure that many tears. So, we hold and rock and bounce. We sing too many melodies to count. And I say a silent prayer that this night will be a simple one, that she will relax easily in my arms, that her breathing slows, and her eyes fall closed. Sometimes, though, she fights every moment of the bedtime routine, pauses her frantic soother sucking to look up at me, and even chuckles to herself periodically, as if to taunt me. Yes. Yes, I am proud of her fight and resilience. Her sense of humour and personality are so endearing. But at the end of the day, when I am desperate for rest, like any mother of any child, I wish she would just go to sleep.

And then she does. Out of nowhere the struggle ceases, overcome by my bouncing or her dad's. She is steady, peaceful and quiet. There is a sense of relief and I stare at her awhile before leaving her side. I stare at her beautiful self. And I am grateful for her, all of her. The hard parts too. I am so very grateful.

My darling. I hold her limp body, exhausted from the day, in my arms. Her sweaty brow rests on my cheek as I continue to hum sweet songs into her ear, and I rock and bounce. The evening sun pours in, kissing her skin and making her wispy

hair glow. It's beautiful, really, how her head sinks into my chest and she needs me so.

Such a poignant picture we have created here, my darling, shall we create it again?

And so, we do, night after night. I hold the weight of her body. Her breath is laboured as she slows herself down for the day; no one has ever known this depth of weariness. Night after night we fold into each other, grasping for closeness.

We are almost one again, darling, wrapped in each other's arms just so.

A CLEAN NAPKIN is laid out on the dresser, a surface on which to place my tools and supplies. The gauze is prepared first. Package torn open, I pull the square out by its corners, careful not to touch more than is necessary. I unfold it and cut it in half. Fold each piece again, and line them neatly on the napkin. Cut, fold and place. A row of one, two, three, four. Another tear; cut and fold, and another row of one, two, three, four. The tubing used to hold it all in place is premeasured and threaded with cotton twill. I lay it against the ruler, to be sure the measurements are exact. Slightly too short, I throw it out. Slightly too long, I trim it down. It too is added to the clean napkin before me. The dressing is cut next, a length of eight centimetres. In the middle, at the four-centimetre mark, a cut to the centre is met with a round opening of just a few millimetres in diameter, placed down on the tubing. A hard twist unlocks the lid on a new bottle of saline water, and I draw up a 10-millimetre syringe with the sodium chloride solution. It is then placed down, alongside medical scissors for cutting the cotton twill, and tweezers for

threading it through. Lotion is pulled from the drawer. Two more squares of gauze, uncut, are placed within reach. The box with the new, sterile tracheostomy tube inside is opened. Holding it carefully, I look through the tube, ensuring there are no defects. I place a thin layer of water-based lube along its length. It rests back in its sterile package until it is time for the exchange. Next, I place a rolled blanket at the end of the couch, where her shoulder blades will lay to open up her airway. A swaddle blanket lays open, ready for her to be wrapped inside.

I take a step back. Examine my preparations.

Did I remember it all? Did I do it just as they taught me? Are we ready for this on our own?

I go through a mental checklist in my mind, ensuring no detail is misplaced or left out. The suction machine is plugged in and ready, a new catheter at arm's reach. Saline water is topped up. The emergency trach kit is accessible, with a sized-down tracheostomy tube inside in case we can't get the correct size in. The bagger sits at the end of her bed. With a slight nod of my chin, I hesitantly approve of my own preparedness.

I go to run the bath water, placing my hand under the tap until the water is at the right temperature. An infant tub is unfolded and securely placed upon the counter. I run the water just high enough to get her legs wet, as I cannot risk any getting near her trach.

"James? Can you bring her now? The bath is ready."

He walks her over, cradled in his arms. Her clothes are off except for her diaper, which is already undone. James gently slips it off as he transfers her gently into my arms. I cradle her and ease her into the water. She cries at first contact, protesting.

Once her bottom half is submerged, though, she settles happily into the lazy spa. I support her head and keep her steady while Daddy lathers the soap and carefully rinses all of the suds off. Her face and head are carefully cleaned with a damp cloth. I think briefly of playfully dripping water on her nose or playing peekaboo with the cloth, but then my mind races elsewhere.

She smiles up at me as I wrap her in a towel. For a moment her trach is not visible. For a moment it is just a baby coming out of the bath, burrito-wrapped in cotton and ready for a peaceful bedtime routine.

My heart starts pounding as I walk this unassuming burrito back to her nursery corner in the living room, anxious about the routine we now have to move through.

None of us enjoy this. I feel numb and robotic as I attempt to reassure her, not that she has any idea what is about to occur.

"It's okay, sweetie. It will be quick, my love. Mommy is here. Daddy is here. It will be okay." The words fall out of my mouth with no substance behind them. Because it is not okay. I am trying to reassure her, because I know what is to come, but mostly I speak to myself.

It must be done, however. Every month, no exceptions.

A tracheostomy is a breeding ground for bacteria. It is wet, heated with a humidifier overnight, and exposed to the elements of the world. Regular trach changes minimize the risk of an infection. We are diligent about cleaning around her trach and neck almost every single night. And just as diligent at scheduling these trach changes, every single month.

Will this get easier? Will we have a grasp on this one day?

"Okay, let's get this over with." James has been adamant from

the beginning that he leads trach changes. It is him protecting her. Creating some control over these situations we must walk through. Our nurses assist with trach cleaning when we need help. But the monthly trach change day is reserved for Mom and Dad. Since we passed our training in the NICU, this has been our charge. We know her best. She trusts us most. And in some unfortunate way, we are purposeful about enduring the most terrible moments with her. If she must face this anxiety and fear head on, so shall we. With her.

"Yes, when I am ready. Give me a minute." I put a fresh diaper on her itty-bitty bum as she rests between my legs, crossed lotus-style. It is my favourite spot to place her, as she is comfortable and secure nestled here, and my hands are free to suction and tend to her. Silky lotion is smoothed on her perfect body. Her G-tube site is cleaned with saline, dried, and ointment generously applied. "Okay, Baby Girl. Here we go. Hush now. It will be quick. It will be okay." I cannot help but attempt to console her. Even though I know it is futile. Even though I know it is dishonest.

Maybe not, though. It will *be okay. Right?*

I lay her down on the open swaddle. She is too big to be contained like this. But we are told it is easier when their hands cannot get in the way. Probably true. We have not braved trying it otherwise yet. She fights the swaddle, as she should. Her legs are left out to kick wildly, and it looks as if I just put my infant in a straight-jacket and told her to relax. I sit at her feet where I can easily reach her neck and attempt to keep her in place. James kneels on the floor at her head. He moves the suction

machine so it is right beside him and puts the napkin I've prepared within reach.

Then we both falter. "What are the steps again?" James asks, exasperated, his eyes closed, trying to envision what took place the last time we did this.

"I will hold her trach. You will clean around it. Then our hands will switch. You will remove the trach, I will clean the stoma site, and you will replace it with the new trach. Then we switch again and get the ties in place."

"Right. Okay. Shit. Here we go."

James starts the process. Saline wipe under the trach. Dry wipe follows. Saline wipe above the trach. Dry wipe follows. I place my pointer and middle finger on either side of her trach tube, pressing on the phalange probably more than I should, but it is necessary with her wiggling and crying body underneath me. He cuts the cotton knot off on one side, then pulls the ties through the other. The bubble tubing gets caught in her neck folds, and I grow increasingly agitated with James' speed. "Hurry up, I can't keep her still."

"I'm trying," he snaps back.

She is crying as we move, and we do nothing to soothe her. Our faces are stern and focused; we are determined to get this done. I cannot imagine what it looks like to her, staring up at our scared, frustrated faces while she squirms, scared and frustrated herself. She starts turning blue, and I know she is desatting now. Probably in the 60s, maybe 50s. There is no monitor attached to tell us this, but we know. Because she desatted with each and every trach change in the NICU. Why don't we have her hooked up to it now? Because it would be irritating and

alarming the whole time, adding to the stress for all of us. It sucks. She desats. We finish. She recovers. We have to trust it will keep happening the same way. S*he recovers*, I assure myself.

"Should I sit her up and rock her, try to calm her down? She is so upset."

"No, let's get this done. We're halfway there."

He's right. Rocking her settles her a second, but as soon as I stop, she'll be back to crying and desatting and it'll have been a useless attempt and a waste of time. Better to finish, soon.

So, the cleaning continues, saline wipe on each side of her neck. Dry wipes follow.

James picks up the sterile, thinly lubed trach from its box with his dominant hand. With his other hand, he reaches across her face to hold her current trach in place. Now my hands are free. One of them to clean her neck after the used trach is removed, the other to keep her body straight and her hand, which she has managed to free, away from the procedure site.

"Okay, are you ready?" James asks me.

No.

"Yes. Are you?"

"No, but here we go."

The trach is lifted. Her eyes go wide, and she squirms beneath me. I wipe once, wet. Wipe again, dry. She squirms still, trying to suck in air through her trach site. Her neck retracts with each gasp for breath, her eyes fearful as she cannot satisfy her need for oxygen. I can feel her screaming "*I can't breathe! I can't breathe!*" as I rest my forearm across her sternum to keep her body square. I hold the arm that has escaped the swaddle and is flailing. Her neck is open and waiting, but all the squirming and shifting has

made it difficult for James to line the trach up straight. I can see the panic on his face. I don't believe he is breathing either.

And then it slides in. She chokes and coughs as it does. I quickly reach for the suction catheter to ensure there is no obstruction. It passes through.

It's clear.

We finish the rest of the process anxiously, quietly. The neck roll is removed. I go back to holding the trach and steadying her wiggling body. James applies the lotion along her neck, protecting it from the abrasion and moisture that wearing a trach inevitably creates. The specially trimmed dressing is carefully placed underneath the phalange, the precisely cut hole slides easily around the trach tube. The new bubble tubing and ties are put in place. James threads the cotton twill with the tweezers, through the holes on either end, securing the tubing in place with three tightly pulled knots. I straighten out the dressing and her skin folds, ensuring that nothing is pinching. Then, as I lift her to place a pinkie at the back of her neck, making sure the tightness is just right, she sinks into my chest.

I pull her exhausted body into my arms and settle myself down into the chair. She is passed out. Breathing easily, her cheeks streaked with tears. James reaches for her oximeter to get a read on her saturations while we recover. She sits at 68. In twenty minutes, we'll be back up to 75.

"That was a mess." James says out loud now that she is stable.

"I know. She's getting strong. I did my best keeping her still."

"Yeah. I know. I hate this though."

Yeah. Me too. Me. Too. ...

OPEN

No matter how wide you stretch your fingers,
your hands will always be too small
to catch all the pain you want to heal.
Believe me, I've tried.

Sarah Kay

The evening before her first open-heart surgery, the climax that we have been anticipating since we received her heart diagnosis almost a year before, is just like any other night. We sit in the stillness of this cluttered living room space, used suction catheters scattered on the floor, toys lying about, a row of Noah's Hot Wheels cars he lined up carefully before bed. James rests on the couch and I in the chair, holding Evelyn in my arms. Yet this night feels different, an eerie calm before the storm. I cannot bring myself to set her down. I cannot bring myself to finish these evening routines. I just want to hold her a moment more,

and another moment more. Perhaps if I hold her, perhaps if I stay very still, as I inhale her scent from the top of her warm head, time will stand still. Time will stand still, and tomorrow will remain far away. Perhaps tomorrow won't come at all. I wish my kisses could heal every part of her. Even though they don't, I continue to press them over her sweet skin again and again.

And again. *Kiss.*

But I know better. There is no delaying or changing the inevitable. Eventually, I do put her down. Carefully, so as not to disturb the steady rhythm she has melted into, I inch her higher on my chest and then lower her into her bed. She squirms. As I expected her to, so my hand is ready to pat her steady as I had been doing a moment before while I held her against me and inhaled her scent. She accepts this firm touch against her body and holds her soother as she squeezes her eyes shut again. Still patting, I position her humidifier in front of her trach opening and attach her monitor to her tiny foot. I linger, longer than usual.

She is most certainly asleep, but I let my hand continue to pat. pat. pat. Soothing for her, perhaps. But mostly, for now, this moment is for me.

Morning comes before sunrise. With the help of her nurse, I dress her in the still-dark room, putting on clothes I'd laid out the night before. It is not often we get an outing these days, as we've hibernated ourselves away from winter germs. Even if it is a trip to the operating room, I intend to make it special. I have picked out a soft grey onesie, her spotted leggings, and the sweetest little moccasins for her tiny feet.

She began fasting when the night started, and I am wondering if she has noticed her empty stomach.

I double-check her diaper bag, even though I know it is unnecessary. I packed it myself yesterday, and I know her night nurse would have looked over everything during her shift just now too. But I check it anyways. Giving my hands something to do. We will need her emergency trach kit to pass to the OR staff; she won't have her own made for her until she is settled into the ICU. Suction catheters, syringes, diapers, some familiar toys. Although I am not sure how long it will be before she is ready to play with them. Even to sit up again. But they are packed, nonetheless.

I feel contempt for myself as I hold her hand in the car. As we drive towards this terrible, necessary event. Knowing I am taking her to be harmed. That she is about to experience pain, struggle. Knowing that we are pushing her into a fight she didn't ask for. Though I know this is needed. Though I know we are wildly prepared for this. Handing my beautifully broken baby girl into the arms of the OR nurse tears me up inside.

One last inhalation from the top of her head.

I am sorry, my love. I promise I will be there when you wake.

THE FIRST TIME WE STEP FOOT into the paediatric intensive care unit (PICU), we are still inpatients on the other side of the hospital, nearing the end of our 117-day stay in the NICU. We are days away from bringing our baby girl home. But before we can do that, James and I need to complete the last aspect of our training for our medically complex baby, in what the NICU complex care team calls "care by parent." We are to do all of her care, a few outings both in the hospital and off hospital grounds, over the course of 48 hours. No nurses or RTs to assist or take

shifts. Just us and our baby girl. To simulate a more "home-like" environment, they set us up in one of the large private rooms in the PICU. There is a cot for James and me to take turns sleeping in as we work in shifts caring for Evelyn.

The day before this is to occur, one of our NICU nurses brings us to the PICU to give us a tour. This is the phone to call the front desk to get let in. Here is the fridge for the breastmilk, here is the bathroom, this is the short cut to the coffee shop, et cetera. During that tour, however, our first encounter with the children's intensive care unit, all I could see were the rows of babies and children lying in their hospital beds. With tubes and wires, ventilators and IV poles. And their moms and dads and caregivers standing by, just as I have been doing on the other side of this hospital in the NICU.

I am stunned by the scene before me, choking up as we walk past. Curiously gazing over the beds before me and the children inhabiting them, I look away again and again. Not wanting to be rude, not wanting to see any more than necessary, not wanting to feel the way I do. This space is heavy, somber. Like life is something that is battled for frequently here, many winning, some not.

It is overwhelming, a thick fog to walk through, to push through.

Being one of the more complex cases in the NICU meant that I was unaware of just how many other complex babes there were. Any time I met new moms in the NICU and we talked about how our babies were doing, I just couldn't relate to them. I saw their eyes go wide as I described Evelyn or the length of time that we had already been there. Often, they were there a

few weeks, working on bottle or breastfeeding near the end of their stay. There was a baby boy who had the same heart condition and another boy with the same Pierre Robin diagnosis. But Evelyn's condition was so much more complex. I felt for all the babies and parents that found themselves in the NICU, but I couldn't help feeling that Evelyn had received the short end of the stick, multiple times over.

A complex CHD, airway issues, craniofacial defects, feeding tube. The tracheostomy set us apart entirely.

It meant this weekend of training, required to prepare us to take our girl home with us.

In the PICU, I could feel a sense of connectedness. Acknowledging the struggle that each of these children and their parents was going through. Seeing each other's brave faces, holding onto the hands of our brave children. Perhaps it was because it was a more open space, its inhabitants more visible to each other. Perhaps because I knew these families were living lives that more closely resembled what ours was about to look like—in and out of hospitals, fighting through illnesses and recovering from surgeries.

Our community was here.

The second time we visit the PICU, we are two months away from Evelyn's surgery date.

We come for preparation that prepares us for nothing and in the end seems useless.

As we enter into a new year, Evelyn is nine months old, and we bring her in for her very first heart procedure, a heart catheterization. The process involves the cardiologist entering the femoral artery in her groin with a thin long tube, called

a catheter. She is under anesthetic. He moves the catheter up the artery and into the heart to measure pressures and oxygen levels in various areas, a process known as a hemodynamic assessment. These findings are necessary for the cardiac surgeon as he prepares for her first surgery.

At the time we are both a bundle of nerves, James and I, thinking a heart procedure and an overnight stay in the PICU is a huge deal. And yes, it is a big deal. There are always risks with anesthesia, needles and probes. This particular procedure, due to the size of the artery used, has a higher risk of bleeding. And our sweet girl has grown in our hearts, just as she has grown in size in these last four months at home, so our anxiety surges as this event approached. Months later I will shrug at the simplicity of a heart catheterization. She will have had many in that time. And when placed beside the magnitude of open-heart surgery, it really is nothing.

This first heart catheterization is a stepping-stone to that first surgery. But this brief introduction to the PICU doesn't seem to prepare us at all.

"THAT DIDN'T GO EXACTLY AS I HAD EXPECTED."

The surgeon is going over the surgery with us now. And this is the way in which he begins his dialogue.

What could you possibly mean by that?

Evelyn needed to be placed on the heart and lung machine, unexpectedly. Most surgeons, he explained, might have planned for that with this particular surgery. He did not, as he often does it without. He is arrogant about this, but it does not bother me. It is not the first time we have heard vain comments by her

doctors. Part of me appreciates it; if you want anyone to be confident, it is the doctor holding the scalpel over your baby girl's body. He goes on to explain how she went into supraventricular tachycardia[7] (SVT) episodes, seven times. And seven times they had to use the electrical paddles to set her heart on course again. She should have required a band around her pulmonary artery (a PA band, they call it), based on the pressure findings during her recent heart catheterization. But as a result of the frequent SVT episodes, her oxygen saturation levels were lower than expected, lower than the surgeon was comfortable with, and the band appeared to have been too restrictive of her blood flow.

The surgery itself was successful. But these unexpected, unplanned events seemed to shake the surgeon. It was obvious he is not often caught off guard, not often wrong in his approach.

I thought I was ready for this. I thought I was prepared. We have done this before.

We walk into the PICU now, to approach our baby girl's bed after her very first open-heart surgery, a surgery we have been apprehensively waiting for since before she was born almost a year ago.

In our pre-op appointment, a couple of weeks before, the nurses showed us photos of other cardiac babies post-surgery to give us an idea of what to expect. So that we would not be stunned, alarmed, by the number of tubes and wires attached to her. By the bruised and swollen skin, and remnants of blood left behind. I remember looking at the photos and feeling quite detached. I brushed it off.

7　Supraventricular tachycardia (SVT): An abnormally high heart rate caused by a problem in the heart's electrical system.

Oh yes, we have seen all that before. This isn't her first surgery.

Open heart. This is another level.

There is something different about this. I am not sure if it was being in an open ICU, with rows of beds in view beside hers, or being away from our familiar nurses in the NICU. Or the crash cart sitting at the end of her bed, or how big she looks now compared to her tiny body recovering from past surgeries inside her incubator. Perhaps it was the build-up to this event, the months of anxiously waiting, the one surgery we actually had time to prepare for and process.

As we follow Evelyn's nurse back to her bed, my spirit leaps to go rest beside her but my body steps shyly forward. Awkwardly I reach across to hold one of her hands, both of which have IVs going in, with multiple lines running to the IV pole nearby. I reach to rest my other hand on her head and am stopped short by a monitor attached to her forehead. *What is this one for, again?* I look over this baby before me and can barely see skin beneath all the medical equipment. Chest tubes and stitches and dressings. Monitors and IVs and defibrillator pads on each rib cage.

This is too much. Too much to look at, but I do not dare look away. If she must endure it, I will remain steady. If she must bear these scars, I will tend to them. If she is broken but still in one piece, I am too.

Minutes pass by slowly. But soon hours do as well. She stirs to cry periodically as the anesthetic wears off, and I sit up from my chair to hold her hand again, to put my mouth to her ear, to shush her still and back to sleep. Sometimes she drifts easily to sleep again. Sometimes she fights it and her body is frantic. More drugs are given to keep her comfortable, to keep her still.

And this process continues, James and I alternating in soothing her, in keeping her asleep and at rest.

We step away for coffee once we see a pattern in her waking, timing it to be back again before she stirs. Eventually, cautiously, with the coaxing of the nurses, we decide to get some dinner. The next couple of days will be difficult, and we know from experience we need to be replenished and fuelled to get ourselves through it as well. We don't go far, not tonight. We sleep at a friend's house a short distance from the hospital. With our phones beside us, alarms set to be up for morning rounds, we crash with the whole weight of the day on us.

Many memories are still painfully, brilliantly fresh. Scenes that play over and over in my mind, as if time had slowed down so I could remember each detail. Other times, so many monotonous days in and out, have hazily blended together. At the time I thought I would want to let a lot of it go, as if holding on to it would just hurt me again and again. But the truth is I would take the hurt to remember each detail by her side. I would take the disappointment to experience her bravery and strength. I would take the fear to know love like this.

[17 months old]

I SEE YOU

Love is the flower of life, and blossoms unexpectedly and without law, and must be plucked where it is found, and enjoyed for the brief hour of its duration.

D. H. Lawrence

To the ICU families:

I. See. You.

It amazes me how many of us are back and forth through these hallways each and every day. These lonely hallways that stretch on and on. The hard-surfaced floor that we stare at, as we walk to and from, day by day, to see our loved ones. That heavy ICU door constantly opening, greeting each entrant with a stainless-steel sink and a large poster on the walls about handwashing and germs. Some of us are in and out before we even have a chance to see another caregiver's face. A traumatic

entrance and a quick exit, and we don't take a moment to look back. Others sit at their assigned bedside, watching the revolving door, wondering when it will be their turn to be upgraded out of here. Before joining this chorus, I didn't think about you. I didn't realize that these brave people existed, that so many lived this heartache and waiting and wishing within their everyday lives. Parents of sick kids. Grandparents to fragile babies. Foster moms and boyfriends and sisters and brothers.

So many stories absorbed into these thin walls and curtains between us.

There is a dad that comes in every night after a long day at work. His daughter needs someone familiar with her always, so he comes after work so his wife can go home to sleep. His wife has been there all day, all week, too; we pass each other in the hallway often. In one instance, we speak briefly while waiting for the washroom on our "coffee breaks," as another mom reaches past us into the fridge to get a snack. At night, Dad reads his daughter books brought from home and eases her up to take a few sips of water. These two are quiet and consistent with their care, routines that seem to have been in place for a long time. Eventually she overcomes whatever brought her here, and they go home. But I get the feeling they have done this many times before and will likely do it all again. These are the seasoned parents of an ICU child.

A BRAND-NEW BABY IS BROUGHT IN, a couple beds over, as I sit beside my sleeping year-old girl. Birth was just moments before, and the babe has bright lights in her face and wires coming from her body. He's a father for the first time and, instead of

holding his girl, he is holding onto words. Words that likely don't make any sense in this moment but will reveal themselves to him and his wife over the next few days. "Your baby girl's heart isn't right. She will need surgery."

I feel a rush of emotion as I relive those moments myself. When your brain is telling you to pay attention, you need to hear this. But your body is rejecting the reality of those words; it just wants safety, normalcy. To touch your baby, to feel the flesh of your flesh, to soak in whatever good you can in this moment of grief and uncertainty.

EVERY DAY, THE MAMA WHO ISN'T MOM comes to sit by her babe's bed. She reads a book in the hospital's wooden rocking chair, alert and ready to stand when her baby awakes, or when a doctor passes by with more to say. But there isn't much to say. This mama who isn't Mom has to wait, so she continues to, day after day, waiting for her child to breathe on her own again. She asks questions, participates in morning rounds. I can see her advocating for the very best care. This mama who isn't even Mom loves like it's her own. And respectfully stands aside when Mom herself makes an appearance. She is brave, and I know her child, yes, her child, will be brave because of her.

THEIR CHILD IS SLEEPING FREQUENTLY, so there isn't much for them to do. Perhaps sedated? I cannot tell as I peer across the span of the ICU. This couple comes together still, hour after hour, and just sits, side by side. They don't say much to each other, or to the staff around them. They hold hands as they stand up to go for coffee. I see them in the line, and they speak just to

place their order. I wonder if it is a cultural thing, that they are so silently enduring. Or perhaps it is just where they have found their strength, quietly sitting and waiting. They seem content, respectful even, with the process they find themselves in. This process of healing and coming to wholeness, it takes time and patience.

THE CURTAIN IS CLOSED but there are just a few feet between us. A boy who isn't a boy, because he is the size of a man, lies in the bed, his feet almost hanging off the end. His mom is on one side, Dad on the other. I get a glimpse of the wires lacing his scalp, the blankets piled on to keep him warm. He is intubated, and I hear the familiar sounds of a ventilator doing the work of each breath. I don't want to listen, because it hurts my heart, but I hear as his dad begs him to live. "Please, Son. Please. Wake up, Son, do you hear me? Can you hear me? Please my son, please wake up. Daddy's here. I'm right here, Son. Please wake up." Mom strokes his hair, her face to his face, breathing him in, sniffling back her fear. And I cannot help but embrace their pain as my own, to take it on myself. A lump forms in my throat and suddenly my face is wet as streams fall from my own eyes. My spirit begins to beg as well, please Boy, please wake up. Please Boy, come through. I don't mean to be nosey, but like I said, they are just feet away from us, only a curtain between. He's obviously a cardiac patient, because he is with us on the cardiac wing of the ICU, but I've seen neurology come by as well. It seems they are concerned about brain activity. It feels like an eternity as this family sits and cries and begs beside us. Aunts and uncles, siblings and friends come to squeeze his

hand and to offer Mom and Dad a shoulder.

Less than a couple days later, their boy pulls through. And this boy, who is more like a man, learns that he went into cardiac arrest and collapsed on his kitchen floor. And his family, his brave and boisterous Italian family, they saved his life with their timely response and CPR. He's going to be okay. But he is now a cardiac child himself, for life.

A BABY FUSSES AND CRIES CONTINUALLY a few spots down. The nurses say his grandma spoils him, as she jumps to his every squirm and need, picks him up and soothes him. Again and again she does this. Even while he refuses to quit crying throughout her rocking, bouncing and singing. This is her foster grandson, though, and I imagine he hasn't had enough of someone jumping to his needs in his little life. So, she does what she can to give him this unconditional, unreserved love. And I think it is one of the most beautiful scenes I will ever witness.

A CHILD MOANS AND SOBS, all day long. Sometimes there are words: "It hurts, it hurts." Her curtain is drawn but I can see right through it. I can see the strength her mama has, to hold her child's hand through this. To sit, helpless, while her child is reeling in pain. To have nothing more than your heartbeat to rest your child's head on for comfort.

Frequently a knowing nod and a pained smile are shared between parents. We pass each other, and our eyes meet.

Sometimes a conversation starts.

Mostly there is just an essence about this place. A sense of humanity in its most raw and vulnerable form. Each of us

walking through intimate moments in public spaces, with others who understand the depths of this pain. With others who understand the weight of this life, and the fight for it.

I find myself listening to conversations. Private conversations, between doctors and their patients' families, many of them experiencing all this chaos for the first time. I listen, and I cling to any resemblance of common ground. As if their struggle, when connected to mine, relieves the weight we all carry just a bit. I hear someone beside me with the plastics team, also on the cardiac wing. There is a connection between us, and I need there to be this connection. Another, our dear neighbour, has a tracheostomy; our bonds are wrapped tight.

THERE IS A SOUND THAT RISES above the usual chatter and cries and machines humming here. It is infrequent but happens more than it should. Unexpected, but everyone knows what it means.

I had never heard anything like it before. And I wish I could say I will never hear anything like it again. But that isn't the case.

The first time a child died in the PICU, I was sitting beside Evelyn's crib, unaware of the happenings around me, as I, probably, engaged in some meaningless task. Scrolling on my phone, flipping through a book. Evelyn was recovering from her surgery and slept frequently throughout the day due to the various drugs pumped into her system. All day I had noticed a bigger crowd coming and going from the bed at the other end of the cardiac patient row. The curtains had been drawn for a while, which wasn't entirely unusual as families tried to give themselves or their child more privacy. Sometimes procedures

were being done, or the patient was trying to dim the light to enjoy a nap in the middle of the day.

Being in this open space means we see and hear everything. I see children wheeled past me fresh out of surgery. Babies brought in straight from the delivery room. Families visiting their loved ones. Caregivers pouring their hearts and souls into the healing processes. So much devotion by the staff, nurses, doctors and care aids alike. Even the receptionists are invested in the stories and outcomes of the little, and sometimes much more grown, children who move through here.

We are reminded multiple times throughout our stay that this is the paediatric intensive care unit attached to one of the largest children's hospitals on the West Coast. Those who find themselves here are the sickest, most complex, most battered patients in the province. This is the worst of the worst. This isn't a casual healing room, where meds are given, time passes, and everyone goes home.

Here, some don't go home.

This open space. There is no privacy here. Curtains pulled, paper walls put up, a select few with doors to close, but no real privacy.

I have come, in some ways, to appreciate, to long for, even, the connectedness experienced in such a wide-open space. But connectedness makes this a much more difficult space to inhabit. The air is thick with pain, creating a level of humanity that wouldn't otherwise be experienced. Being present, aware of, or a bystander to another stretches you, pulls you into a story you wouldn't otherwise, willingly, go towards. In that stretch, your empathy grows, and your ability to stand beside another in their affliction matures.

Five patients died in the ICU while we were there. Five patients. Children and babies, all with loved ones left behind, stories left unfinished. Between post-op to heart surgery, our six-week stay, and our frequent readmissions, we were present for a lot here. Crash carts pulled rapidly to beds, procedures taking place beside us, and the terrible sound that death makes—the sound of those left behind.

A wail like I have never known. A deep lamenting moan, blended with sharp piercing cries, as a child exits this earth. For some the cry goes on and on and on, drowning into the earth beneath them. For others it is loud and quick, startling themselves and us bystanders, and then silence. Silence that can be heard, taking up dense space among us. The silence of bodies crouched, rocking and shaking. Silence in white-knuckled fists, skin shaking on the bones. Silence but for the heartbeat in their own body, here, left on earth.

Our neighbour in the ICU is in bad shape. She has a trach and ventilator, and I know what a complex combination this can be with any type of cardiac condition. I learn her lungs are very damaged, but I feel hope for her. Her beautiful doll face. Her wide-eyed, terrified parents. I feel hope for them. She will come through; I believe it for them as we will our own girl along through her healing. I offer Mom a warm smile. And when she seems ready, I try to give an encouraging word. She sounds hopeless, though. She has given up. She is not sure they will ever bring her home. No wonder they struggle to come each day, to sit by the bedside of their very sick girl. I understand now why they need compassionate coaxing from the social worker to be more present and involved in their daughter's care. They have lost

hope. So, I try to offer them some of ours. They see our girl, also a cardiac patient, also with a trach, and see how she is strong and thriving. Sitting up in bed and smiling at every passerby. I think they come to accept this hope; they embrace this gift they see of what could be, of looking into a possible future of their own.

As detached and fearful as these parents are, their baby girl has the most darling dresses stacked on her shelves. And the nurses bathe her in a bath that was not supplied by the hospital. There are bubbles in the water and a small shower head attached to complete her nightly spa experience. These parents fear with genuine love. These parents hope with desperate need.

"I don't know. I don't know if she'll make it." Neighbour Mom tells me as we both wait for the bathroom in the ICU parents' lounge, a common place to meet at each other's level. The microwave beeps behind us; someone is making their lunch.

"Have hope. Keep showing up for her. She is still here." I don't know if my words have any weight. I don't know if they are helpful or true. But they are the same words I told myself last year when we were in the NICU, and I was unsure that we would ever come home. *She is still here.*

Their cardiac surgeon is stubborn, the same stubborn man who cares for our girl. I have overheard, in snippets of conversations, that many have already suggested hospice. There is nothing more to be done. Rounds at her bedside are tense. Frequently they discuss her previous night and a code was involved, more drugs had to be given, ventilator settings adjusted. Students and residents have nothing to add to the conversation. This patient is a learning opportunity for them, but she has been here for four long months. They will participate in reading out her lengthy

history, but none of them will understand the depth and details within. The intensivists and the surgeons discuss care plans, often butting heads. But Dr. G is determined. He is not giving up. "Let's try this." "Let's try that." Something has got to stick. I can see his mind grasping.

We gave them hope. Evelyn gave them hope. And then it is ripped away.

We smiled at each other as we stood over our children's beds, day after day.

And then we never saw them again.

James was there the night it happened. He watched and heard the whole of it unfold. Baby girl. Cardiac baby. Trach baby. Our kindred friend in this space.

As he rocked our own to sleep in his arms, the baby a few feet over is falling into her forever sleep.

"She is beautiful," he hears Mom and Dad say, as they witness their darling, free.

I WALK THESE HALLWAYS COUNTLESS TIMES. Back and forth between the ICU doors and coffee shop and cafeteria.

Eyes downcast, it is easy to think that you are the only one experiencing such heartache and difficulties. It is easy to think that you got dealt the only short end here. In fact, sometimes it is nice to think that what you are going through is unique, that you are conquering more than most will ever experience or understand. That you are somehow special in your suffering. But the reality is that none of this is unique. This story is actually quite unremarkable. It is not to say that Evelyn is unremarkable, or that what we have experienced is anything less than what it

is. But we are not alone in this. We certainly are not the only ones to have experienced these lonely hallways. We are not the only ones to shed tears over our child, to beg our child to keep on fighting. To put our child's life into the hands of doctors, into the hands of God, repeatedly.

No, this story is nothing special. It is the same as dozens of other parents walking these halls on this day, and the thousands who have walked them over the years. There is nothing unique about being a parent of a sick child. There is nothing heroic about a medical diagnosis; they are all shit. We do not get a gold star for showing up every day. There is no grand finale or ultimate finish line to cross. Just a series of victories and setbacks, intertwined together in an unpredictable pattern, while we tread the waters of an ever-changing current.

It is the same whether someone has been fighting by their child's side for mere minutes, or this is yet another admission after countless ones before. We will all carry these memories in our bones. We will all crack at the thought of them. And we will move on, and through, in the best way we know how.

PUMP

I used to think
the opposite of control is chaos.
But it's not.
The opposite of control is surrender.

Erin Loechner

I was fierce while delivering Noah. I didn't just feel strong, I felt powerful. Like the pain gave me power. Tenacious, steadfast power. My body did its thing while I willed it forward and James encouraged me on.

In the middle of pushing, though, I hit a wall. After labouring all day, Noah rocking back into my pelvis during the pause between each push, I breathlessly exclaimed, "I can't do it. I don't know how. I can't do it anymore."

"Yes, you can. You can! You are so close," my midwife says. "Laesa, look." She holds my hand to brace me up so that I can

see the reflection within the mirror in her hand. "There is your son. He is right there. Let's get him in your arms now."

The power welled up within me once again, and Noah was delivered soon after I saw the top of his dark curly head. I wanted him in my arms more than I wanted to avoid the pain of getting him there.

And into my arms he came, immediately. Umbilical cord still attached, he was placed on my bare chest. A stark white towel was used to pat him down, the placental liquids falling off his body. I cradled him securely against me, his cheek resting against my swollen breast as my head fell limply back against the angled bed beneath me. My eyes welled and a grin moved across my face as I caught James's gaze. *We did it.*

"Look what we made. He is perfect!"

Noah nursed right away, using my nipples for sustenance and comfort, suckling long after my breasts were emptied. After resolving an inefficient latch, it was smooth sailing for us. Well, sorta. Though lack of supply was never an issue, I instead swung to the other side of the pendulum with an over-abundant supply of milk. It was helpful so that I could pump and freeze, James could feed him with a bottle, and I fed him his freezer supply even after he self-weaned from the breast. It was not so helpful in that he often overfed, resulting in reflux after almost every meal. At the time I thought it was just normal baby behaviour to spit up constantly. Knowing what I know now though, I am sure that wasn't the case. Regardless, he breastfed beautifully once we got past that four- or five-month mark, and he weaned himself just a couple weeks shy of his first birthday.

Though engorged breasts and being attached to a baby at such regular intervals throughout the day is exhausting, it was so special to me. I remember pulling Noah into bed in the wee hours of the morning to nurse. His chubby baby fingers found my skin, pinching and stroking my neck, breast, arm or whatever he could grab; his eyes closed as he passionately pulled milk into his mouth. As he grew, he pulled my shirt down to help himself throughout the day. Nursing him at night while we rocked in his chair always lulled him to sleep. I enjoyed our skin connecting. I enjoyed him needing me so fully, bringing him nourishment and comfort.

When Evelyn was born, a feeding tube known as an OG, or oral gastronomy, tube was inserted into her mouth. It would normally have been placed through her nose, but they couldn't get the tube through her tiny nostrils. I didn't know how long she would need it, but it was obvious she couldn't nurse, or take a bottle, with a breathing tube down her throat. I hoped that once she could breathe, once she was big enough, once she was stable, we might have a chance at breastfeeding.

At the start, I pumped not just for the benefits of giving her breastmilk, but with the hope that she would eventually nurse, and my supply would be there waiting for her. I felt like, as long as my breasts continued producing, I could continue giving her the best of myself to grow with, and there was still that chance that she might nurse the way I had always imagined. As time passed, I knew this was less and less likely, and when we found out about her cleft palate, I knew it was unlikely she would be able to latch. My dreams of breastfeeding my second baby faded as her complex needs became clear.

I kept at it anyways, for more than a year. At first, I pumped every four hours, around the clock. My body had no problem keeping up with supply. It was at least a 30- to 45-minute process each time, a bit faster when I was pumping at the hospital with their hospital-grade pumps that I could attach to both breasts at the same time.

Looking back, I am not sure how I willed myself to continue on. Those first few months were exhausting. I think I just kept telling myself, *a little bit more, a little bit more.* And before I knew it, months had passed, and I had fallen into a routine. I stayed up late to pump before falling asleep, only to be woken by my alarm three-and-a-half hours later to do it all over again. Each time I pumped, labelled and stored the milk, then tediously washed and dried each of the bottles and pump pieces. It was monotonous. Dull. So many hours of scrolling social media and interacting with people happened while I was attached to the pump. Over time, it became more manageable. I stretched my sessions to every five hours, then six; then I was able to give up the middle of the night pump altogether. By the end of our stay in the NICU, when Evelyn was four months old, I was pumping five times a day. Once at home, three times at the hospital, and once before bed. This routine quickly changed when we got home, though, as I couldn't fit in this much sitting by myself each day. Instead I pumped every time Evelyn napped. Which meant I didn't have time for Noah, and I wasn't eating properly or getting any downtime. I trusted my supply, and I remembered Noah nursing only four times a day when he was about eight months, so I spread out the sessions even further. Thankfully,

the milk continued to flow, in large volumes, fewer times throughout the day.

Our dietician was continually amazed by how well Evelyn was growing. Because of her heart condition, she burns more calories than most, but somehow my milk provided enough nourishment to keep her thriving. Roll after roll began to form on her thighs and forearms; her pudgy belly spilled over her diaper. At one point she had three chins hiding her tiny jawline.

As her first open-heart surgery approached at 11 months, her doctors were happy with her body fat reserve, as she needed it to withstand surgery and for an optimal recovery afterwards.

I was proud of this. Proud that I did this for her. That I got her to this point. Though I knew breastfeeding was not going to be an option, this was as close to it as I could get. And I was happy to do it.

The day following our first hold in the NICU, my breasts engorged even worse than they had with Noah. It was severe, like I was carrying two hard, hot footballs on my chest. I couldn't sleep because of the pain, and James often found me in the shower in the middle of the night, crying and desperately trying to deflate my chest, hot water pouring over these foreign objects attached to me. The nurses in the NICU paged the lactation consultants, so someone besides Google could offer me some assistance. "They won't be back until Monday morning," I am told on a Saturday afternoon. Excruciating, disheartening days.

I looked up remedies and relief treatments. Ibuprofen. Hot and cold compresses. Massage. Cabbage leaf.

Cabbage leaf?

I googled some more. Apparently, this is a real thing. So, I bought the cabbage. I pealed one leaf off and placed it on the right side. Then another placed on the left. The cold cabbage, right out of the fridge, offered instant relief. And as it stuck to my chest, some magic exchange occurred; 24 hours later there was a noticeable difference. I didn't tell many people how I got through it, but if they had looked closely, they might have seen the wrinkly cabbage leaf through my shirt, or even poking out of my top, as James once noticed as he made me tea on a Sunday morning.

I hold Evelyn in my arms in the afternoon. Finally, we have settled into some sort of rhythm. For more than a few days now, this has been a regular part of the day.

I empty my breasts first. And my bladder. Then come back to the room with a gown to wear and towels for propping and supporting us both. Instead of sitting in the chair, waiting to receive her in my arms, I am now allowed to pick her up myself. I lean over and reach into her isolette, carefully sliding my left hand beneath her torso. She is so small I can lift her head with just my fingers, the weight of her shoulders in my palm. My other hand goes under her bottom half, navigating between a feeding tube, SAT monitor and the lead wires. It finds its way to the bed surface and slips easily beneath her bum. From here I pick her up and ease her body towards my chest, pressing her securely in place before lowering myself into the seat behind me. I lean forward and allow my butt to lead the way, looking for its blue plastic landing place that we lock in place beforehand. My nurse and RT are on either side of me, holding all the bits and pieces attached to my baby, ensuring nothing snags or

pulls along the way, ensuring especially that her breathing tube remains safely in place.

My grasp does not loosen once I am seated. My shoulders tense, I allow pillows and rolls of towels to be stuffed and fluffed around me. I slowly release my muscles, my hands in their original positions, still supporting and pressing her securely against me. They remain this way for the duration of our cuddle. No squirming, shifting and slumping. Just holding. Actively holding.

Once our nurse and RT are done fussing over us ("Does this feel good? Is that arm supported enough? Do you need one more pillow?") and fastening the various bits and pieces coming from her body to a now immovable structure called Mom, we are left alone.

The week of her due date, when she is two months old, it is as if she wakes up. I have her on my chest, as always. Her head is turned sideways, cheek resting on my sternum. Today, though, today she tries to move. A deliberate movement, lips gently bouncing atop the tube in her mouth. She is looking for my nipple. The milk is soaking through my gown a few inches from her face, and she is rooting for it.

What type of newborn would she have been, I wonder? I will never know. There were no coos and afternoon naps together. No mouth at my breast and sweaty hands caught in my hair. But she wanted it. I think she would have wanted it.

The rushing between rooms and ritualistic pumping and painful engorgement was worth it. It was all worth it.

I was proud of the milk I produced.

It was my contribution. It was the only part of me I could consistently give her. The only part of me I felt she truly needed, that she could truly use. I cannot be by her side at every waking

and sleeping moment. I cannot pick her up and hold her at will. I cannot tell her it will all be okay, that Mom and Dad will protect her. Because really, this is her fight. But I can give her my milk. I can give her this piece of me. I can help her grow and stay healthy and have the best nutrition available. And I am incredibly proud of this.

After we are home for a short while, when no one else is around, I attempt putting Evelyn's lips to my nipple. I've just finished pumping and there is a creamy residue waiting for suckling. I hold her head in my hand, as I would to prepare a newborn to nurse, and let the milk lather her mouth. Her lips do not part like I thought they might. She turns her head away instead. Unsure of what to do with this. Her instinct to root and search for her mom, gone. Her desire to suck is satisfied by the soother plugged in her mouth.

She can hardly handle the saliva in her mouth, Laesa. What made you think she might take to your breast?

Two days after Evelyn's open-heart surgery, one of her chest tubes starts discharging a cloudy liquid. Chylothorax, we are told it is called. For short, the medical staff call it "chyle" or "chylous." During our pre-op appointment, weeks before, we had been told about this possible complication following surgery. It is a rare and unlikely occurrence, simple to treat. Tedious, we were warned. But simple.

Most of the time.

Chylothorax is caused by an injury and pressure imbalance within the chest cavity. It causes pleural effusion, or fluid leaking from the lymphatic system, the system that transports fatty acids and fats from the digestive system.

The best, simplest way to treat chylothorax is to restrict fats. My fatty, high-calorie breastmilk was suddenly detrimental to Evelyn's health.

Once the leak has healed, we could go back to the breast milk.

This isn't the first time Evelyn couldn't have my milk. Many times in the NICU, she was sustained with "total parenteral nutrition," administered into her veins rather than her feeding tube. When this happened, I continued to pump, store and wash, keeping my supply ready for her for when she could digest it again.

This seemed just like that.

It wasn't, though. Save for five days, five months from now, Evelyn would not receive my breastmilk ever again.

It takes me a month longer to recognize this fact. To be okay with it.

I had envisioned pumping and giving Evelyn my breastmilk for well past a year. She was growing so well on it. And I knew that it was the best thing for her. It was my contribution to her care. I didn't quite know how much longer I would do it, but I planned to stop when I was ready. When I decided I had had enough of the pump and there was a new plan for her nutritional needs. I never guessed that this would be taken from us too, that once again I would have no notice or say.

In this month, in my stubbornness and denial, while we are discharged and readmitted multiple times for SVT episodes and reaccumulating chylothorax, I continue to pump. I continue to store milk in my freezer, washing and scrubbing each piece of equipment for use. Unaware that it is futile, that there will be no need for it. I shrug off the inconvenience; it is just a few times

a day. Once when I wake, once at the hospital, and once again before bed. A completely manageable schedule. If anything, I have come to enjoy the routine that it forces onto my day. And, strangely, I enjoy sitting in the closet-like pump room at the hospital, the one attached to the PICU waiting room.

Often, I sit here with a sandwich or wrap in hand, my break in the day from the ICU bedside, while the hospital-grade, double-pump wizard does its thing. *Womp. Womp. Womp. Womp.* I enjoy this small space, strangely. The dim light over the sink. The rickety wooden chair that I sit upon. I enjoy having all four walls within my reach after spending so many hours in the open ICU with only curtains to ground me in space. *Womp. Womp. Womp. Womp.* I enjoy letting my face rest how ever it pleases. No pleasantries or forced grins, for strangers and comrades alike. I take deep breaths here, many deep breaths, sitting in this room. I let tears roll down my face. I patiently let them fall, giving each drop the moment it needs. Then I wipe them away. Casually. Matter of factly. Sometimes, though, for no particular reason other than the ocean behind my calm face and a lack of space in which to truly feel, I sob here. Heaving, holding my own chest, sharp gasps. My private space, my private moment in the day.

I do not cry for long. I won't let myself. Let it out, sure. But I cannot get stuck here or the rest of the day will be like walking through quicksand.

I saved milk in those weeks, the milk that I pumped at home. I'd pour it into its little storage bag and stash it in my freezer. Watching the dates on each bag, counting months and hoping it would get used before the expiry neared.

I had asked our dietician a couple times, casually, during that first month off breastmilk, if she thought I should stop pumping. I think she could tell how attached to it I was, how much I needed to do this, so she gently told me she would never tell me to stop. If the chylothorax resolved itself tomorrow, breast milk could be an option again in a few weeks.

But it didn't stop. And after being admitted again and having to take Evelyn off any tube feed at all while the TPN was pushed through a central line, I knew this wasn't going to end easily. Or soon.

I can't recall the exact day, in the timeline of events, but I vividly remember asking our dietitian in the middle of that six-week stay, "Is it time for me to stop? Am I pumping for nothing now?"

"I won't tell you to stop," she says again, still sensitive to my feelings. "But it could be a long time before Evelyn is ready for your milk again. A very long time."

So, it is time to let it go. To put the pump down and put this season behind us. I know it now. I am ready now. My heart hurts and the tears come as I recognize this place.

"You've done really well, Laesa. You have given her the very best. And she has thrived because of it. She came into this surgery strong and sustained well, with so much reserve to push through this next hurdle. That is because of you. You can be proud of that. Feel no guilt about stopping now."

Feel no guilt.

EMERGENCY

i hate

that i cannot heal you.

all i can do

is love you.

Danielle Doby

"Hello. This is 911. What service are you in need of today? Police, fire or ambulance?"

"Ambulance. Please. I need an ambulance for my daughter."

"Okay, an ambulance is being discharged to your location now. Can you tell me what the emergency is?"

"My daughter. My daughter. She is. Um. She is unresponsive on the floor."

My tongue stumbles with every word.

Oh my God. Oh my God. What is happening? Why is this happening?

"Okay, ma'am. Stay calm. The ambulance is on their way. I'm going to stay on the phone with you until they get there. Okay? Can you please give me more information that I can send to them? Is she breathing? Can you tell me if your daughter is breathing?"

Breathe.

This is the second phone call to 911 this week, the last just three days ago. Different symptoms, different time of day, but the same panic, the same backstory, the same angst.

"Yes. Yes, she is breathing. She … she is medically complex. I have her hooked up to her O2 sats and heart rate monitor right now. Her heart rate just kept dipping; she's hovering in the 40s now. Um. This. This. It isn't normal."

I can't get my words out.

Tremor. Gasp. Blur. Pull it together, Laesa.

I leave the room to go pace outside. As if standing there to welcome those in uniform will make them arrive sooner. I also cannot think straight staring at my baby on the floor while my mother-in-law kneels over her, calling her name and praying fervently. I need to give a report now. Her charts, her life, it is all categorized in my head. This is my reality as a medical mom. There is no time to weep over a limp body. I need to act. Practicality and preparedness; I need these paramedics on their A-game when they arrive.

If I don't do it, who will?

I gather myself and start spewing it all out. I've listened to enough reports to know how to give one myself.

"Evelyn. Her name is Evelyn. She is currently 11 months old and is an ex-32-weeker. She has a single ventricle heart

and is three weeks post-op, an open-heart surgery, the Glenn procedure, performed by Dr. G at BC Children's. She has Wolff-Parkinson-White syndrome and is at risk for SVT. We were discharged one week ago from Children's, after an 11-day stay that included multiple SVT episodes, during and after surgery, and chylothorax. We have since been in hospital again, a couple days ago, due to an SVT episode that occurred at home. She was discharged the same night on a new medication, propranolol, prescribed by her primary cardiologist to regulate her heart rate. We just saw her cardiac surgeon and cardiologists today in clinic, and she was put on an alternate medication for her heart rate, flecainide. She received her first dose of flecainide 60 minutes ago, at 4:30. She woke up from her nap at 5:15, 45 minutes after the dose was given. She was playing normally at first, then seemed a bit off. Not sitting up very well, kind of spaced out. I picked her up and she started vomiting. I placed her on the floor, on her side, to suction her. Oh yes, she has a tracheostomy as well. No vent, no oxygen. But a trach tube for a stable airway, secondary to Pierre Robin sequence. Anyways, I suction her and clean up the vomit. That's when she started going limp and her eyes were closing. I hooked her up to her monitor and watched her heart rate drop, from 100 to 80, to 60. It is now hovering in the 40s, as I said. Her oxygen saturations remain just below her normal range; she is at 68 to 70 percent right now. Normal for her is between 75 to 85 percent."

"Okay. Good. Thank you. Can you tell me again, is she still breathing?"

I've been pacing outside this whole time.

Is she still breathing? How could I let myself walk away from her? What an idiot I am.

I rush back in. My mother-in-law is still trying to wake her up. But, yes, she is breathing. Her sats are okay and her heart rate has not dropped any lower.

"Yes. Yes, she is breathing."

"Okay, your response team is just a few minutes away. I will stay with you on the phone until they get there. Please let me know once they have arrived."

"Okay. Okay. Yes."

"Can you tell me what other medications she is on?"

"Yes. She is on omeprazole. Iron supplement. Lasix and spironolactone. Previous to the dose of flecainide given today, she has been on propranolol 4mg three times a day.

"They are here. I can hear the sirens in the neighbourhood. The fire truck is pulling onto our street now."

"Good. The ambulance will be right behind."

I realize that Noah has been sitting on the couch, watching this all unfold. He stares at me blankly.

"The ambulance is coming to help your sister, Noah," I say with the phone still to my ear. "She will be okay. They are going to help her. Don't be scared, sweetie."

A sweet nod.

My mother-in-law tries to shoo him upstairs to go with Haraboji, out of the way. But he won't budge. "I need to watch my sister. I need to stay with her."

I let him. "Stay on the couch, Son. Keep out of the way. It's going to be okay." I try to look him in the eyes as I say this, willing assurance onto my face so he believes me. But I don't

believe me. There is no time to be sure of what I believe in this moment. I certainly cannot believe that my baby girl is crashing right here on our living room floor.

As they come through the door, Evelyn starts to move. The timing is impeccable. She squirms and then vomits again. As I clean it up and suction her trach and mouth to be sure she isn't aspirating any of it, her heart rate begins to climb again. I watch the numbers rise, bit by bit, now inching higher than her norm.

What is normal anymore anyway?

I give the same report, all over again, as the paramedics and firemen flood into the room with their heavy boots and booming voices, carrying their own monitors and oxygen tanks. I answer questions as I move, suctioning her and gathering our belongings to get out the door. Each response is thorough; I'm careful not to miss any detail. We can see her heart rhythms bouncing on their screens now, and though I know a lot about medical terms and the complexities of my daughter's case, I would not pretend to understand these images. The paramedics are perplexed by it, though, disturbed. The gaps are wider than they should be, or was it narrower? Anyways, it is not as it should be.

None of this is as it should be.

We make our way outside and toward the ambulance to load ourselves in. Before the back door closes behind me, I shout back to my mother-in-law to call James, to have him meet me at the hospital. I will not have time to get on the phone between here and there. I lay Baby Girl onto the stretcher. She is mostly alert now. She doesn't cry or make any fuss—there is just a curious frown between her brows as she takes in this new

scenery. I stay right beside her the whole time, letting her wrap her hand around my finger, and I try my best to soak in a bit of her bravery for myself.

Three days before we were loading into the back of an ambulance the same way. Big heavy doors swung wide open and a stretcher carried down to hold its small passenger.

We were just a few days home from the hospital when she went into SVT. If she hadn't been already hooked up to her monitor, we might not have even caught it. Not right away, anyways. Most people have symptoms when they are in SVT. They look uneasy; there are sweating and dizziness. At this age, Evelyn is what doctors call asymptomatic. But she was on her monitor at the time, as her nurse was putting her to sleep, and it started to alarm as her heart rate reached 280 beats per minute. The nurse called James and me, and not one of us could believe that the monitor was correct. Surely, she would be in distress with her heart rate so high? We turn it off, reposition the tape sensor on her foot, and try again. Still, it is at 280 bpm.

OMG. This is happening. Now. How is this happening? Why?

James holds Evelyn while I get on the phone with 911. Giving my report, the backstory for our medically complex little girl. Her heart rate regulates and then jumps back up again three times while we wait for the paramedics. They come, we pile into the ambulance, James races behind us, we arrive at our local hospital. Not Children's Hospital, three cities over.

I am used to people who know Evelyn, who know James and me. Nobody here does. And it is quickly evident as we are wheeled into the paediatric ER trauma room that this will be the most interesting case they see all week. The room is flooded

with bodies. Unnecessary bodies, as far as I can tell. We need one nurse, okay maybe two, one RT and one doctor. Instead there are multiples of everyone, curious and staring and wide-eyed, as I go over her history.

I inform the doctor in charge that he needs to page the on-call cardiologist at Children's, as her team there has requested we be in contact during an emergency at any other hospital. My request is brushed off. Moments later, when I see no one has moved for a phone, I ask again. This time to the whole room.

"Can someone standing around here please get on the phone with cardiology at Children's?"

"Don't worry, Mom. We will call them as soon as we get your daughter stable," says the overly confident doctor with no specialized paediatric cardiology training, about stabilizing a complex congenital heart patient just a few weeks post-op and in severe tachycardia.

What!?! No. They should be involved in this stabilizing process. Why won't you do what I ask?

I am too polite, too timid to say this out loud, though. We are supposed to trust doctors, right?

I should have called myself and put the phone to his ear. But my phone is in her diaper bag, which sits on the floor at the entrance to this room. And I am needed here at her bedside. The respiratory therapists are useless here. They all look like they just graduated. A tracheostomy should be second nature to them, no? Instead they fumble with suction catheters, handling them improperly, and give care suggestions that are not relevant. I think they are trying to act helpful, but they are not, so I take on the role of RT until James arrives, while answering all

of the questions of the charge nurse and trying to get through to this pompous doctor.

As he stands back staring at my daughter's numbers, which are still sitting in the 280 range, he holds his chin, in awe of what is before him. "Hmmm. Interesting. Have you tried any vagal methods?[8] Should we get some ice? It is amazing that her heart is functioning like that."

No shit.

"No. Not this time. It has been tried before, and she does not respond to vagal methods. No, she needs adenosine. She requires 0.3 milligrams per kilogram of adenosine."

This amount of that drug is not standard practice. In fact, it is three times the amount that is suggested, especially for a paediatric patient. But we have done this before, and it has been established that Evelyn requires a larger dose.

"Okay, Mom."

Mom. What they call you when they don't take the time to learn your name. In this case, it also seems to emphasize their unwilling-ness to take me seriously.

"We'll get the adenosine. But you must be mistaken about the dose. Let's start with 0.1mg/kg, and if that doesn't work then we can try Mom's suggestion."

It wasn't a suggestion. It was a statement. But I let them try it their way. The IV is started and they push the adenosine. Awkwardly. The nurses here clearly don't do this often, as they talk through the steps a couple times before giving it a go.

It doesn't work.

8 *Vagal methods: Shocking her cardiac rhythms back into place by smacking a cold bag of ice on her face or tilting her upside down. Apparently, it works for some. Not for her.*

"Just give it a moment, sometimes it just needs some time," says the doctor I am now starting to think is totally incompetent.

Adenosine is a fast-acting drug. It enters the bloodstream and works instantaneously. If there is no reaction, it is because the dose is wrong.

This dose is wrong.

They finally give the dose I told them she needed. The dose the experts at Children's told me would work and that I witnessed in action just over a week ago.

"Okay, it is time to get this chest tube out," Dr. G tells me. "When I put this one in in the OR, she went into SVT. She did not like me touching her heart. It wraps around and behind the heart, like this," he explains as he motions his finger moving around his fist, "so it is going to touch her heart on its way out, like this. I expect she will go into SVT, just as she did then."

I nod along. I understand this means her heart will beat fast. I'm not sure what else to expect. I have never seen her, or anyone, in tachycardia. The crash cart is at the foot of her bed, ready to go. It has been there since she came out of surgery two days ago. And the adhesive skin protectors have been ready to go, on the sides of her chest, since she came out of the operating room too. There is a bag of ice placed on the table and the nurses are drawing up a medication behind the surgeon, preparing multiple doses of something I have never heard of before. Adenosine. I am told quickly about this fast-acting drug, and how they will try it to shock her heart and bring it back to its normal rhythm. The crash cart is ready if it doesn't work, or if there are any adverse effects. *You mean if you shut down her heart completely?* I'm surprised they are letting James and me stay here

for this. I think they know they can trust us to soothe her, to stay out of the way if needed, and not to panic. *Don't panic,* I remind myself.

The ICU intensivists are nearby, but it is just me and her surgeon on either side of her bed, James at the foot of it, a handful of nurses standing around us.

"Okay, here we go."

Skillfully, he begins pulling back the dressing from her left chest tube and removing the stitches that have held it securely in place for the last couple days. Then, with no further warning, he begins pulling the tube out. Slowly, but with firmness, like he is dragging a coiled rope off of the floor. I hold her hand and stroke her head, envisioning the length of the tube coming out from inside her chest cavity. Seconds after he begins, the monitor above my head alarms. Evelyn's face and body posture are unchanged before me, but the numbers don't lie. They are now reading a heart rate of 284.

The following moments are frantic, packed with movement and shouted directions, all unfolding before me in slow motion.

"Adenosine! Bring it over, now! Dr. S! We need Dr. S over here," calls Dr. G.

Someone pulls up a clipboard and begins charting, recording Evelyn's vitals and the events unfolding. Dr. S, the electrocardiology specialist, runs around the corner towards us. On his way to Evelyn's bedside he grabs the bag of ice on the table behind us, lifts her to sit more upright, and places the ice abruptly onto her face.

"Let's give this a try first."

It startles me, and I am sure my own heart skips a beat. But though the ice makes her mad, her heart is completely unfazed.

The RTs are at the foot of her bed now. One PICU intensivist stands ready with the crash cart. The rest are standing back, observing, ready to be called on if needed.

A heart rate this fast is dangerous—there is no knowing how long she can sustain herself in this state. For many with SVTs, it is an uncomfortable event, something to fix, for sure, but they have time. Evelyn's heart function is already impaired. A single ventricle heart means half of her heart is pumping for her whole cardiovascular system; now that half is in an uncontrolled, rapid rhythm and no one has any idea how long she can endure it.

They now go ahead with the adenosine, the typically prescribed dose of 0.1mg/kg. Her heart continues to beat recklessly. Usually the lower dose would be tried again, a second attempt, but Dr. S pulls out his calculator, punches in some numbers, and instructs the nurse to go ahead and try 0.3mg/kg instead.

It works.

"There it is. That's the special formula for this one. 0.3mg/kg of adenosine."

A week later, when we are just a couple days away from discharge, this drug dose is written boldly on top of our paper handouts on the topic of supraventricular tachycardia. James and I are trained in what to look for and what to do in the event of an SVT episode at home. But we are assured, again and again, it would be very peculiar for that to occur.

"We do not expect her to go into SVT again, as the only times she has is when her heart is directly touched." (The three occasions were a heart catheter procedure, surgery and the chest

tube removal.) We are given a stethoscope to take home and taught to count her beats per minute (BPM), though we learn quickly that this is an almost useless practice. If we can count the beats, her heart rhythm is just fine. If we cannot count them because they are going too fast to count, then we know we have a problem.

Now we are back at our local city hospital. It is unavoidable. Going to Children's Hospital would mean passing six capable ERs, which the majority of paramedics are not comfortable doing. This time I come armed with even more Mom grit. I brace myself for whatever personality I am greeted by. And I also have a handwritten note, dated, signed and stapled with the credentials of the electrocardiology specialist, Dr. S, for me to use as leverage.

During our trip from home to hospital, Evelyn's heart rhythms continue to be abnormal. The paramedic prints records in real time, to be able to show to the doctor in the emergency room. It seems that she has worked her way up into SVT again, although this time it is under the 200 BPM threshold. The last hour consisted of her going from bradycardia (an extreme low heart rate) to tachycardia (extreme high heart rate).

The paramedics give introductions upon our arrival at the paediatric emergency room and then graciously hand over the task of reporting to me.

"Mom is the expert here."

Yes. Yes, I am. Thank you.

And so, I give my report again. Starting from the beginning. "This is Evelyn. She is 11 months old and an ex-32-weeker. She

has a single ventricle heart and is three weeks post-op to an open-heart surgery ..."

I finish by requesting they call cardiology at Children's Hospital before administering any treatment. If they administer adenosine to help her out of this suspected SVT, then this (as I hand them my handwritten note) is the dose that she requires.

Cross me once. That is all.

Instantly, though, I can feel that this will be a different experience. Perhaps because of the fire I have brought with me today. But mostly I think the team before me is meshing with us so much better. I am taken seriously from the beginning, and the nurse has paged the on-call cardiologist at Children's before I even finish talking. The doctor takes the printouts of her strange rhythms from the paramedic and begins studying them. An IV specialist nurse is called from this hospital's NICU to start an IV on this tiny patient.

The adenosine is given at the 0.3mg/kg dosage, and her heart responds beautifully, falling back to its regular beat.

Its rhythm, the waves we see scrolling by on the monitor, continues to raise eyebrows. It is decided we will be transferred to Children's this time. As we wait for the specialized paramedics to arrive from the infant transport team, the doctor talks on the phone with the cardiologist at Children's. He takes pictures of Evelyn's heart waves and sends them to her. They discuss and watch her heart rate, rhythm and motions very closely while we sit and comfort her on the trauma room bed.

During our transfer to Children's Hospital, her heart rate climbs again. Slowly. Over the course of 40 minutes it goes

from 110 bpm to 180 bpm. It appears she is back in SVT, but not the way that's expected, quickly, without notice.

Twelve-point leads are placed on her chest upon arrival at Children's, an ECG to monitor and study the electrical patterns taking place. Textbooks are brought out and referenced. Discussions. Confusion.

Adenosine is given again. Another shock to her system. Another jolt in her veins.

She responds, even though the cardiologists didn't expect her to because of the peculiar way the SVT came on.

By morning, all anyone could do was shrug their shoulders. Perhaps the new medication had caused a poor reaction. But we'll never really know for sure, because no one will be administering that drug again. I list it as an allergy now, every time we are admitted to the hospital.

"We need to pray for Evelyn," Noah tells his grandmother as he watches his sister being carried away by the ambulance. I don't think he recognizes the gravity of what he witnessed, his baby sister's unresponsive body on the living room floor, Mom pacing around while talking to the 911 operator, the crowd of firemen and paramedics flooding into his home. He is so brave, so sensitive, and also probably in shock. He chose to stay and watch his sister, knowing that he is just as much her protector as we are, that she needs him just as she needs her medical team. He stays.

"Will she be okay?"

The following day, a last-minute decision is made just before discharge. An X-ray should be done of Evelyn's lungs to be sure the fluid that was in them after surgery had not crept back.

It had. Minimally. But it was there.

A surgeon's instinct, a nagging feeling. He was right to check. This time, Evelyn's cardiac surgeon drains the fluid with a needle rather than placing a permanent drain. We agree with him and the team that there is no need to keep her any longer. She is back on the original heart medication we started at the beginning of the week. New prescriptions are written for an increase in diuretics. And a list of follow-up and chest X-rays are scheduled for the following week, and the week after that, and the week after that.

We leave the hospital, now with the anticipation of the back and forth about to occur here, every few days for an indefinite time, as we monitor and watch her heart and her lungs as they continue to heal.

The following Saturday, there is a pit in my stomach all day. Evelyn needs to go to the ER. Her breathing has become more and more laboured throughout the day, sharp exhales and wheezy breaths. *What is that threshold?* Every time we check her numbers her sats are slightly lower, her heart rate slightly higher, than the time before. I continue to make notes in my mind, listing symptoms and subtleties that have crept up throughout the week, weighing the pros and cons of bringing her in, yet again. *When is that threshold?* I double-check her emergency bag, overnight bag and supplies. We cuddle frequently throughout the day. Not just because she wants to be held, but so that I can hear, feel and experience what her body is doing. This is not her norm. Something is wrong. *Have we reached that threshold?* Finally, she falls asleep for the night and I can get a longer, clearer picture of her numbers. James and I sit on the couch,

hand in hand, as we stare at the monitor. Watching, waiting, anticipating. We are familiar with desats. This is not new to us. We are also capable of getting her out of them, capable of helping her recover. However, our methods are not working this evening. She continues to find her way down, lowering herself towards that threshold. It's time. I call and relay the last 12 hours and the progression of the past week to the on-call cardiologist, who is already familiar with her and her story. Yes, he agrees, bring her in now. Upon arriving at the hospital, Evelyn vomits violently in the car, and then again by the time Daddy lays her down on the ER bed. A chest X-ray is done right away, and it reveals what we had hoped it would not. The chylothorax fluid has built up. Again. This time significantly.

Is this for real? Can we not catch a break? We have been in and out of this hospital all month.

I want my baby girl back. The chunky one that was growing so nicely on mama's milk. The one learning to sit up and reach for toys. I want our pre-surgery life back. To wave goodbye to the hospital staff and feel no dread that my goodbye means nothing because we'll be back again in no time. Because we are back, again, in no time.

I just can't hold you close enough. I can't keep you safe. I can't protect you from sirens blaring, crowds of strangers, pokes through your skin, a growing list of meds or cold unfamiliar beds. But can I hold you? Let me embrace you, all of you and all that comes with you. Let's sit and find peace together. Perhaps even joy. Let's find joy together, love. No matter how joyless some of it may seem. Let's live in this joy and share it wherever we can. Let us live in this embrace, love.

[11 months old]

CLOUDY

There is a kind of secret strength.

It lives in you and no one, not even you, know it's there. It lives inside of you, waiting for the day it's needed, waiting for the darkest hour of the darkest night. And then, when you are defeated, when your heart is so broken you don't know if it can ever be put back together again, it whispers,

"Hello. You don't know me. But I am here."

Iain S. Thomas

Despite the ambulance rides last week and the back and forth to the hospital for repeat X-rays all week, this has caught us all by surprise. Admitted? Again?

We are transferred down the hall to the ICU, the same bed we had left just a week ago, following the second SVT emergency that week. We settle her back to sleep for the rest of the night, and she is put on oxygen support to keep her saturation levels stable.

She sleeps, labouring through each breath.

Morning rounds and another chest X-ray inform us that the fluid build-up is on both sides of her chest. After too many IV

pokes to count and a cocktail of meds, the surgeon on staff surgically places the chest tubes, with the curtain drawn here in the middle of the ICU, to give her relief and start the process of healing again. These tubes are different than the last, stiffer, making it more awkward to move her. They are meant for larger volumes, attached to a suction to help draw out the fluid and empty it into a holding tank. We watch these tanks fill with fluid quickly; every couple of hours the levels have risen and are measured and recorded. Her team is concerned, and different treatment options will be discussed and explored. For now, though, sleep. We hope she will sleep the day away. So much fluid for such a tiny body. She is wiped and will need time to recover.

Chylothorax is not a visible illness, unless you count the puffiness of her face and the miserable lethargy, or the pleading "Make it all go away" look I see in her eyes.

Otherwise, you wouldn't know how very sick she is right now. The oxygen helps as we work to get her back to her baseline. Again.

The uncertainty of being back in the ICU is overwhelming. As if we had never left. As if an end may never arrive.

Only three days in and there are no words. No strength. No joy. No outlook that makes any of this okay. I just want her home already.

We have discussions on the next best course of treatment. Perhaps a band is required around the pulmonary artery if there is too much upward pressure? A simple ultrasound suggests this might be a good option, but a cath or central line in the neck would be needed to know for sure. The suggestion to switch to a

nonfat formula is also discussed, as the low-fat formula seemed to be doing little.

Both options are turned down after consulting with the lead surgeon on her case. He is out of town and insists that no one touch her until he returns. We sit in the ICU waiting for his return, with two stiff chest tubes making cuddles awkward and her usual play routines uncomfortable.

We sit and wait, amidst the hustle and heaviness of the paediatric ICU. Because of her tracheostomy, she requires one-to-one care. The nurses upstairs are not trained in trach care, so she stays here, in this wide-open ICU space, right in front of the receptionists' desk. She can be seen from almost everywhere in the ICU, and she can see everything. The RTs to the left. The doctor in the conference room to the right. She sits in her crib with a box of toys and books, rummaging through, playing with one after another. Then rotating through the whole of them again. I am so relieved she learned how to sit up by herself before all this happened. That she can have some bit of independence while stuck in this bed, some amount of control of her activities. She reaches for what she wants. Her nurse helps, plays with her. The care aides take turns entertaining her. The doctors make faces from across the way, fishing for a smile from her sweet face.

She has captured them all. I can see it. Her beaming smile is reflected in each of theirs as they do whatever they can to bring that smile back again after a difficult day.

Our surgeon returns and we first attempt changing formulas, the least invasive option. They do a heart cath and rule out the need for a PA band. We increase diuretics and add more

meds to the list. She then goes on TPN. But still, no change. The cloudy fluid still drains from her chest.

How can I ask for a miracle, when I have asked and been denied countless times before? Who am I to ask, when the answer seems to be no? The answer seems no, plain as day, because each day we ask, we wait, we see no response. Each day, we wait.

This road we walk is neither wide nor straight. It isn't fair or normal or right. This isn't the path I would hope for her, my sweet girl. But still, I hope.

Still we hope, like fools looking for the shoreline after our ships have been wrecked at sea. Still we hope, holding onto the wreckage. I feel like we have been left behind. The world keeps on turning and here we are, treading water.

The only thing I can be sure of is the sun will set and then rise again. Each day will pass, one after another. Until finally we'll reach … we will reach something. What that something is I cannot know. But can I ask for that miracle? Just one more time, let me ask.

I have no doubt in my mind that God hears us. Our asks are not lost. But sometimes, often, in my experience, what we think we need and what we need are different things. Perhaps the miracles we want aren't the miracles we get. The miracle rests in the bigger picture, the blessings already received. Of that I am sure.

The TPN trial does not work for Evelyn like we had all hoped, even though the surgeon ran the course days longer than originally planned. Fluid is still draining from her chest tubes. Aside from sitting in a hospital bed and waiting for an

indefinite time, the last option we are left with is a thoracic duct ligation, another chest surgery. We have been praying to avoid this one. It is not what we want for her. More scars on her tender body, another difficult recovery, another complication added to the list. But here we are. Treading water. We don't get to choose what type of life preserver we get handed—we just hold on tight.

We go into surgery, again. And the most hopeful outcome is that it gets us closer to home. Because that is our ultimate prayer right now.

I have second thoughts. Leading up to this surgery, the morning of. Just hours before they wheel her away.

"Dr. G., I have to ask again. How sure are you that this is necessary? How sure are you that it will work?"

"I am not sure. Maybe a 50 percent chance it will work. A 50 percent chance that it won't. But I am sure it is necessary to try. She cannot stay living here with these chest tubes. It's time to get her back home."

"Okay. Okay. I trust you."

And I do. But there is a pit in my stomach as I say so. And I doubt the need to put her through this. I doubt the chances of this being successful.

The post-op recovery is the worst yet. She is in pain, obvious pain, with every single breath. Her incision site runs the length of her right rib cage, so she feels a sharp jab with every breath.

Her right lung partially collapses.

A significant amount of fluid continues to come out of her chest tube drains. And the surgeon is disappointed not to see immediate results. But it could be days before we know if the

surgery did what it is supposed to. Except days pass, and still there is no change.

We come in late on Saturdays. Same as our NICU routines the previous year. Today we bring Noah with us, as it is slower in the ICU. I am careful about bringing a small child into this environment out of respect for the families here who want and need quiet, and to protect him. But there are no planned admissions on the weekends, no surgical patients being wheeled in and out.

Before we walk around the corner to her bed, we hear music. Someone is having a quiet(ish) party in here. It is Evelyn! And her nurse. They've got R&B playing, and I am told it is her favourite. But I cannot be sure because she cries as soon as we come into view.

I know she was okay just moments ago. I trust that she was having a good time all morning, with all the nurses and RTs doting on her. But now she has seen Mama and she remembers that she misses me and that she is alone here. So, she cries. My arms wrap around her and she notices her big brother behind me, and her tears disappear.

It is 28 days later, almost an entire month, before Noah and Evelyn finally see each other again. She has a huge belly laugh at his arrival. And I am relieved to see she knows him still. Of course, she does.

This isn't exactly how I would have pictured a springtime afternoon with two children. Being silly with hospital staff. Raiding unfamiliar closets for toys. Making friends with volunteers and other visiting siblings in the hospital playroom. Rocking my girl to sleep behind thin curtains, with noise

and light on the other side, afternoon walks around the block accompanied by a nurse and RT. Taking one home at the end of the day; leaving one behind.

No, I most certainly would never have thought this would be our spring. And I would never wish this on anyone. But it is ours. And there are still plenty of normal moments: siblings fighting over toys, one child making shy, one child being moody. Lots of laughing and smiles from everyone. I am so looking forward to better days ahead. But these days can be pretty great too, if you just accept them and let them be what they are.

One of the drains finally cleared, more than a week after the thoracotomy. We seem to be getting somewhere. Then her breathing begins to get more laboured. Again. Again, and again and again. Aren't we finished with this yet? It is a weekend, and not customary, but I request another X-ray. We have watched this so many times. I know, the fluid is back. And sure enough, the X-ray confirms just that. Continually we are taking one step forward, one step back. Never getting anywhere at all. Walking forward on a treadmill from hell.

There is no end in sight at this point. It is what it is. We are at a place of acceptance. It is a necessary place to come to, I think. I think about when I started accepting the lengthy NICU stay last year. It doesn't necessarily make it easier, not in the slightest. But it becomes a lighter load to carry. And, deep breaths. Constant deep breaths.

More than four weeks inside these ICU walls and a meeting is called with her whole team. Why hadn't we done this sooner? Evelyn's cardiac dietician created flow charts depicting each course of treatment we have tried since her heart surgery in

March. The special formula, each time we increased or decreased diuretics, TPN trial, thoracic duct ligation surgery, chest tubes placed and removed and placed again. The only thing I could see very clearly from this chart is how quickly new courses of action had been made. How little time we truly gave anything to work. And how many things we would change at one time, so we could never truly know what was working and what was not. I was infuriated—why hadn't I seen this more clearly as we went through each decision? But none of us could have predicted Evelyn's body response to each of these treatment options. All good, reasonable treatment options. Thoughtfully decided upon by a crowd of professionals, all heavily invested in her and her well-being. All wanting the very best outcome for our girl. Now, with hindsight, I can see the flaws in our process. We all can. And I say "our" because I know that James and I are just as much a part of this medical team as the intensivists working their 36-hour shifts.

Our team meets. Including our cardiac surgeon, cardiologist, two ICU intensivists, our dietician, a cardiac nurse clinician and one of E's most frequent ICU nurses. And it felt great to get everyone on the same page. To clear the slate, so to speak, and start fresh again as we move forward. Evelyn's chylothorax complication was proving itself to be more persistent than any-one could have predicted. We accept that this is a long-term struggle and recognize its significance as a warning for her next heart surgery. We will be prepared for it next time, but that won't make it heal any faster.

In our round-table meeting, Evelyn's surgeon speaks trans-parently about her unique physiology, and I hear the words

"palliative care" brought up for the second time. He talks about the life he expected for Evelyn, given all of her unique complexities. It is in this discussion that I hear her cardiac surgeon say, "She has proven to be an outlier and has defied all the statistics stacked against her."

Yes. Yes, James and I both know this of our girl. We know what her resilience and bright spirit are capable of overcoming. We know she has a full and bright future ahead of her. But to hear him say this—the surgeon who was hesitant to do any heart surgery at all—makes my heart soar.

This was the booster I needed to continue waiting for this fluid to clear. Because it will. It will clear. Though it feels there is no end in sight. Though it seems there has been no progress made. It will clear.

We step out of this meeting with her team with the decision to take a step back and not change anything. I came with this plan in my own heart and mind, ready to fight whoever opposed it, with all my mama fierceness. But I didn't even have to bring it up. Dr. G himself admitted we had tried too many treatments, too fast.

"It is time to let her heal; to give her time to heal."

It's easy to get lost going through the motions of each day. My body moves and my mind doesn't rest, and then I stop to breathe and recognize my chest is heavy and racing. As if there is a constant need to replenish myself, to steady myself within this thick fog, but I don't recognize the need most of this time. Not until I stop to breathe.

So I breathe, and I give my inner self a moment of what it craves, and then I move on. Continuing through the motions of the day.

Most days I smile through it all, through the fog. I think it helps, but perhaps I am just pretending the fog is not there. Some may think this is fake, but I think it is good for me. There are days where I feel everything: angry, sad, frustrated; days I am completely wiped out from just feeling.

So, I smile even when it is uncomfortable, even when it doesn't feel natural or right. I smile as I whisper to Evelyn that it is going to be okay. I smile for Noah's sake. I smile as we discuss difficult things with hospital staff. I smile through the pain, and I think it has gotten me to the other side.

As days pass, as I have smiled through it all and given my lungs the deep breaths they ask for, I know that it is not all fake or forced. Feeling good starts to come naturally as I allow myself the simple pleasure of feeling that way.

Often there is another layer, another thought, a deep breath, behind the smile. But sometimes ... sometimes that smile is simple and honest, pressing through the hard moments with no effort whatsoever.

[13 months old]

THE BEDS BESIDE US ARE ALL EMPTY. Everyone has come and gone already.

We take Evelyn for a walk. The season changes while we are here, from the brisk winter mornings to the sunny spring afternoons. There is an orchestration, as there always is, to get everything together to take her out. The hospital's old carriage stroller is brought for us, and it makes me smile from ear to ear. How darling she will look! And she does, so incredibly darling. On the first walk she still has an IV in her arm, so not only do we have to bring the suction machine and emergency kit for her trach, but our nurse walks closely beside us, wheeling along the awkward IV pole.

Soon the IV is gone and the walks become a part of our daily routines on the days the sun is bright.

When the sun does not shine, one of the intensivists insists on "taking her for a spin" around the ICU. She plops her down inside the blue frilly carriage and strolls the ICU circuit, waving to other patients and doctors as they go. Evelyn is bright and satisfied with her tour—the both of them are. She's been fighting for the health of our girl for weeks, and this is her victory lap just as much as it is ours.

And then just as unexpectedly as we ended up in this space, we are packing up to go home. It seems that, as soon as we decided to hunker down and be still, just wait with patience and joy and expectation, it all fell into place. Tubes came out one by one, and we got everything in order to get ourselves back home.

What does home even mean anymore, when we've created our own version of it right here?

As we drove away from the hospital and onto the highway towards our house, the clouds broke open and a rainbow appeared overhead.

"I did the math. That's 40 days and 40 nights inside the ICU this last go."

Wow. No kidding. We drive in the light of sunset, towards home.

And I am reminded that hope is not an ambiguous thing. It is real and powerful. It is a promise of fresh starts and new beginnings.

We hope now, and we hope always. For the future that is forever unknown. For the present we cherish and hold close. For the past that has challenged, shaped and strengthened us. And we continue on. To enjoy what we have in this moment and press through whatever next comes our way.

SORRY

*Anger is an acid that can do more harm
to the vessel in which it is stored
than to anything on which it is poured.*

Mark Twain

Another day, another admission. This time, it's the calmest walk into the ER we have ever experienced, yet even still, they are expecting our arrival and lead us to a room right away.

Familiar faces are there to greet us and help move things along. As is standard for Evelyn—if there is reason to come in to be checked, then there is reason to stay overnight to be observed. She is tucked in for the night in a new ICU corner, and we wait for the inevitable desats.

After a night on oxygen support, a second X-ray the next morning has revealed fluid accumulation in her chest cavity.

Are you kidding me? Again? I feel we've done this already, been here before. We don't yet know if it is just residual fluid from being sick or if it is the chylothorax returning. Some tests today will reveal more.

In this moment I just feel so grateful for James and the team we have become in all this. Our instincts are always in sync, and even when Evelyn isn't presenting many symptoms, we have both learned to recognize when something is wrong. We have reached a unique level of trust and communication, and it is this that gives me comfort and strength as we continue to navigate these choppy waters, together.

"Why? Why her? Why again?"

I cry out in my kitchen, bracing myself at the kitchen table. Allowing myself this moment to feel weak. Helpless.

"I know. I know." He tenderly places the words between us.

"I cannot do this anymore. Fuck. Fuck. I want my baby home. I don't want to be scared anymore. I don't want her to be scared. Fuck."

There are stuttering inhales for every sharp exhale as I suffocate behind these tears.

His hand finds mine. He draws me in to find my breath against his strong shoulders. Are these shoulders enough to carry the weight of these tears? I slump there. Soaking his shirt.

"We'll get through. Just like we always do. We'll get through." Hushed chatter from his lips, convincing the both of us of this truth. He supports me in his arms, and the weight of his head leans against mine. The weight of each other, holding us up.

With fluid returning again, our primary cardiologist begins making his plans for helping Evelyn through this complication.

She is on a fat-free formula, struggling to gain weight. We give her MCT oil to add fat that her body can process without producing chyle. But it means calculating measurements and pushing oils every two hours. Every four hours, diuretics are administered. Every eight hours, she receives a beta blocker. Around the clock, with syringes and flushes. Around the clock feeding, as she is still attached to the pump for 20 hours a day.

Dr. H suggests a pulmonary plug. It would work similar to a pulmonary band, but he would be able to place it through a catheter rather than open-heart surgery. It's brilliant, and for the life of me I cannot understand why it hasn't been suggested before. Before we went ahead with the invasive thoracotomy. Before we sat idle in an ICU for six weeks. Before all the chest tubes.

But it is an option now. And it's brilliant. A cath procedure is simple, non-invasive, and just a one-night stay in the ICU. Yes. Yes, let's give this a try.

Following the cath procedure, we transition from non-fat to low-fat formula, and she vomits profusely. The following day we are admitted, again, with another round of rhinovirus in her system. Perhaps she vomited because she was coming down with something rather than from the new formula? Regardless, the poor transition makes us all take a step back and evaluate how we are going to go ahead with this.

There is a pile of frozen milk in the freezer. Only a small supply left that hasn't yet expired, and our dietician suggests going straight to full-fat breastmilk. Why not? We could very slowly transition to a low-fat formula. Then very slowly transition to regular formula. And then it could be months before we

are done with diuretics and actually in the clear; aware of the success, or lack of success, of this most recent treatment.

"Ripping the band-aid off" seems like a good plan to me. Either it worked or it didn't. Let's find out now, not three months from now.

With the nod from Dr. H, we go ahead and put her back on breastmilk. And I feel relief, such joy flowing through my veins, as I feed our baby her mama's milk again.

If this doesn't work, we are truly moving six steps back and will be back to where we started in March, directly post-op to her heart surgery. But if it works, if she tolerates my body's gift to her, this will finally be a thing of the past. We pray. Begging God. It is time to put this complication behind us for good.

How do I put this into words? How to express anxiety and elation at the same time? I am not sure why I am feeling so anxious about celebrating. But—I think—we just conquered our five-month battle with chylothorax. I think our prayers have been answered. I think—I am numb to celebration.

I feel dissatisfied.

My insides are all knotted up as I anticipate this turning around on us, yet again. I am saddened that I cannot be happy with good news because I worry the news may not stay good for long. These last months have put my spirit through the wringer. And by months, I mean all 16 months of this, not letting up. Lifted up and pushed down again and again. Hope-filled, hope shattered, hope restored, again and again.

But I do celebrate. I celebrate her. I celebrate us. We made it! We made it through this valley at least. And yes, I am sure there is another one on the horizon. I am sure we will all come out the

other side; repeatedly, we emerge. I celebrate the rawness of my being, the strength that continues to rise within. I celebrate the small things. The non-medical things, the truly special moments witnessed each day. Yes, there is much to celebrate. And, if you like, you can now celebrate this fluid being a thing of the past.

I'll be over here holding my breath over it.

Certainly, I believe, there is a time to be fire. There is time to let your roaring insides be heard. There is a time for rage. To stand up for something important. To feel all you need to feel. To experience the grief and heartache and pain. To allow anger to surface.

But if that is all you experience during these seasons of difficulty, I promise you that you will burn yourself. More than anything else. More than anyone else. You will go up in flames, as this fire roars.

There is a time to soothe, to keep yourself composed and go through the motions.

Throughout this journey, I've been asked often, "How do you do it?" People have said, "Wow, you are coping so well." What is there to say, except that it is the same way anyone would do it. If this were your child, you would do the same. Although, after witnessing so much in the ICU, I know this isn't always true. Everyone doesn't do the same.

My innermost self goes through a roller coaster of thoughts and emotions during our back and forth visits to the ICU. There is no certainty. And when I wish that someone could give us something concrete to hold on to, I have to remind myself that uncertainty isn't just mine or ours; it isn't specific to this situation. Uncertainty is a constant for all of us. I just happen

to be a witness to it more frequently. I just happen to live this uncertainty in more obvious ways. I have become acutely aware of its presence, its anxiety and stress. I've been humbled by its relentlessness.

I've been challenged to look in its face and be okay with whatever it brings me next.

My hope is that I will come out of this gracefully. That I will be stronger each day than the day before. It is a process, though, a process that I cannot engage in when the fire in my belly is raging. When my thoughts burn from the inside out, full of "what ifs" and "why us" and "what of tomorrows?" Fire doesn't cause beautiful change. It causes destruction and pain, and it encourages fear. Water, though, water etches away the unnecessary. Water flows strongly and freely and purposefully. Be water. Let the rains pour and let yourself be moved. Let yourself.

DREAD WASHES OVER ME as I realize her secretions are rolling out of her trach more frequently. She is coughing to help them along. The suction machine is used, on and off, on and off, over and over again throughout the day. Open bag. Unravel tubing. Pull out catheter. Methodically place fingers on "8." Turn on. Remove HME. Place inside trach. Swirl. Hold. Swirl again. Slowly pull back. Replace HME. Open saline water. Flush catheter. Turn off. Thread catheter back in packaging. Coil tubing. Close saline. Put back in bag. Zip.

She coughs again.

Open bag. Unravel tubing. Pull out catheter. Methodically place fingers on "8." Turn on. Remove HME. Place inside trach. Swirl. Hold. Swirl again. Slowly pull back. Replace HME. Open

saline water. Flush catheter. Turn off. Thread catheter back in packaging. Coil tubing. Close saline. Put back in bag. Zip.

Her breathing is wet and laboured. And fast. I can guess how fast without counting a thing. Fifty-five breaths per minute.

Though I decide to count just to be sure. Pulling out my phone's stopwatch, I begin watching her chest rise and fall.

I stand corrected: 53 breaths per minute.

It could be worse. It could always be worse.

I find myself taking deep breaths throughout the day. Like I have forgotten to breathe myself. I cannot breathe myself. There is a weight, not on me but deep inside. A weight is resting inside my chest, and I forget to breathe when it is there.

You know that sensation at the back of your throat when you have just cried, like really, really cried? Weeping and heaving and gasping for air? This sensation sits in my throat now, haunting me, because I haven't even cried yet. Do I even have a reason to? She's fine. I'm fine. Everything is fine. But I want to cry. If I close my eyes and let myself feel for a moment, I can sense the dew behind my eyelids bubbling. If I had a moment to feel, I …

She coughs again. Open bag. Unravel tubing. Pull out catheter. Methodically place fingers on "8." Turn on. Remove HME. Place inside trach. Swirl. Hold. Swirl again. Slowly pull back. Replace HME. Open saline water. Flush catheter. Turn off. Thread catheter back in packaging. Coil tubing. Close saline. Put back in bag. Zip.

Without even thinking about it, I move to check over her emergency go-bag. Ensuring it is stocked and ready. Not that we are going anywhere. She's fine. I'm fine. Everything is fine. There should be oxygen tubing, oxygen connection HMEs,

extra syringes and sterile water, an extra G-tube extension, a soother, a blankie and bunny to cuddle. Most of what is in this bag the hospitals have or should have. But it's always faster, simpler, if I have it already to go myself.

I wipe the doorknobs down with Lysol. It is too late for this; she is already sick. But I cannot help it. I make a batch of soup for her tube meals this week, lots of garlic and chicken broth. I put a load in the wash, making sure towels and sheets are ready in case she stops tolerating her feeds and vomits. The oil diffuser is on in the kitchen, an immune blend. Maybe it helps, maybe it doesn't.

She coughs again, and I rush towards her on the living room floor. Open bag. Unravel tubing. Pull out catheter. Methodically place fingers on "8." Turn on. Remove HME. Place inside trach. Swirl. Hold. Swirl again. Slowly pull back. Replace HME. Open saline water. Flush catheter. Turn off. Thread catheter back in packaging. Coil tubing. Close saline. Put back in bag. Zip.

At bedtime, I am thorough in checking over her skin. Sometimes she gets rashes with viral infections. And then she'll itch. And it is just one more thing.

She wakes hours later. Unsettled and coughing; needing another cuddle. Only now my time with her is up. The nurse has arrived. And another woman is here to rock my child to sleep. To soothe her in her distress. To comfort her between wakings. I am torn as I walk away. As she cries and reaches for me, I tell her, "Mommy loves you. I will see you in the morning." Because I must sleep. Because tomorrow may be worse. Because a hospital admission is always "right around the corner." Because I cannot safely care for her if I'm too tired.

Each time there is an emergency, each time we rush to the hospital, I feel a little more of my self slip away. I don't recognize me, the me that was before. The physical self has changed; my breasts have flattened and my butt has expanded. The shape of me shifted, softer to the touch but hard beneath the surface. My core strength is gone but my arms can lift and rock a baby for hours on end. I don't exercise or train for marathons; a run to the mailbox would have me heaving. But I have endured many marathons, back to back to back. Sitting, standing, rocking, shushing. The baby-soothing marathon. Emotionally, I am as stiff as a rock, holding it together through unnaturally difficult circumstances. But I am also a bursting dam, ready to crash through the walls I have built at inconvenient and unnecessary moments, to cry over jeans that don't fit rather than my baby's scarred body. But oh, also, how the tears have shed over that body. That fiercely resilient, battered and scarred body. That beautiful hole-filled body.

I have to remind myself that this isn't normal. That this isn't okay. I have to remind myself that it isn't normal to explain medical history and medication lists with such fluency and ease. It isn't normal to know exactly how and what to say to hospital staff to ensure that they hear you and follow what you say. It isn't normal to be so prepared, so well versed, so natural in these settings. It isn't normal to casually watch your babe be poked and prodded, again and again, calmly holding her hand and whispering *"brave"* into her ear.

None of it is normal.

None of it is okay.

But this is my normal. And I cannot avoid it. No length of time, no stretch of growth or safety we feel brings us further from this truth. This truth is always there, whether we acknowledge its presence each day or not.

No, I do not want to sit in fear. Always thinking the worst. Waiting for the worst to occur. But I also cannot become complacent. I can never be too settled, too free in the easy days. I don't just see the good and the growth since yesterday, but also the hard and difficult days still before us.

This balance, this simultaneous accepting and letting go, is a constant struggle. Putting aside the thoughts that are not helpful or productive, each day. Reminding myself of the grace and goodness here, each day. Being relaxed as I mother my kids—and being ready to shift gears at any moment. Each day.

I don't know if there is anything that makes this load easier, except just being real and honest about it.

My normal is difficult and absolutely not fair and painful to face. My normal is also miraculous and filled with grace and love that knows no bounds.

I remember the first time I changed her diaper. She was a couple days old, and just barely bigger than three pounds. There were cords and wires and IV lines all over the place. It seemed like a maze, and I couldn't understand how the nurses could find what they needed. I was so nervous to change her, for fear of moving the wrong thing or hurting her. I remember learning how to use the G-tube. Attach, unclasp, push, clasp, detach. I had to say the steps in my head as I did them, to ensure I didn't accidentally spill meds all over the bed. Yet you can be sure it happened a few times anyway! When her trach was placed and

I realized I would have to do the suctioning and cleaning the site, I was petrified. I felt awkward and grossed out by it. Now, I am in my element in this space. There is not much that phases me here. I know exactly what drawer to open to get what I need. I know the lingo and the hierarchy of doctors and how the pace of the day will unfold. I move through the motions of suctioning and feeding, keeping a mental note of her numbers. Somewhere along the way, the fear left me. At some point I became more comfortable with this than with a casual conversation in a lineup. A shift occurred and suddenly I am the expert in this room. It is incredibly empowering to recognize this, to come to this place. I've probably been here for a while, but I am acutely aware of it now. I am aware of how far I have come, to be at total ease in caring for her.

I HOLD MY BABY GIRL IN MY ARMS, pressing her body against my own, as I tell her I'm sorry. It's barely audible as my lips form the words, nuzzled into the nape of her neck.

I say it again. Looking for her eyes. "I'm sorry."

"I'm sorry. I'm sorry. I'm sorry. I'm sorry."

I'm rocking her, chanting my repentance. Audibly and firmly I say it, though minutes later it is just my mouth moving and there are tears in my eyes and an unaware babe's face before me. I press my lips to her forehead, let my nose rest on her hairline, and say it again.

The chant began because of my guilt about how I handled her stubbornness this evening. I had been trying to get her to sleep for hours. Yes. Hours! And in my frustration, my moments of weakness, of genuine mom exhaustion, I have my own tantrum.

"JUST. GO. TO. SLEEP!"

I plop her bum on the floor before me to make a point. I am not catering to your every demand! But then, when the tears become more aggressive, I pick her up again to help soothe her breath, so her heart doesn't start racing.

She throws her blanket to the floor. So I throw her teddy down with it.

Tears continue to soak her face, and more than two hours later I have yet to find what she wants.

My one arm secures her flailing body on my lap while my head falls into the darkness of my other hand. And I mumble, under my breath, "Please, go to sleep. Please. Please. Please." My chin begins to quiver, my chest awkwardly heaving, and now wet streams drench my cheeks too.

Still I say, pleading, "Please, go to sleep."

A small hand finds mine, resting on the hand burying my face. And it is working to pry my fingers back. A little face curiously dipped sideways, trying to catch my eyes that are hiding behind tears and shadows.

Now both little hands have stopped their pushing and thrashing and instead rest on the sides of this mama's face, pulling it down towards her. She nuzzles in, under my chin, face pressed against my heart, and concedes to sleep. Accepting her soother, holding her blankie, gesturing for teddy. Eyes fall shut.

Hers.

And mine.

Both of us kicking and screaming to get our way.

Then compassion. From the child.

The apologies continue to fall from my lips, telling my girl sorry for so much more than this evening. I am sorry for all of it.

I'm sorry that you have had to fight harder than most, just to get air into your lungs. That your body has holes scattered throughout, poorly formed structures—such unfair disadvantages to start your life with.

I'm sorry you didn't enjoy your mama's skin moments after exiting her body. That instead, after your incredible work and strength to come into this world, there was no rest, just more you had to fight to stay here.

I'm sorry you watch your family coming and going from your home while you stay inside day after day. Germs are not kind to you and your protective bubble may feel more like imprisonment. I long to see you enjoying coffee shops and grocery stores and long, unplanned walks. And it saddens me that you don't really know what you are missing.

I'm sorry you can't shout back at me, that your cry is only known by me, that "Mama" is not uttered throughout your day in play and "Dada" repeated over and over and over again.

I'm sorry that your future is still so very unclear. There is no guarantee. No "final" surgery to cure you, no certain outcome, no comforting statistic to hold on to.

I'm sorry for the activities you may not do. Keeping up with your friends in a game of tag. Or competing in sports. Or travelling the world with a backpack on your shoulders.

I'm sorry that I cannot take all this away. That I cannot pray, hope or wish hard enough to change what is.

I am sorry, my baby girl.

AFTERMATH

When you talk to others,
hold this truth close:
that most scars are not visible,
that most wounds do not bleed.

b.oakman

Most days I hold myself together without effort. Most days I can show up, execute motherhood and nursing and managing and marriage; all that is required of me. Most days, silver linings are found. We find joy in the little things and continue pressing on.

Most days.

Some days though, some moments, odd triggers break me. They are often unexpected and abrupt, caused by situations that logically shouldn't affect me.

One afternoon, while Noah and I enjoyed some time out together, a child was injured on the playground. My fight-or-

flight response kicked into gear and I was suddenly running around the playground looking for the boy's mom, then calling over a lifeguard from the nearby pool. The boy had fallen and wasn't moving. I felt frantic, wanting to do whatever I could to help, while keeping an eye on my own child watching the scene unfold before us. When the appropriate people were caring for the boy, tears came flooding up from deep within me. My whole body trembled. I fought to keep it together as I walked back to the car with Noah, assuring him that the boy was going to be okay. Assuring myself that it was all okay.

Often it is complete strangers that witness these moments or face the wrath of them. These trigger moments where I lose my emotional and mental capacity, my ability to reason, rationalize and contain my inner wars—when I need to scream and wail and weep. Sometimes it is a phrase that somebody says, an inconvenience that irritates me, or a lack of empathy from someone who doesn't even know that empathy may be required. Once it was a poor retail girl I yelled at, another time a confused and probably concerned receptionist I cried on the phone with.

I am not yet sure what to do with these episodes, this aftermath of our trauma. This, I think, is what my healing may look like. There is pain as the wounds close. Pain that no longer has the trauma itself to be distracted by. There is no longer something else to focus on, to put aside for later. No, now it is just an open wound that has not been cared for. And I can hardly recall the injuries that caused it because they were too painful; they occurred too abruptly to take in. This healing process is slow, aching and unpredictable. Just as the trauma came to us without warning, so too do these episodes of aftershocks.

Reverberating through our beings, throughout our days, one after another. The after intensely more difficult than the during; the residual effects greater than the initial destruction.

What I have gained from this are eyes that see the possibilities behind each stranger's face. The fact that you just never know what someone else is going through, what their inner wars may look like. As much as I hope those who I irrationally lash out at will have grace for me, I hope, too, that I will always remember to offer grace to the strangers around me. The one who weaves in front of me in traffic, or snaps at the clerk in the grocery store lineup or is impatient with their child. Because those strangers are me, and I am them. We are each an individual story bursting from the seams, spilling out into this "normal" life before us.

Hey, Mom. Remember when the fire truck and ambulance came and took you and Evelyn to the hospital?

Yes, love. I remember.

That made me sad. I was so sad to see you go.

What else did you feel?

I was scared. And angry!

Was your heart racing?

No, my heart was gone. That made my heart go away. My heart was gone, Mom. That was not my favourite.

Remember when you had to have a sleepover at the hospital?

You mean when Evelyn was still in my belly?

Ya. And you had to stay at the hospital, away from me. That was also not my favourite.

Those two things were my least favourite part.

They were my least favourite part too, love.

Mom. Remember that time Evelyn was at the hospital and you came home to cuddle with me at bedtime and then had to leave again in the morning? That made me very sad. I didn't like that, Mom.

I know, love. I didn't like leaving you either. I felt so sad to leave you.

What do you remember, Mom?

I remember when we brought Evelyn home from the hospital for the very first time. When you were still just three years old. And she was so happy to be home, and you were so proud to have your baby sister.

Oh yes! I remember that too. That time was my most favourite part!

Mom? Are you all done going to the hospital with Evelyn? Can she stay home always now?

Mom. Evelyn hasn't been to the hospital in a while.

No love, she hasn't. She's been getting stronger.

But when she is sick again, she'll have to go back.

Yes. Perhaps.

He nods with understanding. Goes back to his activity, like it's the most natural thing to expect your sister to be back in the hospital at some point.

Mom?

Yes, love?

I am so glad that Evelyn didn't die.

I am so jealous, Mom. You don't love me as much as you love her!

EVELYN'S SPEECH THERAPIST comes to our house once a month. The aim isn't to speak, it is to communicate, in whatever capacity she is capable. With her trach in place, she is unable to pass air over her vocal cords, which means she is unable to speak. So, we take up sign language. I knew a handful of words that I taught Noah when he was a baby. Most of these words were useless for Evelyn starting out; words like milk, eat, banana. She would never need to ask me for milk. Not for a long time anyways. So instead we started with "more" and it was used in relation to repeating games like peek-a-boo. She caught on quick. I also taught her "no," when she swatted or pinched Noah. She caught on to that as well and started telling me "no" too.

I got over my nervousness about having her in a public space, nerves related to both germs and stares, and sat in on baby sign language classes. Both were present but we made it through. We learned all the common nursery rhymes and baby songs in sign language, and her hand communication grew as she learned how to "sing."

Then I started signing while flipping through her favourite board books. *Big Dog, Little Dog* was a regular choice, so I signed "big dog, little dog" and all the basic words throughout the story. One day I found her sitting on the floor, signing through her *Going to Bed Book*, signing the words. One page at a time. "Go to sleep." "Brush teeth." "Bath." "Rock and rock and rock to sleep." As she rocks her body, cradling herself, hands to her cheek "to sleep."

Two years into speech therapy and Evelyn signs more than 50 words.

We sit on the kitchen floor, bringing our therapy session to wherever Evelyn is. I'm shown an app, an electronic communication device.

"I think it is time we start introducing these concepts to Evelyn so she can begin building sentences and being audibly heard by those with her."

"But why?" I ask. "She is with me, or one of her nurses, or her dad, and we all know how to communicate with her. We know what she is saying, and we can continue to build her signing."

"Yes. You know. But she won't always be with you. If preschool is going to happen in the next couple of years, we need to give her tools to communicate with her peers. She can't be stuck trying to make friends with a nurse's attempt at sign language as the interpreter."

I know she is right. But I am pissed that she is telling me this rather than me coming to this conclusion on my own.

Electronic communication? She isn't cognitively challenged. It's not like she isn't capable of forming words. It is that she physically is not capable of voicing words.

Shit. Check yourself, Laesa. There is nothing wrong with needing a support device. There is nothing wrong with those who use it.

Will they think she is weird? Will it take her longer to form a sentence because she has to punch words and phrases and ideas into an app? Will she get discouraged and give up? Will it discourage her from signing or attempting to speak?

Shit. I want my baby girl to talk. I want to hear her voice. I don't want her to need this.

I smile nicely and nod along as I am walked through these apps. The different options available. And I am burdened by

this next step. She may be ready for this. But I am not. She may need this, but I do not.

I don't need to hear her thoughts through a computer. I can look in her eyes and find them there. I do not want her to yell at me from across the room, through a computer, when she could run to my side and pat me on the leg. Face gazing up at me, pointing to her need.

And I ask her. "Do you need help getting on the chair?"

She throws her head back, wide-eyed, full grin. "YES!" she nods enthusiastically.

"Okay," I say.

And she walks over to the chair, reaches her arms up for me to lift her, and beams her thanks in my direction.

We do not need an electronic communication device. We communicate just fine.

It is a lonely life, that of a special needs parent. Sure, there are many resources these days to connect with others, to know that you are not in fact alone. To know a larger world than the one you feel stuck in each day. With the click of a button, you can find others just like you, usually in other places in the world, because so many of these complexities our children face are "rare." Even with this connectivity, though, it is often still lonely.

I have joined a number of Facebook groups over the years and met many individuals on Instagram with children with one or some of the same complexities as Evelyn. Some with no similarities, who share instead in the pain and joy, struggle and perseverance that we are walking through. It has been helpful to see how others cope. It gives me strength to watch others overcome. To see persistence and progress move hand in hand with

other families. To pull myself away from any sort of pity party, as there are others with the same, or even more complex, diagnoses than ours. There have been many instances where I have learned from these moms, moms from around the world who have gone before me and share their experiences with the rest of us. I have learned about the best lotions and creams for scars and stomas, how to create feeding schedules and blend tube-fed meals. Where to purchase the best syringes. What to expect after particular surgeries. I've learned about my country's healthcare system and how it varies province to province. Despite its flaws, I have seen first-hand how incredibly well cared for our kids are in this country. And I have learned compassion for those in countries with fewer options, with less support and scarce resources. I have learnt about symptoms to look out for, names of various infections, and a collection of other diagnoses that I would not have otherwise known. I have asked questions and received countless responses. I have given my knowledge back to others as they reach out for support, clarity and friendship. I have learned about seeing people beyond the face that they present to the world. I have learned to ask the hard questions and brace myself for the gut-wrenching responses, to be a giver and receiver of honest and truthful conversations. I have learned how to support others, and I have been supported by strangers and friends alike.

There is a whole world of moms, dads and caregivers just like us, living their daily life in rhythm with their medically complex child. Living their "new normal" as best they can. Scrambling to piece together their own lives as they piece together their child. Many will swear that it gets easier, and that, as their child

grew in size and age, the list of challenges began to shrink. Feeding obstacles were overcome, speaking became possible. Learning how to walk. Breathing without support. Fewer meds to administer. Fewer specialists to follow up with. For many, the early years are intense, in and out of hospital, holding our breath during cold and flu seasons, helping our babies play catch up against whatever odds put them behind in the first place.

Many others say that, as their child grew, the road before them became more difficult. Developmental accomplishments were slow and far between, and though they spent those early years preparing their child for school, attending school will never be a simple, regular activity for them. Life continues to be complex and the intensity of their journey will continue on and on and on.

And we all press on.

Whether doctors are sure our child can be "fixed" with a surgery, or they are uncertain about the longevity of their life, or they question the type of life that may be led. We all press on.

It has given me knowledge and comfort and perspective to be part of such a wide, unique world—all of these brave, intelligent and strong parents and caregivers—but it has not made me feel any less alone.

See, when you are a special needs parent, every daily activity is different than most. And you feel out of sorts constantly. Out of balance, out of sync and out of anyone else's inner circle. You are stuck in your own circle, one nobody else can enter.

As I pick up my son from school, I should have my toddler on my hip waiting with me for her brother to come running with the bell. But this is not feasible, because she cannot be

in her car seat for a simple drive without a parent or nurse beside her.

Having family and friends over for a visit should be a carefree, regular event. Instead it brings anxiety and the need to double-check with each person arriving that they aren't bringing germs with them into our home.

A walk around the neighbourhood has us packing bags as if we are leaving for a whole weekend. Though it is just her suction machine and emergency bag, complete with a backup trach and bagger, we always plan and prepare for the worst.

Eating and walking and talking are not skills she picks up like every other baby or toddler. Achieving each milestone is a fierce struggle. Progress is made only with patience, guidance and persistence, from me to her and her to me. And so on, and so on, and so on.

And we press on.

We press on because there is nowhere else to go. Because it is necessary to do so. Because the light of a new day is never too far away.

LAYERS

My latest hobby is screaming.
I scream into things.
It was just pillows at first,
now it is anything
I think can hold my trauma.

I have haunted the whole house.
Rachel Wiley

I stand at the kitchen sink washing her feeding bag and syringes for the third time today. My eyes constantly move back to the living room floor where she sits in her bouncy chair, toy in hand, watching her brother as he plays with his dinosaurs in front of her. Her breathing is loud and wet, so I stop briefly to go to relieve her with a suction. Then back to the washing.

I stand at the kitchen sink piling the freshly cleaned dishes high. The sun streams in through the window and I close my eyes for a moment to enjoy the warmth on my face. I am brought back to reality with a *bang bang bang*, as Baby Girl

scoots on her bum on the floor beside me, making a racket with the pots and pans.

I stand at the kitchen sink putting together Noah's school lunch; the kids play in the next room. I hear her laugh and I hear him call her to follow along. She does, eagerly. And two pairs of feet are heard drumming on the floor as they move through the house.

I stand at the kitchen sink prepping for dinner. The two of them sit contently side by side on the couch, resting after an afternoon at the rec centre. I hear her breathing change, quicken, and I look over to see she is crying. I quickly dry my hands on a towel as I walk over. She is slouched against Noah, slipping deeper into the couch cushion behind. My hand slips under her shoulder to prop her back up. She is warm, too warm.

Her crying continues, so I pull the weight of her into my arms. *Something is not right.* Her usually firm body is limp against my shoulder as I walk her back to her room to get the monitor on her foot. *Shit. SVT?*

"Noah!" I shout. "Noah? I need you to help me."

He obediently comes running, standing in the doorway with concerned eyes and fidgeting fingers.

"Noah, please go into the bathroom and get me a towel from the cupboard."

He stares a moment longer before he nods and disappears around the corner. As he goes, she slips away from me, eyes closing as her chest rocks and she gags. He comes back with the towel and I place her on it on the floor, in case she vomits, but also to soak up the sweat dripping from the back of her

neck. Between arranging her safely and suctioning in between, I finally get the monitor on her foot—280 bpm.

Okay. Here we go again.

"Noah, I need you to help me again, okay? I need you to go upstairs and get Halmoni."

"Is she okay, Mom? Do you have to go to the hospital?"

"Yes, we have to go to the hospital. She'll be okay, love. Now go, get Halmoni to help please."

She doesn't look okay. I'm not sure any of this is okay.

We sit across the table, James and I, at the end of it all. Eating a cheesy quesadilla I had started for Noah hours before, filling our faces faster than we should. Exchanging remarks about how it all went down. Mistakes that were made. Moments we wish we could change.

"I am so sorry you were alone for this," he says to me.

"I wasn't alone. Noah was here, and you seemed to get to the hospital just as quick as we did."

"I'm still sorry. That you had to hold it together, to get her there. You did good, babe. I am so proud of you."

The edges of my lips curl upwards as if they want to smile. My heart is flying as he sees me here. Sees my strength. But the smile doesn't reach my eyes. Not tonight. Because as proud as he is, as proud as I am, there is no option but to do good. There is no room for error.

"You are so sharp. It is nice to know, even after all this time away from the hospital, we are still on it."

Yes. We are still on it. Still ready. Always waiting for the terrible. And yet it has taken us by surprise, again.

We laugh. Awkwardly. With tears brimming in our eyes. Laughing at the doctor's expense, the hospital's expense. Knowing the whole energy in the room would have been different had we been at Evelyn's primary hospital. We laugh at the crowds of people in the waiting rooms, with "sick" children. Kids crying from fevers and coughs. Go home. You are fine. We talk about how usual this will continue to be for us. Shrugging our shoulders at something we have to be okay with. This will happen again, unexpectedly, again. And it is our job to be the advocates in the room for her. As exhausting as it is to be on top of everything the whole time. As tiresome as it is to be a part of the care for our baby, rather than relax as bystanders and trust that doctors will do what is in her best interest. They won't always. They just don't know. They don't get complex cases like this regularly, so we are her voice. We are an extension of her medical team, whether this unfamiliar group willingly accepts it or not. And we talk about what we will have to teach her. How we won't always be there with her.

She will have to be her own advocate.

Someday. In between passing out and chest pains, she will have to learn how to educate her care providers as we do. Because they don't know.

And Noah. This is not fair. He should not have to walk through this. To witness this.

"Do you think he was afraid she was going to die? She was ghost white and not moving at all. He just sat on the floor, staring. Expressionless."

And all he asked was, "Will you have to stay at the hospital a long time again, Mom?"

And then silence.

Reliving it all, moment by moment. And now there is no more to say, only feel. Our eyes peek inside each other's beings, and we just know. This is painful. This is terrible. My body aches. My spirit is so weary. It was just one night. One evening. We are home now. But it was trauma, layered on top of past trauma, and our bodies will someday surface all the hurt from this moment. Both our eyes are wet, a pink glaze beyond the tears, sadness only we can understand. We hold the gaze for a time, and then let it fall to the schoolwork scattered on the table, the edge of the glasses in our hands, the hallway to her room where she now sleeps soundly.

Is this going to be the thing that kills her? After all we've been through, a heart beating through her chest will be the end? I cannot accept this. Cannot fathom this coming to be.

But a part of me must fathom it, because it consumes my mind for weeks afterwards.

I hear a siren blaring when I am away from the house, and I am convinced it is going towards her.

I sit in traffic on the highway due to an accident up ahead. The familiar whirring comes from behind me, a firetruck first, then an ambulance right behind. As the sound grows, nearing, I realize I have not taken a breath in moments. Instead I am transported back, days ago, sitting on my daughter's floor. Hearing the sirens in the distance, waiting to welcome strangers into my home. She is motionless before me. White, cold, damp. I want to cry. I can feel it rising from the depths of my stomach, but I refuse to let it surface. Bubbling up, it rises higher and higher, until it is frothing in my throat. But I cannot let it surface.

It surfaces now instead. With my knuckles gripping the wheel before me; my breath stuck in my chest. The cry bursts

through my throat. A fountain falls from my eyes and my body rocks to ease it along.

The sirens pass me, deafening, and move into the distance ahead. The moment has passed, but the tears remain as I drive and allow myself the pleasure of feeling.

I GET OUT OF THE GROCERY STORE and pull my phone out of my pocket.

Missed call: JAMES.

That's weird. He never calls or checks in first thing in the morning.

I load the groceries into the back of my SUV and meander across the parking lot to return the cart. Once I am inside the vehicle, I pick up my phone to call him back. *Ring. Ring. Ring. Ring. Ring.* "Hello, you've reached James …" *Beep.*

"Hi, love, it's me. It's 9:40. Sorry I missed your call. It was on silent in my pocket while I picked up groceries. Is everything okay? You have me worried now. Call me back, k?"

A vision of him sitting on the curb, getting checked out by paramedics, a smashed car in front of him, flashes before my eyes.

I text him as well. Maybe he is in a meeting and can't call. "Are you okay? Is everything okay?"

I plug the phone into the car charger. Turn the volume ON. Turn the volume UP. And lay my phone into the crevice of my lap. Then I begin to make the familiar drive back home.

My mind continues to race. My eyes continue to glance down at my lap. My heart hammers in my chest. As I near the street that I am to turn right on, I can see glowing lights in the distance. Just a few streetlights away.

It's not James, Laesa. Relax. He would never come this way before work.

It doesn't matter that it is not him, though. It could have been him. Those same lights were at my front door five weeks ago. I struggle to catch my breath, and a cry comes out of me. It shocks me, and I stop it instantly. Only to look over and see the lights still there, and now I cannot contain it. Each inhalation reverberates throughout my chest. A single tear escapes and slides down my cheek; I can feel more forming. I brush it away with the palm of my hand.

Focus on the road. You are okay. Deep breath. Deep breath. Breathe.

I wonder if I should go straight home. I had planned on making a stop at the pharmacy. Evelyn's propranolol is ready for pick up. She will need it for her four o'clock dose today. Home or pharmacy? Which one is it? I instinctively move into the left turn lane and go to finish my errands. Better to just get it done.

Groceries are unloaded, moving on autopilot with shaky breath and quivering hands.

I try calling again. No answer.

What if it wasn't a car accident, I think? What if something is going on? How has his mood been this week? Has he seemed low? Has he run off? Is he safe? OMG, what if he died?

Laesa, stop being dramatic. He didn't die.

Should I call his work? I don't want to embarrass him by checking in, but I need to know he is okay.

I look at my clock. Not even an hour since I missed his call. *You are being ridiculous.*

I can't breathe. *Breathe.* I can't breathe. *Breathe.*

Again, I dial his number, this time leaving another message.

"James. I just want to be sure you are okay. Are you okay? Please call me back. I'm thinking I will call your office if I don't hear from you soon."

My fingers fidget at my side. The rest of my body is motionless, outwardly calm, while my hands roll an imaginary ball. They cramp for a moment and pause. Grip themselves tight while the air escapes from my throbbing chest. And then the fidgeting commences. Wildly busy with nothing.

My chest aches, and soon it will be tight. Soon I will struggle to keep myself from rattling. Vibrations through my skin, as I'm being shaken from within.

Ring. Ring.

"Hello?"

"Hey babe, it's me. Did you call? I was in a meeting."

I gasp wildly, sucking back and sucking back and sucking back. And exhale.

"Where have you been? James. Shit. You're okay?"

"Yes. I am okay, love. Are you okay? What's going on?"

"I thought something happened. I didn't hear from you again. I thought something terrible happened."

His voice is tender, reassuring. "It is okay, love. I know. I know. I am right here. Do you need me to come home?"

"No. No, I'll be okay," I respond, my lips still shaking. Still sucking back air. Still rattling and vibrating.

After the tears have dried and my pulse has slowed, I have an intense urge to bite my nails. Nervously, I do it, just as I did as a child. I stare at nothing and sit motionless on top of my unmade bed. The rest of the day disappears before me. Nothing else is important, beyond filling my lungs with air.

WHOLE

We all call broken as beautiful
But how many of us have the strength
To accept and love
This beautiful
As whole.

Anjum Choudhary

I drive to the hospital each day. Mostly, my mind is blank. I cannot recall a single thought that runs through it. But also, my thoughts run rampant. Pleading, begging, praying for this all to be different. Surrendering myself to be made stronger, to endure this that cannot be changed.

Why me? Why us? Why HER?

I do not understand. I cannot fathom the justice here. Because there is none. But also, God is good. There is still hope, there is still redemption, there is still room for miracles to be made. Isn't there?

I sing.

You call me out upon the waters
The great unknown where feet may fail
And there I find You in the mystery
In oceans deep
My faith will stand
And I will call upon Your name
And keep my eyes above the waves
When oceans rise, my soul will rest in Your embrace
For I am Yours and You are mine
Your grace abounds in deepest waters
Your sovereign hand
Will be my guide
Where feet may fail, and fear surrounds me
You've never failed, and You won't start now
Spirit lead me where my trust is without borders
Let me walk upon the waters
Wherever You would call me
Take me deeper than my feet could ever wander
And my faith will be made stronger
In the presence of my Savior

Somewhere around "take me deeper" the floodgates open and I am leaking salty rain down my cheeks. *Take me deeper. Take me deeper. Take me deeper.* Okay. That is deep enough. I cannot breathe. She cannot breathe. When will we breathe? This is too deep now.

I give God the glory for her coming out alive.

Then I am confused and heartbroken when she cannot breathe. She cannot breathe. She cannot breathe. How many

times must we try, and fail, and try again? Deeper. Deeper. Deeper. And I find my faith isn't stronger. It is shaken. Unrecognizable. And my soul finds no rest, no peace, as I watch these waves crash over us all.

I attend an evening session at my church, as part of our yearly women's conference. I'm not sure I really want to go, but I feel obligated. I feel I owe the church my presence. At the very least. I don't feel I ever gave anyone a proper thank you for all the homemade meals and gifts on our doorsteps, the hospital visits and kind words over Facebook and prayers sent up to the heavens. Thank you will never be enough. Thank you does not encompass the gratitude in knowing people have surrounded you with love. I should go and smile and hug and show them how worth it it all was. Thank you. We made it through.

I find a seat. Near the back. Because although this is an incredibly familiar place to me, I am a foreigner here. I am not the same. This me, this battered me, has never attended this church. Not like this, so unsure why I am here. Not knowing what the hell the point of it all is. I've sat on these chairs, among these rows of people, after hitting my own rock bottom. I've sat here and found forgiveness, grace and joy again. I have knelt at the Cross and received love, in spite of my flaws and shortcomings. I have sat here in these chairs and walked through years of growth and servitude.

I sit here now, angry. Because I came to the Cross on behalf of another, on behalf of a child, my child, and received nothing. Perhaps strength, because we endured. Perhaps peace, because we know rest. Perhaps joy, because we still have gratitude. But I had hoped and prayed and stretched my faith to believe in

more. To believe in healing and wholeness. I believed. Not well enough? Not hard enough? Not enough.

I sit here now, confused. I was raised in the church. Not this particular building, but the church raised me. When my own family was broken, I had this. I leaned on Him. I have countless journals sprawled with the ink of a 10-year-old girl. For years my pen moved across the pages as his Spirit moved throughout me. I knew Him. I trusted Him. I am Yours and You are mine.

The music starts. I stand with the crowd and clap my hands, muscle memory helping me along. I have stood and worshipped my whole life. But today, this is all. I cannot lift my hands. I cannot move my lips. I cannot open my heart. I am frozen here. In a crowd of women, so sure of themselves, so alive in this moment, I am stuck. Will someone notice that I am not joining in? That I cannot move? The phrase "He is good" seems to find its way into each song. The words strike my heart, over and over. It is a battle within. Is He good? To my girl? To the baby next to ours that died? To the other baby next to ours the following year that died? To the ones spilling into the NICU and PICU every single day, is it truly good? And then a blow comes from the other angle, my body and soul remembering how they used to respond to these words. These words that would move me, make my heart soar, put everything in my world into perspective. I believed these words, into the deepest parts of my being, I believed them. And when I could forgive the pain I had caused others, because I knew that God had forgiven me, I sang. When I was lost in love and unsure of my future, I sang. When I feared for family relationships, struggling in the shadows but clear in my view, I sang.

I stand here now, and I cannot sing. I cannot. My lips tremble at the thought of parting. The lump in my throat grows. I move to steady myself with the slow fall of my lashes against my cheekbone and a gentle exhalation from my lungs. A liquid pearl appears from underneath those lashes. I am not steady here; I am stuck and rigid again. Because letting this pearl drop from its place at the edge of my eyes will only make room for more to appear. I am not interested in letting the tears free-fall from my face. I cannot sing. I cannot contain. I don't have the capacity for this. My capacity is brimming. This is too deep now.

This depth is overwhelming. This depth is unclear. This depth is too much.

HOPE.

If I am being perfectly honest, I don't always feel so hopeful. It feels safer to approach life realistically, objectively. Hope feels too magical, perhaps; the possibility of being let down is too great.

I have felt hope strongly. Many times. So fiercely it flowed through my veins without any resistance. Believing that an extubation would be her chance to breathe or that a surgery would be the fix she needed. I've hoped doctors would have the answers needed to let my baby come home from the hospital; then, day after day of not being one step closer. I hope she won't get sick, though the common cold continues to plague her. I have hoped for clarity for her future, for her heart diagnosis to be anything other than what it is. I hope she will breathe unassisted one day, though there is no telling when, or if, that will be.

Through all this, I have become fearful of hope, apprehen-

sively holding it in my hands. Studying it closely, as if to better understand what it means. What it doesn't mean? To place your hope in something, on something, around something. To place your hope. Meaning you always have hope with you, and it is up to you to choose where it lands. Where will you place your hope? Is your hope cowering in your belly? Is it wrapped tightly in your grasp? Or do you let it soar, freely dreaming of your tomorrows? Does it rest on someone else's shoulders to carry, or will you bear the weight of it yourself? What if you choose to let go of that weight, and place your hope in Jesus? I'm not even sure I know what that means anymore. Or perhaps I know better now than I ever did before.

I read the beautiful words of Ann Voskamp: *"The essence of everything living is at least one-part hope. To live is to hope ... and Holes exist to place hope inside."*

I realize we may not always feel hope, or hopeful. But it is not in how we feel, but in what we do. And we live hope in our everyday. In our building of ourselves, and believing that change can happen, and does happen. Over time. Through work. With patience and persistence. Being hopeful is living. It is a continuous pursuit. To put one step in front of the other. It is what gives us life. It is what we give to life.

I'd really like to say that, through the storms, my hope has been set firmly on my Jesus. That I have held on to His Truths to survive the floods. That I have trusted Him throughout. That I've put fears aside and let peace take over. That He has been my constant, my everlasting.

But that wouldn't be the whole truth. The truth is my hope has rested on doctors, on diagnoses, on treatment plans. It has

been a weight in my own hands to carry. I have placed it on the shoulders of my loved ones. And though I press on, hopeful in some capacity, always, fear and anxiety are not far behind. They linger, taunting me with both the unknowns and the realities I would like to avoid. And my hope for the future, the peace I so desperately try to cling to, duels with this uncertainty each day.

I guess what I am saying is that my hope is unsettled. Unsure.

I want so desperately to hope without wavering. To believe in something greater than myself, to trust that an outcome can be different than the facts predict.

But I just cannot get there anymore. I think I used to. I think I truly believed that Evelyn would breathe at each chance that was given her. I believed what we all want to believe, that healing meant wholeness. I have hoped for many things along this journey to be different, things that have never come to pass. That may never come to pass.

The winter after our spring and summer in and out of the ICU, the winter before Evelyn turns two, I have a very frank conversation with her paediatrician. A conversation surrounding a question I had that I already knew the answer to. My heart already knew the truth of it. But I had to ask, as I like to hear these things straight from the experts' mouths versus my own wildly imaginative mind. And I know this expert in particular will give me the most honest response.

Evelyn's pulmonologist and ENT surgeon believed there was a good chance we could get her trach out in the coming spring. "She just needs to grow a bit more" becomes a common phrase we hear. I want to trust their expertise, and I want to hope for my girl that this is possible, but my inner, perhaps

slightly cynical, self feels otherwise. So, I pose the question to her paediatrician, who has been by her side, by our side, since her very first days in the NICU.

"Do you think she'll be able to breathe this spring? Will this be the time?" I ask.

"No, Laesa. I don't think so. I do not think that she is ready. Is it possible? Sure. But we should be prepared for her trach to remain in place until she is school age. A reasonable target, I would say, might be preschool."

A reasonable target, a place to put our hope. Is that the safe zone where hope should rest, then?

His words do not surprise me. And yet my heart breaks at the sound of them. My own breathing hurts. Was I hoping for sooner, more than I let myself think? Was I speaking casually, callously, but feeling genuine optimism? Do I put on such fronts for others that I cannot even recognize my own feelings anymore? Do I pretend to place hope at such a distance, on a pedestal, when in reality I am gripping it desperately in my hands?

I know this would be the place where I should consciously place my hope on Jesus and continue believing that spring will be her time to breathe. What do doctors know anyways? They have been proven wrong before. But I just can't. I fear putting my heart on the line like that, I fear the disappointment that follows. The disappointment that I have had to endure time and time again before. So instead I listen to the facts. I weigh statistics and case studies. I keep my feet firmly planted in reality.

Am I limiting my God's power in doing so? In believing so strategically, so apprehensively? Perhaps.

But this where I am now. Finding rhythm in hoping for

a future that is not guaranteed for her, but also for any of us. Hoping for more life to be lived, not just pushing through the days, but lived and enjoyed fully. But this rhythm also involves being okay with where we currently stand. Being proud of how far we have already come. And not putting any expectations on her and her health and her future. It does not serve any of us to do so.

I did not walk through it all like I thought I would. Like the old me would have thought I should. Proclaiming God is good from start to finish. Singing through the pain. Believing this is all part of a bigger plan. It wasn't strength unwavering. I did not go step-by-step unshaken. It was a constant quavering, a slipping grasp, a thickly clouded vision before me.

I was scared. I am scared. Unsure of what is to come. Tired. Willing myself to continue on for her sake. And so I did, and we do. Continue on and on and on. For my sake too. We find a way to come out the other side. In one piece? Probably not. We are all in pieces.

Somewhere in the middle of our reoccurring ICU admissions (there were 12 in a 12-month span), I stopped asking for prayer. For her, for us. I stopped searching for prayer because I no longer believed in the prayers being asked. "Heal her body." He did not. "Let her breathe." She cannot. "Give us answers." There are none.

In fact, I can pinpoint the exact day that it stopped. Unintentionally. But obvious to me now, looking back. We had been in the ICU for weeks, battling with this reoccurring chylothorax. So many chest tubes and IVs and even a central line had been placed. Even with attempts to starve her body and

instead provide nutrients through TPN, the chyle continued to form and drain from her and fill tanks with fluid. Rather than going in for another open-heart surgery, our cardiothoracic surgeon presented the option of a thoracic duct ligation. It would cut off the supply of fats to the lymphatic system, stopping the chylothorax. Another major chest surgery. He would go in through her rib cage on the right side, stretched open to operate in the chest cavity. I felt sick. This was our next option? After diet changes and TPN trials and gathering more information through catheterizations, this was the best they could come up with. The chance of success? A shrug—50-50.

I researched incessantly. Reading case studies and medical journals so that I could understand the jargon being thrown around during rounds. It was a good option, from my reading. The next logical option. But still, such a terrible option when success wasn't guaranteed, not even a little bit.

A day came, when we had already tried TPN for three days longer than initially planned, when the surgeon told us: "Just one more day. This isn't working. We need to try something more."

I felt angry. Let down. Disappointed. In God? Perhaps. In everyone. As if every well-meaning person who prayed to heal her body or make her heart whole had failed. And instead of feeling grateful for those well-intentioned prayers and people, I was angry.

Her body is not healed. Her heart is not whole. She is broken, always. But it is still a whole body. Wasting time and effort and prayer on fixing something that cannot be fixed is exhausting. It is unnecessary. And it is unaccepting of the beautiful brokenness that is in our hands. I cannot spend my life

thinking that my daughter needs to be fixed. I cannot dream of complete healing. Can we not just hold and love and be comfortable with the broken ones?

Don't we all have pieces in us incompletely formed? Don't we all have some form of brokenness? Does dying because of brokenness make you less whole? Does living in spite of brokenness make you less alive?

Although my heart still feels sure that I do not walk this path alone. Though my spirit is hopeful for more than is earthly possible. Though joy certainly is my strength. I do not know more than this.

Our world is a broken place. Broken people, broken hearts, broken promises and broken hope. And though many would like to pray wholeness and healing over it all, I have come to see that the most beauty resides precisely in these broken parts. If you shy away from brokenness, you shy away from compassion, grace and empathy. The holes we each carry within us, whether physical, emotional or spiritual, these holes do not need to be filled. Beauty resides there. And we can live wholly with holes. Sometimes, the opening that is not meant to be there, the extra bit of you or the piece that is missing, is precisely what is keeping you alive. It is precisely what makes you *you*.

Having holes does not make you less than whole. Being broken does not deny you a path to holiness.

Jesus walked out of the tomb marked, scarred.

And of course, we will walk out marked and scarred, too.

Perhaps healing does not always mean wholeness.

CONTRAST

Deep Joy:
That is a state of smiling gratitude
Informed by intimacy
With pain.

Mari Andrew

"So, she's okay now? Right?"

The conversation starts, "She looks so well. It's so great to see her walking around."

"Yes, we have had a good streak these last few months."

What else can I say? This is what you want me to say. This is what you want to hear. That she is well, and everything is fine. You don't really want to know that the last ambulance ride is still replaying itself in my mind, moment by moment. The troop of uniform-clad emergency personnel with their huge heavy boots, casually walking into our home, their voices

booming over her small frightened self. The scene of them filling up her bedroom haunts me each time she cries in fear at night. Or that our last admission is a reoccurring panic in my chest every time she gets a sniffle. Will she get that sick again? *Will she? Will she? Will she?* When. You do not want to acknowledge the difficulty or the severity of someone living with a tracheostomy. That her lifeline is a literal tube in her throat, kept securely in place by cotton twine. You cannot fathom the time and attention required each day to keep this lifeline clean, the exhaustion that sets in with this repetitious care. You forget that this isn't it. That her walking, though a major achievement and celebration, is more than a year delayed. You forget, while looking at her small frame, that she is nearing three years old and unable to speak more than three words, each of which is only understood by me. You forget that major surgeries still loom in her future. Many of them. And you couldn't possibly understand the psychological impact all of this has had on her. The terror on her face when she wakes up each evening, a couple hours after being put down, unsure of where she is, frantically looking to find if Mom and Dad are still nearby. And I realize it is the same panic she likely experiences each evening alone with a strange nurse in the ICU. The side glance she gives to each of her therapists, unsure each time they meet if she can trust their presence today. The tears that streak her face in seconds as she is required to sit and participate in yet another follow-up appointment, with yet another circle of faces staring down at her, analyzing and studious; high-pitched baby talk directed towards her. You

couldn't possibly understand the delicate nature of advocating, respectfully listening, gathering information and becoming an expert in the field of Evelyn. No school prepares you for this type of work.

You don't really want to know how we all are when you start your question with an answer. When you assume our highlight reel depicts our reality. You don't really want to know.

So, I smile awkwardly, forcing my face upward. And I nod my head, again and again, giving you the reassurance that you crave. That things are good. That we've all come out the other side. That yes, yes, she is okay.

Perhaps this is unfair. For me to be so critical of your need for reassurance. Because it is true, things are good. There is goodness scattered throughout each day. Incredible joy experienced in both mundane and miraculous moments. Light radiating off the faces of children. And we do continue to come out the other side, after every single blow that attempts to take us down. But what does this other side look like? It certainly doesn't reflect the same ground that you are standing on. It cannot. Your world is entirely different than mine.

It is not your fault. You couldn't possibly understand. You couldn't possibly comprehend the daily breaking that occurs. In my heart. In my being. You cannot understand this world I live in.

You do not know. You cannot know this pain.

But also, you do. Pain flows through all of us. If your blood runs red and your cheeks flush pink and air moves through your lungs, there is pain. If the sun rises and sets each day in the world you live, so too do the highs and lows of your life. Sorrow

and joy. Pain and comfort. Darkness and light.

You do not know. Not my pain. Not my story. But you know. And isn't that enough to connect us? Isn't that a thick enough cord to tie between us?

This is life. This is normal living. To struggle. To feel. To keep on moving.

I AM FINE.

I can put a smile on my face while in and out of hospital clinics. Talking about each detail of her growth and development. Analyzing every bit of her progress. Planning for next steps, some unknowable time in the future. I can put a smile on.

I am fine. Everything is fine.

Except behind the scenes, under the surface, it doesn't always feel that way. And fine is such a nonsense word—it really should only be used to describe a delicate wine. There are unseen wounds here. Rippling aftershocks. Paradoxes with each passing moment. There is more to be said, and nothing to say, and I don't believe it ever seems to come out quite right.

I am fine.

And then I am not.

Then a wave crests over me that I cannot hold back. Goosebumps move up my arms. My throat is tight, with all the words I cannot say. All the words I fear will be misunderstood. Every muscle in my face softens; weighted, it falls towards the earth. The heaviness is too much to bear. There is always a breaking point. Five days without a tear. Five weeks without a tear. At one point, I make it five months. Because I tell myself, I berate myself, that I have nothing to cry about. There is nothing

tragic here. There is no loss. She is sleeping down the hall, she is beaming, resting on my hip, she is alive in my arms.

Except I have lost. And tragedy plagues my thoughts. And there is no way to escape it. Eventually, it catches up to me.

The wave crests, and then it breaks. On an unassuming day. It breaks over me, and I break open. And there I am heaving, sighing, sharp inhales, wiping my face with the edge of my already damp sleeve.

When there is no breaking, when I'm not breaking, I am stuck. I am stuck somewhere between complete joy and elation with life and constant disappointment and leftover pain.

So, I say I am okay. I am fine. As I cannot seem to find a way to feel any more or any less than that.

Feeling elation and joy. Feeling depressed and weighted. It all happens at once, and I am left to feel nothing at all.

Somehow, I need to separate these emotions within me so that I can feel each of them separately, one by one. Because right now, often, they coexist between the hairs on my skin, cancelling each other out. And I feel nothing at all.

There is no this or that. You cannot put these experiences into a box and tell me what is inside. This is not simple. There are many boxes here.

You can feel a multitude at once. Relief coincides with anger. Joy rests awkwardly with sorrow. Clarity sits easily beside uncertainty. And there is no separating them. Somehow you must allow yourself to feel these paradoxical emotions. Introduce peace to sadness. They may enjoy being friends; they may find that they need each other. For peace to exist there must be a tension that requires her presence. For joy to

be intimately understood she must experience the company of sorrow.

As I sit in my chair, an arm's reach away from my little babe, I am in deep despair. Why is this happening to me? Why must she endure such terrible experiences, just to live? I sit and wallow, and I feel intense sadness.

I wallow and I allow anger to rise to the surface.

As if beckoned to join the chorus, gratitude fills me as my hand reaches into her space and feels her warm skin.

If you cannot allow these contrasting emotions to coexist, you will go mad.

I am this and that.

No or.

Many days simply beg us to live in contrast. And though it is a difficult place to rest, everything is so much clearer here.

I have lost myself here, with you in my arms. I have found myself, too, in this embrace. And I want nothing more than to continue finding, you and me and us and them, searching and finding. Reaching out and welcoming in. Shifting and growing and expanding the soul. I do not know what tomorrow looks like. And it haunts me. I do not know of certainty and expectations. And I am frustrated beyond words. I do not know how to keep up with the rhythms of this world when my own world rests in standstill. So, I just stand still. This day, this moment, we welcome as it is. We take each kiss and cry and overcoming step as a joy. The weight on my shoulders and breath-lessness in my chest and lump in my throat, this is my living. This is my living. With a pained smile and fragile heart. This is my living. With a miracle in my hands and grace over our beings. This is my living. And it is a beautiful life.

[Two years old]

A CLEAN NAPKIN IS LAID OUT on the dresser, a surface on which to place my tools and supplies. The gauze is prepared first. Package torn open, I pull the square out by its corners, careful not to touch more than is necessary. I unfold it and cut it in half. Fold each piece again, and line them neatly on the napkin. Cut, fold and place. A row of one, two, three, four. Another tear; cut and fold, and another row of one, two, three, four. The tubing used to hold it all in place is pre-measured and threaded with cotton twill. I lay it against the ruler to be sure the measurements are exact. Slightly too short, I throw it out. Slightly too long, I trim it down. It too is added to the clean napkin before me. The dressing is cut next, a length of eight centimetres. In the middle, at the four-centimetre mark, a cut to the centre is met with a round opening of just a few millimetres in diameter, placed down on the tubing. A hard twist unlocks the lid on a new bottle of saline water, and I draw up a 10-ml syringe with the sodium chloride solution. It is then placed down, alongside medical scissors for cutting the cotton twill, and tweezers for threading it through. Lotion is pulled from the drawer. Two more squares of gauze, uncut, are placed within reach. The box with the new, sterile tracheostomy tube inside is opened. Holding it carefully, I look through the tube, ensuring there are no defects in its design. A thin layer of water-based lube is applied along the silicone tube length. It rests back in its sterile package until it is time for the mechanism exchange.

I take a step back. Examining my workspace, my preparations. *How many times have I laid these items out, just so? Too many.* I go through a mental checklist in my mind, ensuring no detail is misplaced or left out. Suction machine is plugged in

and ready, a new catheter at arm's reach. Saline water is topped up. The emergency trach kit is accessible, with a sized-down tracheostomy tube inside in case we can't get the correct size in. The bagger sits at the end of her bed. A slight nod of my chin, as I approve of my preparedness.

I go to run the bathwater, placing my hand under the tap until the water is at the right temperature. An infant tub to hold a toddler is unfolded and securely placed upon the counter. I call into the living room, as I pour the last warm water inside, "Evelyn, it is time for your bath!"

She comes running instantly. Pitter-patter, pitter-patter. Both fists rub on her chest as she signs "bath" back to me, a grin on her face and arms reaching up to be undressed.

"Let's go get a suction first," I say to her with both my voice and my hands.

She nods and her mouth moves with a barely audible, breathy "ya." There is an unbalanced turn to run out of the bathroom towards her bedroom next door, and I follow cheerfully behind. Now she is pointing to her chest, "suction," she says, mimicking me exactly. The HME is removed, machine turned on, catheter unthreaded, and my fingers find their familiar placement, right between the 7 and 8. Suction, flush with saline, replace HME and rethread the catheter. Back to the bathroom we go. She stands on the counter, making faces into the mirror as I pull off her clothes and undo her diaper. Then I ceremoniously lift and place her inside the tub. The water still comes up to her waist, but with her legs stretched out, she is the entire length of it. It is not an oversight, though, to use an infant bath for so long. I've thought it through carefully. Here we have the most control.

She is directly in front of me, at counter height, and not being able to lie down is a good thing. The trach cannot be submerged in water. She plays with a small cup, scooping and pouring, as I lather soap all around. She places her index finger upon the palm of her hand, asking for some soap. I put a tiny amount between her small hands, and she rubs them together, then puts it in her hair, on her cheek, atop her belly. By this time James has joined us. His hand grazes my back and he moves in to help rinse everything off, with special care to keep water from running over her neck. I tell her we are all done, and she shakes her head dramatically, "no, no, no." There is a mischievous grin on her face, her eyes scrunched closed. I cannot help but smile at her silliness.

"Okay, just one more minute."

Then the minute is up and James places her soaked body into my arms, where there is a plush cotton towel ready to wrap her. She giggles at her face in the mirror as we round the corner back into her bedroom.

The joyful face shatters as the mirror disappears and the pieces laid out on her dresser come into view. She sees the new trach resting inside its box. She knows exactly what is about to happen, and she is not pleased about it.

Neither am I. None of us enjoy this.

Her body begins reacting in anticipation, arching back and kicking legs. Numb and robotic, I attempt to reassure her, "It's okay, sweetie. It will be quick, my love. Mommy is here. Daddy is here. It will be okay." But my words fall out of my mouth with no substance behind them. Because it is not okay.

It must be done, however. Every month, no exceptions.

I used to think that this would get easier. And perhaps in many ways it has. She doesn't desat into the 40s anymore; her colour remains normal. But in some ways, trach changes have become more difficult. The anticipation, especially, is more emotionally painful to bear. Because it is no longer just James and me shaking, hearts pounding and fearfully anxious. Evelyn is too. She cannot breathe without her trach. It is as if someone removes her airway. Not just a hand over the mouth, panicking sensation of no breath. But the airway itself, physically, is gone.

She cries with long streaky tears, sadness crumpling her face. Her wails are fearful and angry. *I feel you, baby girl, I really do.*

"Okay, let us get this over with." James continues to be adamant that he leads trach changes. We know her best. She trusts us most. We endure with her the most terrible moments. We face this anxiety and fear head-on, together. With her.

"Yes, we are ready. Okay, baby girl. Here we go. Hush now. It will be quick. It will be okay." I cannot help but attempt to console her. Even though I know it is futile. Even though I know it is dishonest. *It's not though. It* will *be okay.*

I pick her up out of her bed. Silky lotion freshly smoothed on her scar-laden body. A new diaper on her still itty-bitty bum. Her G-tube site has been cleaned with saline, dried; ointment generously applied. Her tiny arms and bony back are firmly in my grasp. We sit down in the rocking chair together. Her body is now the length of my thighs, her legs straddled around my waist, and I hold her head protectively in my non-dominant hand.

James starts the process. Saline wipe under the trach. Dry wipe follows. Saline wipe above the trach. Dry wipe follows. I place my pointer and middle finger on either side of her trach

tube, gently resting on the phalange. He cuts the cotton knot off on one side, then pulls the ties through the other. The bubble tubing falls away.

She is crying as we move, and we try to soothe her with song. We used to just power through this with determination, distress and irritation in our expressions. But she picks up on our energy, so despite the tremors we feel inside, despite our own reservations, we smile. And sing.

"Let's sing a song, love. Baa baa black sheep ..."

She is still. Eyes darting, frantic, panicked breathing, beneath my hold. But she likes the song, and points at her daddy leaning above her face, to sing along too. He does.

"Baa baa black sheep, have you any wool? Yes sir, yes sir, three bags full." We both sing, on repeat. Alternating between this and "Twinkle Twinkle" or "The Wheels on the Bus" as we go.

The cleaning continues, saline wipe on each side of her neck. Dry wipe follows. I lift her head so James can prop a rolled blanket under her shoulders to prop her neck up and open, allowing an easier placement of the new trach. It makes her mad, though, and she is now flailing her arms beneath me. Trying to push me away, push all of the hands away.

"Don't touch my hand, Evelyn. I am holding your trach in place. You are okay."

Stay secure, Laesa. Don't let that hand flinch. You are holding her breath.

James picks up the sterile, thinly lubed trach from its resting place with his dominant hand. With his other hand, he reaches across her face to hold her current trach in place. Now my

hands are free. One of them to clean her neck after the used trach is removed, the other to keep her hands away from our procedure space.

"Okay, are you ready?" James asks me, locking his eyes with mine for assurance beyond words.

"Yes, remember to give me a moment to wipe both the wet and the dry cloth." We must rush, but the stoma site needs to be cleaned thoroughly too.

"Yep. Okay, sweetie, here we go. You are okay. One. Two. Three." He always counts down for her now. We started it months ago, deciding that it is better she knows it is coming and freaks out than to not know it is coming and still be freaking out.

The trach is lifted. Her arms are flailing. I wipe once, wet. Wipe again, dry. A quick look at the stoma site. A nod from my head. And the new one is placed in.

Done.

"That's it. We're done. You did it, love. You did it."

The tears are falling, chin quivering and her hands are shaking in my face: "All done, all done, all done."

Yes, all done.

We finish the rest of the process smoothly. The neck roll is removed. I go back to holding the trach and cradling her head. James applies the lotion along her neck, protecting it from the abrasion and moisture that wearing a trach inevitably creates. The specially trimmed dressing is carefully placed underneath the phalange, the precisely cut hole slides easily around the trach tube. The new bubble tubing and ties are put in place. James threads the cotton twill with the tweezers, through the holes

on either end, securing the tubing in place with three tightly pulled knots. I straighten out the dressing and her skin folds, ensuring nothing is pinching. As I lift her to place a pinkie at the back of her neck, making sure the tightness is just right, she continues lifting herself up. She leans towards my chest, falling into my arms.

And then we sit, as we do. Her body slightly longer, her weight just noticeably changed, her head sweaty against me. Her ear is pressed against my heart, the way our hold was established during our NICU days. She can hear mine, and I can feel hers, pounding within our chests. I wipe her cheeks with my hands, the tears still fresh. James kneels before us both and places a kiss on each of our foreheads, his strong hand resting on her back as he does. We look at each other, eyes sad and heavy, but with small smiles at the edges of both of our mouths.

Done. We did it.

Exhale.

She gets up quickly and wants to go play now. She attempts "play" with her fingers shaking, and signs "N" for her cherished big brother, then points off into the distance.

"Let's go. Let's go!" she signs urgently.

I let her slide off my lap and slip a nightie over her head before she runs off, pitter-patter, pitter-patter, out the door and around the corner, waving "bye!" as she disappears.

And then we finish. Our duties are done. The scraps are tossed into the trash. A quick hug and touches of love are exchanged. And she moves on. We each move on.

"Did she cry?" Noah asks as James and I come to join them both in the living room.

"Yes, she cried," I respond simply.

"But she is okay now?" He knows she is, but he wants to be assured, again and again and again.

"Yes. She is okay."

We all are.

ACKNOWLEDGMENTS

I have often felt lonely on this path I walk, being Mom to Evelyn and now, an "author." Both roles have required stretching myself and my understanding of what I am capable of; both roles have demanded long hours of solitude. Despite my feelings of loneliness, though, without a doubt, I have not been alone. And those who have stood alongside me have brought me to this current state of exhalation.

Writing this book with a medically complex child at home has only been possible with the resources available to me in this country, Canada, and more specifically, this province of British Columbia where I live. A rhythm has been created that allows me to be Evelyn's primary caregiver and also to have energy and time to give to my husband, my son and myself. I am continually grateful for these resources, our social workers who advocate for the wellbeing of our family as a whole, and our at-home nursing team who come through our home each week to care for Evelyn.

My gratitude extends to the staff of BC Women's and BC Children's hospitals for their dedication and outpouring of love towards their patients. It has been an honour to witness

the happenings inside these walls and the ways the staff serves the humanity in its care. Thank you to the doctors, nurses and respiratory therapists who rotate throughout the Neonatal and Pediatric ICUs. Thank you to the receptionists, care aids, specialists and surgical teams. Each individual has contributed to the life my daughter lives.

I owe a multitude of thanks.

To our church community, friends and family who cared for our practical needs while we were in hospital. We were nourished with home-cooked meals and groceries to stock the fridge. Gifted money for gas and coffee and eating out. Though many days in hospital were spent alone, there were also many who came to sit with me, many whose generosity in their simple presence was greatly valued. Each gesture, big and small, cared for our needs and lifted our spirits.

To the online community who encouraged me to place my words on paper and has cheered us on, prayed for our girl and celebrated each step along the way. You and our friendships have been an unexpected gift in all of this.

To Rachel Langer, Ashley Reiter and Carly Taylor for reading and providing feedback on the early pages and chapters of this book. Your insight helped me create a framework from which to continue writing.

To Megan Watt of The Self-Publishing Agency, for hosting that workshop on a random September evening some years ago. Your enthusiasm for getting books out into the world, and for the ability each one of us has to do so, gave me such drive and hope in what this could be.

To my editor, Lori Bamber, you are a treasure. To me, to this world, and most certainly to this work.

To my parents, Tammy and Graeme Huguet, Myung and Tae Kim, who supported us in ways I couldn't fully comprehend or acknowledge properly in the moment. Grateful is too small of a word for our knowledge that our family will always be loved and loved on by you.

To my children, Noah and Evelyn. You are the light shining through each and every day, the joy that keeps my feet stepping.

To my husband, James. This book would not have come to be without your persistent encouragement and motivation. This version of me would not have come to be without your unwavering love and affection. Look what we did, together, love.

Made in the USA
Middletown, DE
09 May 2020